47 THINGS YOU NEED TO KNOW ABOUT YOUR CANON EOS REBEL T6

David Busch's Guide to Taking Better Pictur

DAVID D. BUSCH

T0347766

47 THINGS YOU NEED TO KNOW ABOUT YOUR CANON EOS REBEL T6: DAVID BUSCH'S GUIDE TO TAKING BETTER PICTURES

David D. Busch

Project Manager: Jenny Davidson
Series Technical Editor: Michael D. Sullivan
Layout: Bill Hartman
Design system and front cover design: Area of Practice
Cover Production: Mike Tanamachi
Indexer: Valerie Haynes Perry
Proofreader: Mike Beady

ISBN: 978-1-68198-436-0
1st Edition (1st printing, November 2018)
© 2019 David D. Busch
All images © David D. Busch unless otherwise noted

Rocky Nook, Inc.
1010 B Street, Suite 350
San Rafael, CA 94901
USA

www.rockynook.com

Distributed in the U.S. by Ingram Publisher Services
Distributed in the UK and Europe by Publishers Group UK

Library of Congress Control Number: 2018947993

This book is printed on acid-free paper.
Printed in Korea

For Elias Reed Daugherty

ACKNOWLEDGMENTS

THANKS TO EVERYONE at Rocky Nook, including Scott Cowlin, managing director and publisher, who recognized the need for a concise guide book for the Canon EOS Rebel T6/1300D. The goal was to provide the most essential tips for using this feature-rich entry-level camera, while retaining the depth and clarity enthusiast photographers need. I couldn't do it without my veteran production team, including project manager, Jenny Davidson, and series technical editor, Mike Sullivan. Also, thanks to Bill Hartman, layout; Valerie Hayes Perry, indexing; Mike Beady, proofreading; Mike Tanamachi, cover design; and my agent, Carole Jelen, who has the amazing ability to keep both publishers and authors happy. I'd also like to thank the Continent of Europe, without which this book would have a lot of blank spaces where illustrations are supposed to go.

INTRODUCTION

THE CANON EOS T6/1300D is an entry-level camera with all the features budding photo enthusiasts need to bring their creative vision to light. The company has packaged up many of the most alluring capabilities of its more advanced digital SLRs and stuffed them into a compact, highly affordable interchangeable-lens camera. Your new 18-megapixel camera is easy to use right out of the box but includes capabilities you can grow into as you master the art of photography.

This book is going to teach you how to use your camera and use it well, paving your path to pixel proficiency through 47 easy lessons that summarize and explain the most essential tools and techniques every Rebel T6 owner should know. This book is aimed at both Canon and dSLR veterans as well as those who are newcomers to digital photography or digital SLRs.

Both groups can be overwhelmed by the options the T6 offers, while underwhelmed by the explanations they receive in their user's manual.

You'll get a quick tour of all the buttons and dials to help you take your first shots, followed by a more detailed tour of the most useful features of the T6 through a series of short, but engaging lessons that let you apply what you've learned. You'll quickly understand how to apply creative focus techniques, shoot exciting continuous bursts of images, and create beautiful landscape photos. Some lessons help you select the most suitable shooting modes while others investigate capturing memorable images at concerts and performances. You'll learn how to shoot dramatic silhouettes, tell stories with the built-in slide show feature, and shoot and edit movies right in your camera.

I'd like to ask a special favor: let me know what you think of this book. If you have any recommendations about how I can make it better, visit my website at www.canonguides.com, click on the E-Mail Me tab, and send your comments, suggestions on topics that should be explained in more detail, or, especially, any typos. I really value your ideas, and I appreciate it when you take the time to tell me what you think! Some of the content of the book you hold in your hands came from suggestions I received from readers like yourself. If you found this book especially useful, tell others about it. Visit http://www.amazon.com/dp/1681984369 and leave a positive review. Your feedback is what spurs me to make each one of these books better than the last. Thanks!

CONTENTS

CONTENTS

HIT THE GROUND RUNNING

CHAPTER 1

Even if you've never used a digital imaging device with as many features as your Canon EOS Rebel T6 (also known as the 1300D outside the Americas), you can begin taking great pictures within minutes of extracting your new camera from its box. By the time you finish this chapter, you'll have mastered the basics of taking photos, making simple adjustments, and reviewing images you've taken. With the get-started knowledge you glean from this chapter, you'll be on your way to deploying the fun and interesting photography tips I've collected for your Rebel T6.

1. TAKING YOUR BEST (FIRST) SHOT

TAKING YOUR FIRST photograph is a snap, and you may even have performed most of the initial steps with a previous camera you've owned. They're as simple as mounting a lens, inserting a fresh battery and memory card, composing through the viewfinder, and pressing the shutter button. The Rebel T6 is easy to use. While the instructions that follow may be too basic for experienced photo enthusiasts, remember that there was a time when you were brand-new to photography, too. Although veterans may wish to skip these initial exercises, aspiring newbies daunted by all the features of the T6 may be surprised to see just how painless it is to get their feet wet.

If you purchased the T6 in a kit, inside the box you'll find these essentials: the camera itself, the kit lens (usually the Canon Zoom Lens EF-S 18-55mm f/3.5-5.6 IS II), an LP-E10 battery and LC-E10 (or LC-E10e) charger, and a neck strap. Also in the box is a USB connecting cable, warranty, and a basic instruction manual. You will need a Secure Digital (SD) memory card, as one is not included with the camera. I recommend using a card labeled "16GB" or larger.

Mounting the Lens

A protective body cap (on the camera's lens mount) and end cap (on the rear of the lens's mount) shield these components from dust and dirt. Loosen (but do not remove) the rear lens cap and set it cap-side up on a flat surface (a pocket of your camera bag, if you have one, may be safest).

Then, follow these instructions:

1 Press the lens release button on the camera (seen in **Figure 1.1**) and rotate the body cap counter-clockwise to remove it. Then lift the rear lens cap from the lens and align the raised white square on the lens with the matching square on the lens bayonet mount on the camera.

2 Insert the rear flange of the lens into the bayonet mount of the camera. Note that if the ring around the front element of your lens is labeled "EF" instead of "EF-S" you should align the raised red dot on the lens with the red dot on the bayonet, instead.

3 Once the lens has been inserted into the mount, rotate the lens clockwise until it click/locks into place.

4 To remove the lens to mount another (or to replace the body cap), press the lens release button and rotate the lens counter-clockwise.

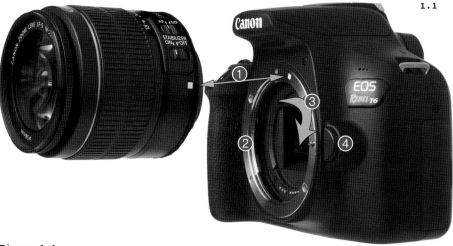

1.1

Figure 1.1
❶ Line up lens index marks
❷ Insert into bayonet mount
❸ Rotate clockwise until lens clicks into place
❹ To remove lens, press lens release button and rotate counter-clockwise

Insert a Battery and Memory Card

All batteries undergo some degree of discharge even when not in use, so your new camera's battery is probably not fully charged. Before you start shooting, I recommend inserting the battery into the LC-E10/LC-E10e charger (it's impossible to insert it incorrectly). A Charge light will begin to glow orange-red. When the battery completes the charge, the Full Charge lamp glows green, approximately two hours later. A fully charged battery should be good for about 500 pictures.

You'll also need an SD card, which is not included with the Rebel T6. These are the most common cards used in cameras and other devices (including GPS navigators), so you may have one already. You can buy them anywhere for $10 to $20 (and up), including convenience, grocery, and drug stores. You'll want one that can store all the photos you'll be taking. I recommend purchasing a 16GB card, which can store almost 2,000 photos in the JPEG format your camera uses. While that sounds like overkill, smaller cards are only a few dollars cheaper, and may not provide enough storage for, say, a full week of vacation pictures.

Just follow these steps:

1 Slide the battery/card door lock on the bottom of the camera and swing the door open. Then insert the memory card into the slot in the top of the chamber with the label facing the side closest to the back of the camera, as shown in **Figure 1.2**. The electrical contacts on the side of the card opposite the label should go in first. To remove the card, press down on the edge and it will pop back out.

2 To insert the battery, position it with the battery's label side *away* from the back of the camera, and the electric contacts on its edge going in first. As you insert the battery, the gray button (at left in the figure) will retract to allow the battery to slide in smoothly. To remove the battery for recharging, just press the gray button, and it will pop out.

3 The battery will seat in the camera only in the correct orientation. If it slides in but doesn't snap in place, you've inserted the wrong end first; if it doesn't fit at all, then you have the label facing the wrong way.

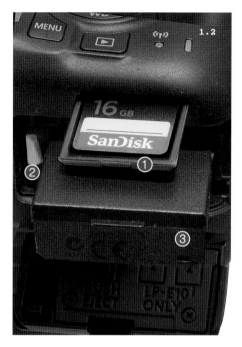

Figure 1.2
❶ Press the memory card to insert or remove
❷ Press the gray release button to insert/remove battery
❸ The battery fits only one way

Take That Photo!

You're ready to go. All you need to do next is turn on the camera, choose an automatic exposure mode, frame your photo through the viewfinder, and let your T6 take the picture. The five easy steps are listed next.

1 You'll find the On/Off switch on the top-right "shoulder" of the T6, as seen in **Figure 1.3**. Slide it forward to turn on the camera, and back to turn the T6 off again. The camera will remain active for a period of time even while you are not taking photos. The default is 30 seconds, but you can choose another Auto Power Off interval in the Setup 1 menu. (I'll explain menus in **Lesson 5**.) If the camera goes to sleep while the On/Off switch is in the On position, you can bring it back to life by tapping the shutter release button.

2 Rotate the Mode Dial (located next to the On/Off switch) to the P (Program Auto) position. With this setting, the Rebel T6 will examine the image framed by the camera and make virtually all the adjustments for you. The P mode is the best mode to use starting out, because it does allow you to change some settings as you gain expertise with your camera. The Mode Dial also has options that are even more automated and allow very few adjustments. These include Scene Intelligent Auto (marked with an A+ icon) and six individual Scene modes for specific types of subjects. For now, stick with P mode and explore the other automated (and the useful semi-automatic/manual) modes later.

3 Bring the camera viewfinder up to your eye and frame your image. (If you wear glasses and have trouble seeing the viewfinder screen, you can rotate the diopter adjustment dial located to the right of viewfinder window.

4 Press the shutter release button halfway to focus.

5 Press the shutter release button down all the way to take your picture. You may notice a red LED at the lower-right corner of the back of the camera flashing. That indicates that your photo is being stored on the memory card. The red lamp will turn off when the transfer to the card is finished.

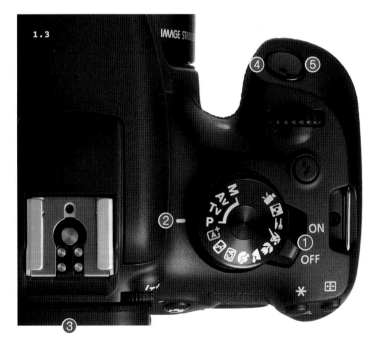

Figure 1.3
❶ Flip On/Off switch forward
❷ Rotate Mode Dial to P
❸ Frame image in viewfinder
❹ Press shutter release halfway to focus
❺ Press shutter release fully to take photo

Review Your Image

By default, immediately after you take a picture, the image will be displayed on the rear LCD monitor screen for two seconds. (You can make this automatic review time longer or turn it off using the Image Review setting in the Shooting 1 menu.) You can also display the most recent picture (and review others you've already captured), by pushing the Playback button, as described next.

1 Press the blue-tinted Playback button located at the lower edge of the back of the T6. The last image taken will be shown on the LCD monitor screen. Canon highlights the camera's image review controls with blue icons, as you can see in **Figure 1.4**.

2 If you have taken more than one photo, press the left directional button (which Canon calls a "cross key") to see the previous image, or to wrap around to the final one. The cross keys each have additional functions when the camera is in Shooting mode (such as autofocus or white balance options), as I'll explain later.

3 Press the right directional/cross key to view the next image, if any. If you continue to press this button after the last image is shown, the T6 wraps around to the first shot again.

4 Press the Trash/Erase button to erase the image currently being displayed. A screen pops up with the options Cancel and Erase shown. Press the left/right keys to choose Erase and the SET button (located in the middle of the cross key array) to confirm your choice.

5 When an image is displayed on the LCD screen, you can zoom in or out using the two buttons in the upper right of the back of the camera. Tap the shutter release button to exit picture review.

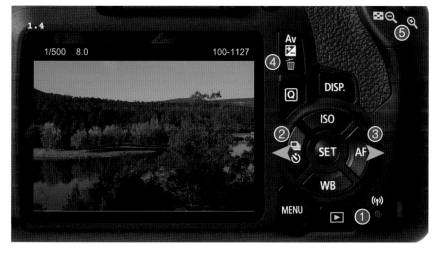

```
Figure 1.4
❶ Press to display last picture taken
❷ Press to see previous image
❸ Press to see next image
❹ Erase displayed photo
❺ Zoom in/Zoom out
```

2. QUICK TOUR OF YOUR REBEL T6

YOUR REBEL T6 has more than a dozen and a half buttons, dials, and switches on its exterior, but the good news is that you really only need to learn a few to get started with your camera. You've already encountered the most important of them—such as the lens release button, Mode Dial, and shutter release—but there are a few more you'll want to become familiar with right away. The rest you can learn as you gain experience with your camera. This Quick Tour will show you the general layout of your camera's controls. I will help you master the most important buttons and dials located on the back panel of the T6 in **Lesson 3**, later in this chapter.

Full Frontal

While the front of the camera is featured on the box and in ads, surprisingly few controls reside there. A quick overview of all the components, as seen from this perspective (without a lens attached) is all you really need. If you later have a question about what's what, you can return to this chapter and look at **Figure 2.1**. The key components are as follows:

1 **Shutter release button.** Angled on top of the hand grip is the shutter release button. Press this button down halfway to lock exposure and focus (when using *One-Shot* and *AI Focus* modes to focus, as I'll explain in **Lesson 10**). The T6 assumes that when you tap or depress the shutter release, you are ready to take a picture, so the button can be tapped to activate the exposure meter or to exit from most menus.

2 **Main Dial.** This dial is actually on top of the camera but can be seen from the front. It is used to change shooting settings. When settings are available in pairs (such as shutter speed/aperture), this dial will be used to make one type of setting, such as shutter speed. The other setting, say, the aperture, is made using an alternate control, such as spinning the Main Dial while holding down an additional button like the exposure compensation button, which resides conveniently under the thumb on the back of the camera. (It doubles as the Delete/Trash button, shown earlier in **Figure 1.4**.)

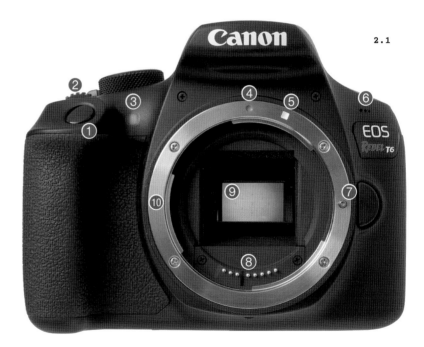

Figure 2.1
❶ Shutter release button
❷ Main Dial
❸ Red-eye reduction/self-timer lamp
❹ EF lens mounting index
❺ EF-S lens mounting index
❻ Microphone
❼ Lens release button/locking pin
❽ Electronic contacts
❾ Mirror
❿ Lens bayonet mount

3 Red-eye reduction/self-timer lamp. This LED provides a blip of light shortly before a flash exposure to cause the subjects' pupils to close down, reducing the effect of red-eye reflections off their retinas. When using the self-timer, this lamp also flashes to mark the countdown until the photo is taken.

4 EF lens mounting index. Line up the round red index mark on the lens and camera body to align lenses labeled "EF" for mounting.

5 EF-S lens mounting index. Use the white square on the lens and camera to align EF-S optics.

6 Microphone. This is a monaural (non-stereo) microphone for recording the audio track of your movies.

7 Lens release button/locking pin. Press and hold down this button to allow rotating the lens to attach or remove it from the camera. A pin on the bayonet mount next to it retracts when the lens release button is held down, allowing the lens to rotate.

8 Electronic contacts. These contacts mate with matching contacts on the rear of the lens to allow the camera and lens to exchange information about focus, aperture setting, and other functions.

9 Mirror. When using the optical viewfinder, the mirror reflects most of the light upward to the focusing screen and exposure meter system and directs a small amount of light downward to the autofocus sensors. The mirror flips up out of the way to expose the shutter curtain/sensor when taking a picture, and the sensor when using Live View mode or capturing video.

10 Lens bayonet mount. This metal ring accepts the rear bayonet on the lens and allows mounting the lens firmly on the camera body.

Built-in Flash and Connections

The main components on the left side of the Rebel T6 are three interface terminal/ports that allow you to connect the camera to a remote control, your computer, or a high-definition television or monitor. These connectors are under a cover on the side of the camera and shown in an x-ray view at left in **Figure 2.2**. Also illustrated in the figure are the camera's pop-up electronic flash, and one of the two mounts used to attach a neck strap.

1 Pop-up flash. The internal flash unit pops up automatically when needed when the Mode Dial is set to the Scene Intelligent Auto (green A+ icon), Creative Auto (with the CA label), or the Scene icons representing Portrait, Close-up, or Night Portrait scene modes. It is disabled entirely when using Auto/No Flash, Landscape, or Sports scene modes. I've labeled each of the pop-up flash modes with a green star at upper right in **Figure 2.2**. (The stars do not actually appear on the camera!)

2 Flash button. The flash can be popped up manually by pressing the Flash button on top of the camera when the Mode Dial is set to P (Program), Tv (Shutter Priority), Av (Aperture Priority), or M (Manual) exposure modes. If you decide you do not want to use the flash, you can turn it off by pressing the flash head back down.

2.2

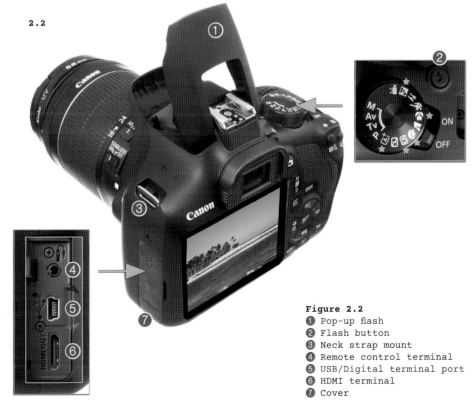

Figure 2.2
❶ Pop-up flash
❷ Flash button
❸ Neck strap mount
❹ Remote control terminal
❺ USB/Digital terminal port
❻ HDMI terminal
❼ Cover

3 Neck strap mount. You can attach the included Wide Strap EW-200D, packaged with the camera, or another strap of your choice.

4 Remote control terminal. You can plug various Canon remote release switches, timers, and wireless controllers into this connector.

5 USB/Digital terminal port. Plug in the USB cable furnished with your Rebel T6 and connect the other end to a USB port in your computer when transferring photos or directing images to a PictBridge-compatible printer.

6 HDMI terminal. Use an HTC-100 Type C HDMI cable (not included in the box with your camera) to direct the video and audio output of the T6 to a high-definition television (HDTV) or HD monitor. You can use any HDMI Mini (Type C) cable. Don't confuse this cable with the smaller HDMI Micro (Type D) cable, or the similarly named USB 3.0 Type C cable.

7 Cover. This port cover protects the electrical connections underneath.

Top and Bottom Views

Controls and other components are fairly sparse on the top and bottom of your Rebel T6. The shutter release, Main Dial, and Mode Dial/On-Off switch combination are the ones you'll use most. The key components shown in **Figure 2.3** include:

On top:

1 Speaker. Sounds emanating from your T6 are heard through this small solid-state speaker.

2 Flash accessory/hot shoe. Slide an optional auxiliary electronic flash into this

mount when you need a more powerful Speedlite. A dedicated flash unit, like those from Canon, can use the multiple contact points shown to communicate exposure, zoom setting, white balance information, and other data between the flash and the camera.

3 Mode Dial/On/Off switch. Rotate this dial to switch among Basic Zone options (various Auto and Scene modes), Creative Zone (P [Program], Tv [Shutter Priority], Av [Aperture Priority], and M [Manual] exposure modes), and Movie modes. You'll find these

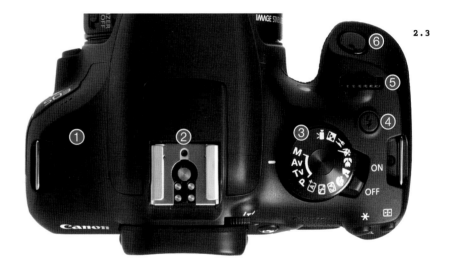

2.3

Figure 2.3
❶ Speaker
❷ Flash accessory/hot shoe
❸ Mode Dial/On/Off switch
❹ Flash button
❺ Main Dial
❻ Shutter release button
❼ Tripod socket
❽ Battery/memory card door
❾ DC cord hole

modes and options described in more detail among the tips in **Chapter 3**. Next to the Mode Dial is the On/Off switch.

4 **Flash button.** Pressing this button releases the built-in flash in Creative Zone modes, and some Basic Zone modes that don't elevate the flash automatically.

5 **Main Dial.** As noted earlier, this dial is used to make many shooting settings. When settings come in pairs (such as shutter speed/aperture in Manual shooting mode), the Main Dial is used for one (for example, shutter speed), while some other control, such as the Av button+Main Dial (when shooting in Manual exposure mode) is used for the other (aperture).

6 **Shutter release button.** Partially depress this button to lock in exposure and focus. Press all the way to take the picture. Tapping the shutter release when the camera has turned off the autoexposure and autofocus mechanisms reactivates both. When a review image is displayed on the back-panel color LCD, tapping this button removes the image from the display and reactivates the autoexposure and autofocus mechanisms.

On the bottom:

7 **Tripod socket.** Tripods and other accessories (such as flash brackets) will be furnished with a standard 1/4"-20 mounting screw to attach them to the base of your Rebel T6.

8 **Battery/memory card door.** Slide the latch shown toward the front of the camera to open the door when you want to remove or insert a battery or memory card.

9 **DC cord hole.** The cord for the DC Coupler DR-E10 (which is similar in size and shape to the camera's battery) used with the Compact Power Adapter CA-PS700 (optional accessories) passes through this opening, allowing the Rebel T6 to be operated using AC power.

Using Your Lens

The kit lens most commonly furnished with the Rebel T6 has rings used to focus and zoom, and a pair of switches that control the lens's built-in Image Stabilization (anti-shake) feature and change between automatic focus and manual focus. Most other lenses have similar components, with a few additions, such as a scale that shows the approximate distance at which the lens has been focused. The key parts you need to know as shown in **Figure 2.4** include:

1 **Filter thread.** Lenses have a thread on the front for attaching filters and other add-ons. Some also use this thread for attaching a lens hood (you screw on the filter first, and then attach the hood to the screw thread on the front of the filter).

2 **Lens hood bayonet.** This is used to mount the lens hood for lenses that don't use screw-mount hoods, which is the majority.

3 **Manual Focus ring.** This is the ring you turn when you manually focus the lens.

4 **Zoom ring.** Turn this ring to zoom in and out.

5 **Zoom scale.** These markings on the lens show the current zoom factor (focal length) selected.

6 **Lens mounting index.** EF-S lenses have a raised white square, while EF lenses have a raised red bump. Line up these indexes with the matching white and red indicators on the camera lens mount to attach the lens.

7 **Image stabilizer switch.** With Image Stabilized (IS) lenses, this switch is used to turn image stabilization on and off. The anti-shake features of IS can reduce or eliminate the blur in your images that results from camera shake, which is most prevalent when shooting at shutter speeds slower than 1/60th second, or when using telephoto

lenses (which magnify the effects of camera motion.) Image stabilization is not needed when the camera is mounted on a tripod or other steady support, and should be turned off to avoid "confusing" the anti-shake mechanism.

8 **Autofocus/manual focus switch.** Canon autofocus lenses have a switch to allow changing between automatic focus and manual focus.

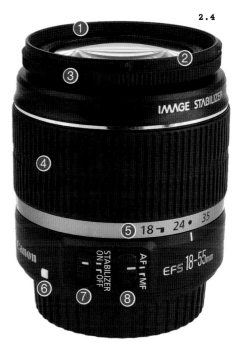

2.4

Figure 2.4
1 Filter thread
2 Lens hood bayonet
3 Manual focus ring
4 Zoom ring
5 Zoom scale
6 Lens mounting index
7 Image stabilizer switch
8 Autofocus/manual focus switch

3. MASTERING THE KEY CONTROLS AND COMPONENTS

THE BUSINESS END of your Canon EOS Rebel T6 is where the tools reside that you'll use to compose and review your images, make key adjustments and settings, and access menus. You'll need to use these buttons and dials to apply what you're learning in the other Tips in this book. As you become more adept with the T6's capabilities, you can always return to this Lesson to review the key functions of any control you have questions about.

Back Panel Controls

The 15 items shown in **Figure 3.1** may seem daunting, but they're easy to work with once you've used them a few times. Here's a list of what they are, and what they do:

1 Viewfinder window. You can frame your composition by peering into the viewfinder. It's surrounded by a soft rubber frame that seals out extraneous light when pressing your eye tightly up to the viewfinder, and it also protects your eyeglass lenses (if worn) from scratching.

You can peer through the viewfinder to view and frame your subject. If you're shooting a picture under bright lighting conditions with the camera mounted on a tripod, or you are otherwise not looking through the viewfinder during the exposure, it's a good idea to cover up this window (I use my hand).

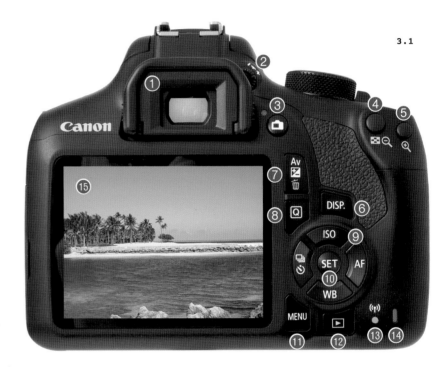

3.1

Figure 3.1
1. Viewfinder window
2. Diopter adjustment
3. Shoot movies or live view
4. Zoom out/Lock exposure
5. Zoom in/Select autofocus point
6. DISP. button
7. Aperture value (AV)/Exposure compensation/Erase button
8. Quick Control button
9. Direct functions/Directional (cross) keys
10. SET (Enter) button
11. Access menus
12. Playback images
13. Wi-Fi connection
14. Memory card access lamp
15. LCD monitor

2 Diopter adjustment for eyeglass wearers. Use this knob to provide optical correction in the viewfinder. While your contact lenses or glasses may provide sufficient correction, some glasses wearers want to shoot without them, so the built-in diopter adjustment, which can be varied from −2.5 to +0.5 correction, is useful.

Press the shutter release halfway to illuminate the indicators in the viewfinder, then rotate the diopter adjustment dial next to the viewfinder while looking through the viewfinder until the indicators appear sharp. Canon also offers an array of different Dioptric Adjustment Lens Series E correction lenses for additional correction. I recommend using these "permanent" add-ons only if you are the only person using your T6.

3 Shoot movies or live view. Press this button, marked with a red dot to its upper left, to activate/deactivate live view for still photography shooting, using the LCD monitor to frame photos instead of the viewfinder. To shoot movies, instead, turn the Mode Dial to the Movie position, and then press this button to start/stop video/audio recording.

4 Zoom out/Lock exposure. This button is located at the upper-right corner of the back of the camera, performs one function when you're reviewing pictures during Playback, and a different function when you're actually taking pictures.

- **Playback mode.** When reviewing photos in Playback mode, the Zoom Out/Index-Reduce button (marked with a magnifying glass icon with a minus sign) zooms out of an image and produces an index view of four thumbnails, and then, if pressed again, nine thumbnails, as seen in **Figure 3.2**. Move highlighting among the thumbnails with the directional/cross keys (described shortly) or Main Dial. To view a highlighted thumbnail image in full-screen mode, press the SET button (described shortly).

- **Shooting mode.** The same button, which also has a * label above it, becomes the Lock Exposure button, and locks the exposure or flash exposure that the camera sets when you partially depress the shutter button. When locked, an asterisk appears in the viewfinder settings display in the LCD monitor (if visible; if not press the DISP. button, described shortly). The exposure is unlocked when you release the shutter button or take the picture. To retain the exposure lock for subsequent photos, keep the * button pressed while shooting.

You can also lock flash exposure with this button. When using flash, pressing the * (Lock Exposure) button fires an extra pre-flash *before the picture is taken* that allows the unit to calculate what the exposure would be when you do take a photo, and lock exposure at that value prior to actually taking the picture. The characters FEL will appear momentarily in the viewfinder, and the exposure lock indication and a flash indicator appear.

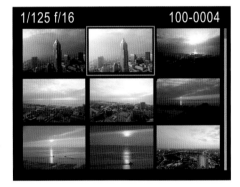

Figure 3.2 Image review thumbnails.

5 **Zoom In/Select autofocus point.** This button, which resides to the right of the Zoom Out/Lock Exposure button, also has different functions for Playback and Shooting modes.

- **Playback mode.** If you're viewing a single image, this button zooms in on the image that's displayed. If thumbnail indexes are shown, pressing this button switches from nine thumbnails to four thumbnails, or from four thumbnails to a full-screen view of a highlighted image. When thumbnails are displayed, press SET to view that image in full-screen mode.

- **Shooting mode.** This button activates autofocus point selection—the part of the frame the T6 will use to calculate the correct focus when Manual focus point selection is active. (See **Lesson 10** for information on autofocus point selection when using Creative Zone exposure modes.)

6 **DISP. button.** When pressed repeatedly, this changes the amount of picture information displayed. In Playback mode, pressing the DISP. button cycles among several different informational screens about your picture, as seen in **Figure 3.3**. In Shooting mode, the DISP. button turns the Shooting Settings screen (shown in **Figure 3.4**) on or off.

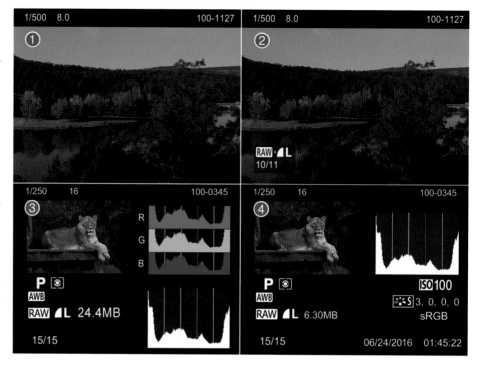

Figure 3.3
❶ Single-image display
❷ Single-image display with recording quality
❸ Basic shooting information with RGB and brightness histograms
❹ More complete shooting information with brightness histogram

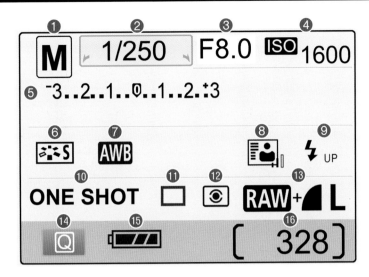

Figure 3.4
1. Exposure mode
2. Shutter speed
3. Lens aperture
4. ISO sensitivity
5. Exposure information
6. Picture Control
7. White balance
8. Auto Lighting Optimizer
9. Flash elevated
10. Autofocus mode
11. Drive mode
12. Metering mode
13. Image quality
14. Access quick control screen
15. Battery status
16. Shots remaining/other information

7 Aperture value (AV)/Exposure compensation/Erase button. When using Manual exposure mode, hold down this button and rotate the Main Dial to specify a lens aperture; rotate the Main Dial alone to choose the shutter speed. In other Creative Zone exposure modes—Aperture-priority (Av), Shutter-priority (Tv), or Program (P)—hold down this button and rotate the Main Dial to the right to add exposure compensation (EV) to an image (making it brighter) or rotate to the left to subtract EV and make the image darker. When you're reviewing an image you've already taken, this control functions as an Erase button. Press to erase the image shown on the LCD. A menu will pop up displaying Cancel and Erase choices. Use the left/right directional/cross keys to select one of these actions, then press the SET button to activate your choice.

8 Quick Control button. This button activates the Quick Control screen (described in **Lesson 5**), which allows you to make many different adjustments rapidly.

9 Direct Functions/Directional (cross) keys. This array of four-directional keys provides left/right/up/down movement to navigate menus and is used to cycle among various options (usually with the left/right buttons) and to choose amounts (with the up/down buttons). The four cross keys also have secondary functions to adjust ISO, White Balance, Autofocus mode, and Drive mode.

- **ISO button.** The up cross key also serves to set the sensor's sensitivity to light, or *ISO*. Press this button when using one of the Creative Zone modes (M, Av, Tv, or P) to produce the ISO screen. Then, use the left/right cross keys to select an ISO sensitivity setting, and press SET to confirm.

- **White balance button.** The down cross key also serves to access the white balance function. Press this WB button when using one of the Creative Zone modes (M, Av,

Tv, or P) to produce the White Balance screen. Then, use the left/right cross keys to select a white balance, and press SET to confirm.

- **Autofocus mode button.** Press the right cross key when using a Creative Zone mode to produce a screen that allows choosing autofocus mode from among One-Shot, AI Focus, and AI Servo, which are explained in **Lesson 10**. Press repeatedly until the focus mode you want is selected. Then press SET to confirm your focus mode.

- **Drive mode button.** Press the left cross key to produce a screen that allows choosing a drive mode, in both Creative Zone and Basic Zone modes. Then press the right cross key to select the 10-second self-timer, 2-second self-timer, or Self-timer: Continuous, which allows you to specify a number of shots to be taken when the timer triggers the shutter (from 2 to 10) with the up/down keys. Press SET to confirm your choice.

10 SET (Enter) button. Located in the center of the cross key cluster, this button is used to confirm a selection or activate a feature.

11 Access Menus. Summons/exits the menu displayed on the rear LCD of the T6. When you're working with submenus, this button also serves to exit a submenu and return to the main menu. I'll explain using Menus in **Lesson 5**.

12 Playback images. Displays the last picture taken. Thereafter, you can move back and forth among the available images by pressing the left/right cross keys to advance or reverse one image at a time, or the Main Dial, to jump forward or back 10 images at a time (or another increment using the Image Jump with Dial option in the Playback 2 menu).

To quit playback, press the Playback button again. The T6 also exits Playback mode automatically when you press the shutter button (so you'll never be prevented from taking a picture on the spur of the moment because you happened to be viewing an image).

13 Wi-Fi connection. Illuminates when the camera is connected to your device using Wi-Fi/NFC.

14 Memory card access lamp. When lit or blinking, this lamp indicates that the memory card is being accessed.

15 LCD monitor. This is the 3-inch display that shows your live view preview, displays a shot for image review after the picture is taken, shows the shooting settings display before the photo is snapped, and all the menus used by the Rebel T6.

Inside the Viewfinder

Most of what you need to know can be viewed on the back-panel LCD screen. However, your Rebel T6 provides a selection of important information within the viewfinder so you can monitor your exposure and other settings. **Figure 3.5** provides an overview of what you're looking at when the camera is up to your eye. **Figure 3.6** shows the status information enlarged.

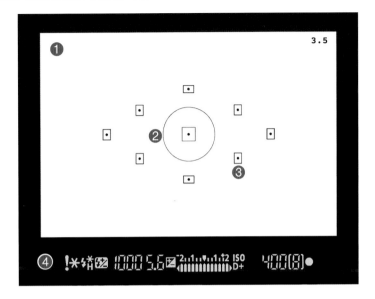

Figure 3.5
1. Focusing screen
2. Spot metering circle
3. Autofocus point
4. Status information

Figure 3.6
1. Exposure lock/Flash information
2. Shutter speed
3. Aperture
4. Exposure compensation
5. Exposure scale/other information
6. Highlight Tone Priority
7. ISO sensitivity
8. Shots remaining/other information
9. Focus indicator

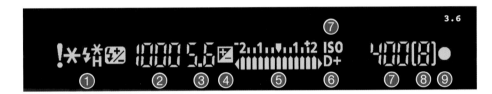

2

GETTING CREATIVE WITH EASY ADJUSTMENTS

CHAPTER 2

Although the EOS Rebel T6 can take great photos using nothing more than the basic settings I showed you in Chapter 1, there are many easy adjustments you can make to spread your creative wings and shoot images that are even more impressive. This chapter offers a half-dozen ways to capture interesting photographs using simple adjustments. I'm going to show you how to grab shots in bursts, use the self-timer for selfies (and more!), introduce you to the T6's menu system, and share your images with your smart device or printer.

4. HOW TO SHOOT EXCITING CONTINUOUS BURSTS

ONE OF THE coolest features available with the Rebel T6 is the ability to shoot a continuous series of photos. Continuous shooting (found in Drive mode—a throwback to the "motor drive" found in film cameras) is a great way to capture sequential images of moving subjects—such as a child playing a sport or a puppy burning off energy in your yard. With Drive mode, you have your choice of taking a single shot each time you press the shutter release, capturing a burst of images at a three-pictures-per-second clip, or inserting a self-timer delay before the photo is actually taken after you press the button (as described in **Lesson 5**).

Continuous shooting is easy. Just follow these steps:

1. Press the Drive button, which is the left directional/cross key, as seen in **Figure 4.1**.
2. The Drive/Self-Timer mode screen appears on the LCD monitor. If it does not appear, you may have the display turned off. Press the DISP. button to turn it back on.
3. Press the left/right directional buttons (upper left in the Figure) or rotate the Main Dial (lower right in the figure) to select continuous shooting.
4. Press SET to confirm.
5. Hold down the shutter release to take a continuous series of images.

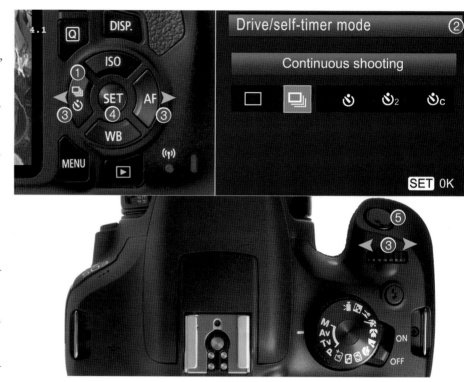

Figure 4.1
1. Press Drive button
2. Drive/Self-timer mode screen appears
3. Left/right keys or Main Dial chooses mode
4. Press SET to confirm
5. Press shutter release to start burst

Your shots will be taken at a maximum of three frames per second. If your battery is nearly depleted or you are shooting under dim light, the burst speed will decrease. If your subject is moving, you will get the best results by setting the autofocus mode to AI Servo; for still shots, One-Shot AF is best. I'll explain your autofocus options in more detail in **Lessons 12** and **13**. However, you can quickly choose AI Servo or One-Shot AF now by following these steps:

1 Press the AF button, which is the right directional/cross key, as seen in **Figure 4.2**.

2 The AF Operation screen appears on the LCD monitor. Press the DISP. button, if necessary, to turn the display on.

3 Press the left/right directional buttons or rotate the Main Dial to select One-Shot (which locks focus when you press the shutter release down halfway, or all the way to take a photo) or AI Servo (which continues to refocus on a moving subject when you press the shutter button halfway, until you press it all the way down to take the photo). (The third choice, AI Focus, is a combination of the two, switching from One-Shot to AI Servo if your subject begins moving.)

4 Press SET to confirm.

5 Press shutter release to start burst.

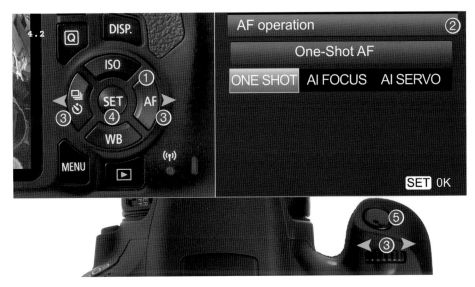

Figure 4.2
❶ Press AF button
❷ AF operation screen appears
❸ Left/right keys or Main Dial chooses mode
❹ Press SET to confirm
❺ Press shutter release to start burst

5. PUT YOURSELF IN THE PICTURE!

THE SELF-TIMER IN cameras pre-dates the current selfie craze by many years. That means it's easy for you to get in the picture by using the self-timer on your EOS Rebel T6 (although your camera doesn't lend itself to using a selfie stick!). You can use the self-timer for many other things, too. For example, if you're taking a long exposure (say, a night shot), the self-timer can trigger the shutter without the potential jolt that results from physically pressing the shutter release button with your finger. Unlike a wired or wireless remote control, you don't need another gadget to trip the shutter using the self-timer. You don't even necessarily need a tripod: just place the camera on a solid surface, activate the self-timer, press the shutter button, and wait while the T6 snaps one (or more) photos after the countdown. Just follow these steps:

1 Press the Drive button (the left directional/cross key).
2 The Drive/Self-timer mode screen appears on the LCD monitor. Press the DISP. button, if necessary, to turn the display on.
3 Press the left/right buttons (or rotate the Main Dial) to select one of the three self-timer icons.
4 The icons are the last three in the array seen in **Figure 5.1**.
 - **Self-timer: 10 seconds.** The picture takes after a delay of roughly 10 seconds. Use this setting when you want to get in the picture yourself, or need the full countdown.
 - **Self-timer: 2 seconds.** This shorter delay is useful if you are using the self-timer when the camera is mounted on a tripod or other solid support, and just need a slight delay so the camera can steady.
 - **Self-timer: Continuous.** Allows taking multiple photographs after the delay.

 If you have selected Self-timer: Continuous, press the up/down buttons to specify from 2 to 10 shots. The shots will be captured in a burst after a 10-second countdown. I like to use this option when shooting group photos to help ensure that everyone is smiling and/or have their eyes open. Four or five shots is usually enough for small groups. For groups of eight or more, selecting 10 shots improves your chances of capturing at least one shot with everyone smiling.

5 Press SET to confirm your choice. The self-timer will begin when you press the shutter release down all the way.

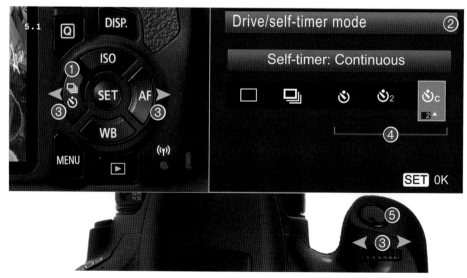

Figure 5.1
❶ Press Drive button
❷ Drive/self-timer mode screen appears
❸ Left/right keys or Main Dial chooses mode
❹ Select Self-timer, Self-timer 2 sec., Continuous Self-timer icons
❺ Press shutter release to start burst

6. WHAT'S ON THE MENU?

THE EOS REBEL T6 has two varieties of menu options. These entries are in the main menu system (summoned by pressing the MENU button on the back of the camera), and the Quick Control menu, which you can access by pressing the Q button located to the upper left of the cross-key pad. Many of the Tips found in this book will direct you to one or more of these menu entries. This lesson provides everything you need to know to find, navigate, and implement the adjustments you'll be making.

Quick Guide to the Main Menu

The main menu system contains tabbed pages that allow you to adjust shooting settings, configure playback options, and set up your camera's operating features.

Tapping the MENU button brings up a typical menu like the one shown in **Figure 6.1**. (If the camera goes to "sleep" while you're reviewing a menu, you may need to wake it up again by tapping the shutter release button.) When you've set the Mode Dial to any of the semi-automatic/manual exposure modes— P (Program), Tv (Shutter Priority), Av (Aperture Priority), or M (Manual)—there are 10 menu tabs: Shooting 1, Shooting 2, Shooting 3, Shooting 4, Playback 1, Playback 2, Set-up 1, Set-up 2, Set-up 3, and My Menu.

In Scene Intelligent Auto and Creative Auto, the Shooting 3, Shooting 4, and My Menu choices are not available, and the options within the menus are slightly different. When the Mode Dial is set to Movie mode, there are three Movie menus, one Shooting menu, two Playback menus, and three Set-up menus.

The key parts of the main menu entries shown in **Figure 6.1** include:

1 **Selected menu tab.** The Shooting menu tabs are represented by a red still camera or movie camera icon; Playback menus are displayed with a right-pointing blue triangle that appears on the Playback button; Set-up menus are represented by an amber-colored wrench icon; and My Menu displays a green star. The currently selected menu's icon is white within a white border, on a background corresponding to its color code. All the inactive menus are dimmed and the icons and their borders are color-coded.

2 **Shooting menus.** There are four shooting menus. One to four dots appear at the right edge of the menu tab, representing menu pages 1 through 4. In still shooting mode, the first three Shooting menus include entries for still photos using the viewfinder. The fourth tab has options for Live View shooting, in which images are composed using the LCD on the back of the camera.

When the Mode Dial is set to the Movie position, the first three Shooting menu tabs offer movie-oriented options; the fourth tab includes settings that apply to stills (which you can capture even in Movie mode).

3 **Playback menus.** In these two tabs, you'll find options for rotating, resizing, printing, and erasing images, along with additional commands for applying "favorite" ratings (one to five stars) or creative filters to specific images, and other settings.

4 **Set-up menus.** The four Set-up menu entries make it easy to specify how your camera functions, with options for power-saving mode, screen colors, LCD brightness, and preferred language. These menu tabs also include various housekeeping functions, such as setting the date and time, cleaning the sensor, formatting a memory card, and setting up communication between your camera and a smartphone or tablet.

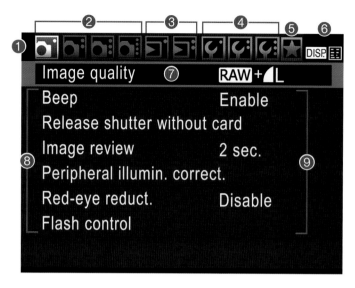

Figure 6.1
1. Selected menu tab
2. Shooting menus
3. Playback menus
4. Set-up menus
5. My Menu
6. Press DISP. button for settings display
7. Current entry and setting
8. Other menu choices
9. Current settings

5 **My Menu.** This tab helps you operate more efficiently by defining a personal menu that contains up to six of your most-used functions all in one place.

6 **Settings Display.** This pair of icons isn't a selectable menu item; it's a reminder that you can press the DISP. button to view a handy screen of current shooting settings. That screen appears in **Figure 6.2**.

7 **Current entry and setting.** The currently active menu entry is surrounded by a highlight box. The item name and its current setting have a black background.

8 **Other menu choices.** The other menu entries visible on the screen will have a dark gray background.

9 **Current settings.** The current settings for visible menu items are shown in the right-hand column, until one menu item is selected (by pressing the SET key). At that point, all the settings vanish from the screen except for those dealing with the active menu choice.

Menu Navigation

Here is a quick overview of menu navigation, using the controls you already understand.

- Use the Main Dial to move among menu tabs.
- Use the cross keys to highlight a particular menu entry.
- Press the SET button to select a menu item.
- To exit from a menu adjustment screen, press the MENU button again.
- You can jump from tab to tab with the Main Dial, even if you've highlighted a particular menu setting on another tab, and the T6 will remember which menu entry you've highlighted when you return to that menu. The memorization works even if you leave the menu system or turn off your camera.
- The T6 always remembers the last menu entry you used with a particular tab. So, if you generally use the Format command each time you access the Set-up 1 menu, that's the entry that will be highlighted when you choose that tab. The camera remembers which tab was last used, too.

Settings Display

The Settings Display is a useful screen that shows important shooting information at a glance. It can be summoned by pressing the DISP. button *while you are viewing a menu*. To return to the menu you were viewing, press the DISP. button again.

DISP. Button Functions

Note that the DISP. button has different functions, depending on the current camera mode.

- **Viewing menus.** While viewing menu tabs or an adjustment screen accessed from a menu tab, pressing the DISP. button shows/hides the Settings Display.
- **During image review.** The DISP. button cycles among four informational screens: single image, single image with recording quality, histogram display, and shooting information.
- **During Live View and Movie shooting.** Cycles among four screens of information.
- **Still shooting.** Pressing the DISP. button turns the information screens on or off.

The data shown in the Settings Display screen includes the following nine nuggets of information:

1. **Remaining memory card capacity.** How much memory card capacity is available.
2. **Color space.** This indicates the range of colors that can be captured. Unless you're working with professional color labs or printers to have your work output, it's a good idea to leave this setting at its default value of sRGB (Standard RGB).
3. **White balance correction.** Any adjustments you've made for these advanced settings will appear here. I'll explain white balance correction/bracketing later in this book.

4. **Live view shooting.** This indicates whether you have enabled or disabled Live View photography, in which you use the back-panel LCD to compose your images instead of the optical viewfinder. In general, there is usually no need to disable Live View, but if you want to eliminate the opportunity (say, you find yourself accidentally pressing the button) you can do that with the Live View Shoot. entry of the Shooting 4 menu.
5. **Auto power off.** Your T6 will shut itself off automatically if you stop shooting and the camera is idle for a specified period. (You can revive it by tapping the shutter button.) The default value is 4 minutes, but you can set periods from 30 seconds to 15 minutes or disable the auto-off feature entirely with the entry in the Set-up 1 menu. A brief time-out conserves your battery power.

If you happen to be shooting an ongoing event (such as a birthday party or action-packed sports contest), using a longer time-out will keep your camera wide awake and ready to shoot.

6. **Red-eye reduction.** If you're using electronic flash, the Rebel T6 can reduce (but not always totally eliminate) the dreaded "red-eye" effect. It accomplishes this by emitting a pre-flash burst shortly before the main flash used to take the picture. If your subject is looking at the camera, their pupils may contract a bit, potentially reducing the "demon eyes" look. Red-eye can also be easily eliminated in even the most basic of picture-editing apps, so you may prefer to do it that way. Disable the camera's feature using the Red-eye Reduction entry in the Shooting 1 menu.

Freespace	7.52 GB	①
Color space	sRGB	②
WB SHIFT/BKT	0, 0/ + 0	③
Live View shoot.	Enable	④
📷 4 min. ⑤	👁 Off	⑥
•)) Enable ⑦	🔄 On 📷💻	⑧
	08/18/2018 11:15:32 ⑨	

Figure 6.2

- ❶ Remaining memory card capacity
- ❷ Color space
- ❸ White balance correction
- ❹ Live view shooting
- ❺ Auto power off
- ❻ Red-eye reduction
- ❼ Beeper
- ❽ Auto rotate display
- ❾ Current date/time

7 Beeper. The T6 emits beeps when focus is achieved and during the self-timer countdown. At religious ceremonies, acoustic concerts, or in public libraries (!) you (or those around you) might prefer silence. You can disable the beeper in the Shooting 1 menu.

8 Auto rotate display. In the Set-up 1 menu, you'll find an entry that commands the T6 to rotate images during playback automatically, so vertical images will display vertically during review, rather than tilted on their side on the screen. You can choose to have your photos autorotated on both the camera screen and on your computer (when reviewing or editing photos), on the computer screen only, or disable autorotation in both cases. If you turn the feature off or set it so that the photo is rotated only on your computer screen, horizontally composed images will appear on the camera's LCD horizontally (as always), and vertically oriented photos will be displayed horizontally. In that mode, they fill the LCD screen entirely, but you must rotate the camera yourself to view them in their correct orientation.

9 Current date/time. Shows your camera's current date and time settings. If Daylight Savings Time is activated, a Sun icon will appear to the left of the date. You can adjust the date, time, time zone, and format (mm/dd/yy, yy/mm/dd) in the Set-up 2 menu.

Fast Adjustments with the Quick Control Menu

The Quick Control menu provides a fast way of accessing your most-used settings, without the need to locate a button or wend your way through a thicket of menu entries. The Quick Control menu is most efficient when used with what Canon calls the *Creative Zone* modes: Manual (M), Aperture Priority (Av), Shutter Priority (Tv), and Program (P) modes. The Q menu also functions in the other automatic modes (called *Basic Zone* modes) and Movie mode, but in a different way. I'm going to provide an overview of the Quick Control menu's Creative Zone options next.

When using Creative Zone modes, a Shooting Functions Settings screen can be turned on or off with the DISP. button. A typical screen and its settings are shown at left and right in **Figure 6.3**. You can specify any of four different color schemes for the Shooting Functions Settings display using the Screen Color entry in the Set-up 1 menu. Shown are Screen Color 1 (white information on a dark background, left) and Screen Color 2 (dark information on a light background). The former is easier to read in dark environments, while you'll probably prefer Screen Color 2 in bright surroundings, including full daylight. Screen Color 3 is white lettering

on a dark brown background and Screen Color 4 is yellow-green lettering on a dark background.

The information displayed varies depending on your shooting mode. For example, in Manual exposure mode, you can rotate the Main Dial to adjust the shutter speed, or hold the Av/Trash button (shown earlier in **Figure 3.1** in Chapter 1) and spin the same dial to adjust the lens aperture. In Shutter Priority/Time Value (Tv) mode, you can set only the shutter speed; in Aperture Priority/Aperture Value (Av) mode, you can adjust only the aperture (also called the f/stop); in Program (P) mode, you cannot change either.

However, when you press the Q button, all the settings in the top four rows can be changed (except for the exposure mode shown in the upper-left corner). The display screen changes to resemble the one seen at right in **Figure 6.4** (illustrated using Screen Color 1 in this case). One setting will be highlighted with an orange box around it. You can change the value of the highlighted setting by rotating the Main Dial, or use the cross keys to move the orange box to another setting. Note that the bottom row of icons represent (from left to right) the Quick Control button, battery status, and number of shots remaining before your memory card fills.

Figure 6.3 Screen Color 1 (left) and Screen Color 2 (right) are two of the four choices for the Shooting Functions Settings display.

Dial or Adjustment Screen?

Note that when a setting is highlighted, you have the choice of either rotating the Main Dial to make the adjustment or pressing the SET button to produce a new screen with all the options available shown. Rotating the Main Dial is faster in most cases, but pressing the SET button and working with the screen that pops up can make it easier to visualize your choices from the array of options. The screen also is helpful when working with functions that have multiple options, such as exposure bracketing (a useful feature I'll explain later in this book).

Here is an overview of the settings you can make from the Quick Control menu:

1 **Quick control button.** Pressing this button switches from the Shooting Functions Settings screen to the Quick Control screen.

2 **Exposure mode.** Displays the current exposure mode. You cannot highlight or adjust the exposure mode from the Quick Control screen.

3 **Shutter speed.** The current shutter speed can be adjusted using the Main Dial (or pop-up screen) when the exposure mode is M or Tv.

4 **Lens aperture.** The current aperture/f/stop can be changed using the Main Dial (or pop-up screen) when the exposure mode is set to M or Av.

5 **ISO sensitivity.** Select Auto to allow the T6 to change the ISO setting; or choose fixed values of ISO 100, 200, 400, 800, 1600, 3200, or 6400.

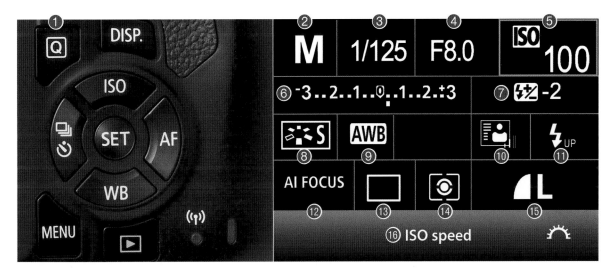

Figure 6.4
① Quick control button
② Exposure mode
③ Shutter speed
④ Lens aperture
⑤ ISO sensitivity
⑥ Exposure compensation/ autoexposure bracketing
⑦ Flash compensation
⑧ Picture Style
⑨ White balance
⑩ Auto lighting optimizer
⑪ Elevate flash
⑫ Autofocus mode
⑬ Drive mode
⑭ Metering mode
⑮ Image quality
⑯ Active setting

6 Exposure compensation/Autoexposure bracketing. Rotating the Main Dial adds or subtracts exposure in semi-automatic and automatic modes, with the amount of adjustment (more exposure, right; less exposure, left) displayed as a square marker underneath the scale. Exposure bracketing is changed by holding down the Av/Trash button and rotating the Main Dial to expand or contract the f/stop range of the bracketing; rotating the Main Dial alone moves the bracketing to the right (more exposure) or left (less exposure).

7 Flash compensation. If your flash pictures are too bright or too dark, highlight this option and spin the Main Dial to subtract (toward the left) or add (toward the right) exposure.

8 Picture Style. Picture Styles are a type of adjustment you can apply to optimize your photos for a particular type of subject. Your choices include Auto, Standard, Portrait, Landscape, Neutral, Faithful, Monochrome, and three custom styles you define yourself. I'll show you how to apply Picture Styles in **Lesson 24.**

9 White balance. While AWB (Auto White Balance) is usually your best choice most of the time, you can also select Daylight, Shade, Cloudy, Tungsten, Fluorescent, Flash, and Custom. I'll explain white balance settings in **Lesson 24.**

10 Auto lighting optimizer. The automatic lighting optimizer is a tool for pulling extra detail out of dark shadows without overexposing the bright areas of your image. You can select Standard or three degrees of correction. I'll show you how to use this feature in **Lesson 22.**

11 Elevate flash. Pops up the Rebel T6's built-in electronic flash, more or less duplicating the function of the Flash button.

12 Autofocus mode. You can choose from One Shot, AI Focus, and AI Servo autofocus modes, as described in Chapter 1, and in more detail in **Lessons 10** and **11.**

13 Drive mode. Use this entry to adjust the camera's Drive mode, as I explained in **Lessons 4** and **5.**

14 Metering mode. While Evaluative metering is usually your best choice, you can also select from Partial and Center-weighted Averaging. I'll show you when and why to use all three in **Lesson 21.**

15 Image quality. You can shoot Large (full resolution), Medium, and Small images, and choose to save in the familiar JPEG format. You can also elect to store files in RAW format, which provides more image-editing options for those who opt to work with image manipulation apps. (You can also select JPEG *and* RAW and save in both formats.)

16 Active setting. The bottom line of the Quick Control screen displays the name of the currently orange-highlighted setting and, in the case of the settings in the rows above it, the values currently selected.

Set-Up Essentials

Here in **Lesson 6** you've learned how to use the key menus found in the Rebel T6. I'll provide recommended menu settings as appropriate throughout the rest of this book. In this section, I'll explain the best options for some of the key set-up adjustments you should master immediately. They're all simple to understand and easy to implement.

- **Format Card.** This command, the third entry in the Set-up 1 menu, erases any information on your memory card and prepares it for storing photos. To set up the card correctly, you should always format the card in your camera, and not on your computer. Navigate to the Format command, press SET to access the Format screen (see **Figure 6.5**), then press the left/right cross keys to select OK. Press SET one final time to begin the format process. You can also press the Trash button within the Format screen to tell the T6 to provide a more thorough "low-level" format that locks out any "bad" sectors that might have developed on your memory card.

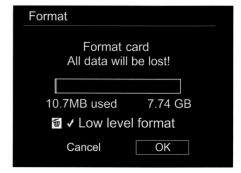

Figure 6.5 Formatting a memory card.

- **LCD Brightness.** Choose this menu option, the first on the second Set-up menu tab, and a thumbnail image with a grayscale strip appears on the LCD monitor, as shown in **Figure 6.6**. You can manually set brightness. Use the cross keys to adjust the brightness to a comfortable viewing level. Use the gray bars as a guide; you want to be able to see both the lightest and darkest steps at top and bottom, and not lose any of the steps in the middle. Brighter settings use more battery power, but can allow you to view an image on the LCD outdoors in bright sunlight. When you have the brightness you want, press the SET button to lock it in and return to the menu.

- **Date/Time/Zone.** Use this option to set the date, time, and time zone, which will be embedded in the image file along with exposure information and other data. Access this menu entry from the Set-up 2 menu,

and Press the SET button to access the Date/Time setting screen, shown in **Figure 6.7**. Then, use the cross keys to select the value you want to change. When the gold box highlights the month, day, year, hour, minute, or second format you want to adjust, press the SET button to activate that value. A pair of up/down-pointing triangles appears above the value. Press up/down to adjust the value, and SET to confirm. Repeat for each of the other values you want to change, including the time zone appropriate for where you live. When finished, select OK, then press SET to finish.

- **Clean Manually.** The EOS T6 does not have an automatic sensor-cleaning feature, so from time to time you may need to clean the sensor manually. Most often, a blower bulb like the Giottos Rocket will do the job. Select Clean Manually from the Set-up 2 menu, choose OK from the screen

that appears, and press SET. The shutter will open, exposing the sensor. Remove the lens from your camera, turn it so the sensor is facing downward (to allow dust to fall away), and then carefully insert the tip of the blower into the mirror box in front of the sensor. A few puffs from the bulb will usually clean the sensor of any dust or artifacts.

- **Feature Guide.** When you first begin using your T6, you'll want to enable the Feature Guide, found in the Set-up 2 menu. When activated, it provides a pop-up description of a function or option that appears when you change the shooting mode or use the Quick Control screen to select a function, or switch to Live View, movie making, or playback. (See **Figure 6.8**.) When you've mastered your camera's basic features, you may find the Feature Guide screen hangs around too long, and you can then disable it.

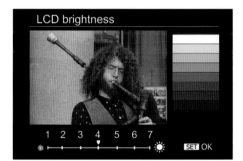

Figure 6.6 Adjusting LCD brightness.

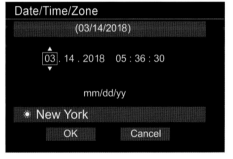

Figure 6.7 Setting the Date, Time, and Time Zone.

Figure 6.8 The Feature Guide screen provides information about a mode or function.

7. EASY BASIC FLASH TECHNIQUES

THE T6'S BUILT-IN flash is easy enough to work with that you can begin using it right away, either to provide the main lighting of a scene or as supplementary illumination to fill in shadows. The T6 will automatically balance the amount of light emitted from the flash so that it illuminates the shadows nicely, without overwhelming the highlights and producing a glaring "flash" look.

The T6's flash is powerful enough to allow proper illumination of a subject that's 10 feet away at f/4 at the *lowest* ISO (sensitivity) setting of your camera. Boost the ISO (or use a wider f/stop) and you can shoot subjects that are located at a greater distance—as far as 20 feet. The flash will pop up automatically when using any of the Basic Zone modes except for Landscape, Sports, or No Flash modes. In Creative Zone modes, just press the flash button (marked with a lighting bolt and shown earlier in **Figure 2.3**).

When using these modes, the flash functions in the following way:

- **P** (**Program mode**). The T6 selects a shutter speed from 1/60th to 1/200th second and appropriate aperture automatically.
- **Tv** (**Shutter-priority mode**). You choose a shutter speed from 30 seconds to 1/200th second, and the T6 chooses the lens opening for you, while adjusting the flash output to provide the correct exposure.
- **Av** (**Aperture-priority mode**). You select the aperture you want to use, and the camera will select a shutter speed from 30 seconds to 1/200th second, and adjust the flash output to provide the correct exposure. In low light levels, the T6 may select a very slow shutter speed to allow the flash and background illumination to balance out, so you should use a tripod. (You can disable this behavior using Custom Function I-3: Flash Sync. Speed in Av mode in the Set-up 3 menu, as described in Chapter 9.)
- **M** (**Manual mode**). You choose both shutter speed (from 30 seconds to 1/200th second) and aperture, and the camera will adjust the flash output to produce a good exposure based on the aperture you've selected.

Learn the Main Controls in a Flash

In most cases, you can pop up the flash (or allow it to elevate automatically in some modes), and then fire away. As your skills improve, you may want to explore the Flash Control menu (see **Figure 7.1**), a multi-level entry that includes five settings for controlling the T6's built-in, pop-up electronic flash unit, as well as accessory flash units you can attach to the camera.

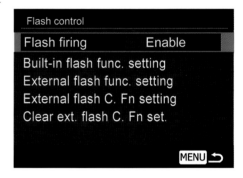

Figure 7.1 The Flash Control menu entry has five setting submenus.

The main options are as follows:

- **Flash Firing.** Use this option to enable or disable the built-in electronic flash. You might want to totally disable the T6's flash (both built-in and accessory flash) when shooting in sensitive environments, such as concerts, in museums, or during religious ceremonies. When disabled, the flash cannot fire even if you accidentally elevate it, or have an accessory flash attached and turned on. If you turn off the flash here, it is disabled in any exposure mode.

- **Built-in Flash Function Setting.** There are four choices for this menu screen.
 - **Flash mode.** This entry is fixed at E-TTL II (electronic through-the-lens metering) and cannot be changed.
 - **Shutter sync.** The default value is *1st curtain sync*, and you can leave that setting alone under nearly all conditions. In that mode, the T6 fires a *pre-flash* prior to the actual exposure with the main flash burst, and uses the pre-flash to calculate the exposure. The optional *2nd curtain sync* is useful only when you are shooting a moving subject under significant illumination (it improves the appearance of any "ghost" images caused by the bright ambient light).

- **Flash exposure compensation.** If you'd like to adjust flash exposure, making your flash pictures brighter or darker using a menu, you can do that here, as well as with the Quick Control menu, as described in **Lesson 6**. Select this option with the SET button, then dial in the amount of flash EV compensation you want using the cross keys. The EV that was in place before you started to make your adjustment is shown as a blue indicator, so you can return to that value quickly. Press SET again to confirm your change; then press the MENU button twice to exit.

- **E-TTL II metering.** Choose Evaluative metering (in which the camera analyzes the scene type and intelligently calculates the best overall exposure) or Average metering (which simply provides an exposure based on the average reflectance of the entire scene).

- **External Flash Function Setting.** You can access this menu only when you have a compatible electronic flash attached and switched on. It includes settings similar to those described above for the built-in flash. It also includes a Zoom option available to adjust the coverage area of certain external flash units, and options for triggering external flash wirelessly.

- **External Flash Custom Function Setting.** Many external Speedlites from Canon include custom functions, which you can set from your T6's Flash Control menu.

- **Clear External Flash Custom Function Setting.** This entry allows you to zero-out any changes you've made to your external flash's Custom Functions, and return them to their factory default settings.

8. THE FASTEST WAYS TO SHARE YOUR PHOTOS

THE BEST PART of taking photos is sharing your images with others. After a successful shooting session, you'll want to transfer the photos you've taken to your computer (or your smartphone/tablet) so you can post them on social media, e-mail them to friends, family, and colleagues, or make prints for display or to show off your improving skills.

This lesson will describe how to transfer your images to your computer. **Lesson 9** will show you how easy it is to make prints, while **Lesson 16** reveals the secrets of linking your T6 to a smartphone or tablet. To start, you'll probably want to transfer your images either by using a cable transfer from the camera to the computer or by removing the memory card from the T6 and transferring the images with a card reader. The latter option is usually the best, because it's usually much faster and doesn't deplete the battery of your camera. However, you can use a cable transfer when you have the cable and a computer, but no card reader (perhaps you're using the computer of a friend or colleague, or at an Internet café).

To transfer images from the camera to a Mac or PC computer using the USB cable just follow these steps:

1. Turn off the camera.
2. Pry back the rubber cover that protects the Rebel T6's USB port, and plug the USB cable furnished with the camera into the USB port on the left side of the camera. (See **Figure 8.1**.)
3. Connect the other end of the USB cable to a USB port on your computer.
4. Turn the camera on. Your installed software usually detects the camera and offers to transfer the pictures, or the camera appears on your desktop as a mass storage device, enabling you to drag and drop the files to your computer.

To transfer images from a memory card to the computer using a card reader:

1. Turn off the camera.
2. Slide open the memory card door, and press on the card, which causes it to pop up so it can be removed from the slot.
3. Insert the memory card into your memory card reader. (**See Figure 8.2**.) Your installed software detects the files on the card and offers to transfer them. The card can also appear as a mass storage device on your desktop, which you can open, and then drag and drop the files to your computer. Some smart devices accept a USB card reader like the one shown, so you may be able to transfer images directly to your phone or tablet.

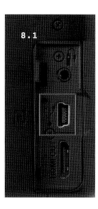

Figure 8.1 Images can be transferred to your computer using a USB cable plugged into this terminal on the side of the camera.

Figure 8.2 A card reader is usually the fastest way to transfer images to your computer.

9. HARDCOPIES AREN'T HARD!

YOU CAN ALWAYS make prints once you've transferred your photos to your computer or smart device. But the Rebel T6 supports the DPOF (Digital Print Order Format) that is now almost universally used by digital cameras to specify which images on your memory card should be printed, and the number of prints desired of each image. This information is recorded on the memory card, and can be interpreted by a compatible printer when the camera is linked to the printer using the USB cable, or when the memory card is inserted into a card reader slot on the printer itself. Photo labs are also equipped to read this data and make prints when you supply your memory card to them.

Direct Printing from the Camera

You can print photos stored on your camera's memory card directly to a PictBridge-compatible printer using the cable supplied with the T6. Just follow these steps to get started:

1 **Set up your printer.** Follow the instructions for your PictBridge-compatible printer to load it with paper, and prepare it for printing.

2 **Connect the camera to the printer.** With the T6 and printer both powered down, open the port cover on the left side of the camera, and plug the Interface Cable IFC-200U into the A/V Out/Digital port. Connect the other end to the PictBridge port of your printer.

3 **Turn printer and camera on.** Flip the switch on the T6, and power up your printer using its power switch.

4 **Play back the image.** Press the Playback button. Navigate to the image you want to print using the left/right cross keys.

5 **Press SET to access the Print Setting Screen.** The screen like the one shown in **Figure 9.1** appears. Set your options as described next.

Page Setup

The EOS T6 offers a surprising number of options when direct printing from your camera. You can choose effects, print date and time on your hardcopies, select the number of copies to be output, trim the image, and select paper settings—from your camera! While you can print using the current values as shown in the status screen, to adjust the settings, follow the steps briefly summarized here, with the camera connected to the printer:

1 **Current page settings.** If you want different settings, you will be able to change them in Step 6. Use the cross keys to navigate to any of the settings shown at right in **Figure 9.1**.

2 **Print options.** Set your print effects here. Use the cross keys to choose Off (no effects), On (the printer's automatic corrections will be applied), Default (values stored in your printer, and which will vary depending on your printer), Vivid (higher saturation in blues and greens), or NR (noise reduction is applied). Three B/W choices are also available, for B/W (true blacks), B/W Cool tone (bluish blacks), and B/W Warm tone (yellowish blacks). Natural and Natural M choices are also available to provide true colors. If the INFO icon appears, you can press the DISP. button to adjust the printing effect, including image brightening, levels, and red-eye correction.

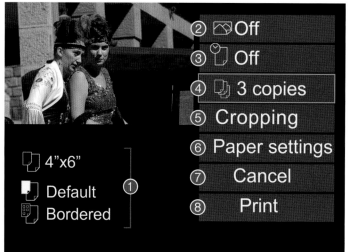

Figure 9.1
1. Current page settings
2. Print options
3. Date/file number imprint
4. Number of copies
5. Crop the image
6. Paper settings
7. Cancel printing
8. Print

3 Date/File number imprint. You can set this to On, Off, Default, Date, File No., or Both.

4 Number of copies. Select 1 to 99 copies of the selected image.

5 Crop the image. Use this to crop your image. Your image appears on a trimming screen. Press the Magnify and Reduce buttons to magnify or reduce the size of the cropping frame. Use the cross keys to move the cropping frame around within the image. Rotate the cross keys to rotate the image. Press the DISP. button to toggle the cropping frame between horizontal and vertical orientations. When you've defined the crop for the image, press the SET button to apply your trimming to the image.

6 Paper settings. Choose the paper size, type, and layout.

- **Paper Size.** Use the cross keys to select your paper size, with choices from credit card size through 8.5 × 11 inches. Press SET to confirm.
- **Paper Type.** Select the type of paper loaded into your printer.
- **Page Layout.** Choose a layout, from the Default settings used by your particular printer, to Borderless, Bordered, 2-up, 4-up, 9-up, 16-up, and 20-up (multiple copies of the image on a single sheet). When using Letter size (8.5 × 11–inch) paper, you can also elect to print 20-up and 35-up thumbnails of images if you've chosen multiple images using the *Direct Print Order Format* (DPOF) options described next. The 20-up version will also include shooting information, such as camera and lens used, shooting mode, shutter speed, aperture, and other data. Another press of the SET button confirms Page Layout.

- **Page Layout.** Select from Bordered, Borderless, or Borderless with shooting information printed on the border of larger print sizes.

7 Cancel printing. Returns to the status screen.

8 Print. Starts the printing process with the selected options. The camera warns you not to disconnect the cable during printing. To print another photo using the same settings, just select it, highlight Print, and press the SET button.

Direct Print Order Format (DPOF) Printing

If you don't want to print directly from the camera, you can set some of the same options from the Playback 1 menu's Print Order entry, and designate single or multiple images on your memory card for printing. Once marked for DPOF printing, you can print the selected images, or take your memory card to a digital lab or kiosk, which is equipped to read the print order and make the copies you've specified. (You can't "order" prints of RAW images or movies.)

To create a DPOF print order, just follow these steps:

1 **Access Print Order screen.** In the Playback 1 menu, navigate to Print Order. Press SET.

2 **Access Set up.** The Print Order screen will appear. (**See Figure 9.2**.) Use the cross keys to highlight Set Up. Press SET.

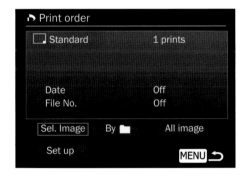

Figure 9.2 Print orders can be assembled from the Playback 1 menu.

3 **Select Print type.** Choose Print Type (Standard, Index/Thumbnails print, or Both), and specify whether Date or File Number imprinting should be turned on or off. (You can turn one or the other on, but not both Date and File Number imprinting.) Press MENU to return to the Print Order screen.

4 **Choose selection method.** Highlight Sel. Image (choose individual images), By Folder (to select/deselect all images in a folder), or All Image (to mark/unmark all the images on your memory card). Press SET.

5 **Select individual images.** With Sel. Image, use the cross keys to view the images, and press SET to mark or unmark an image for printing. If you'd rather view thumbnails of images, press the Magnify button. Press the Reduce button to return to single-image view.

6 **Choose number of prints.** Once an image is selected, press the up/down cross keys to specify 1 to 99 prints for that image. (For index prints, you can only specify whether the selected image is included in the index print, not the number of copies.) Press SET to confirm. You can then use the cross keys to select additional images. The camera displays a running total of images to print to the right of the print number box. Press MENU when finished selecting to return to the Print Order screen.

7 **Output your hardcopies.** If the camera is linked to a PictBridge-compatible printer, an additional option appears on the Print Order screen: Print. You can select that; optionally, adjust paper settings as described in the previous section, and start the printing process. Alternately, you can exit the Print Order screen by tapping the shutter release button, removing the memory card, and inserting it in the memory card slot of a compatible printer, retailer kiosk, or digital minilab.

3

TEN STEPS TO GETTING GREAT PICTURES

CHAPTER 3

Your EOS Rebel T6 makes it easy to exercise your creativity. Once you've refined your vision to spot worthy subject matter and honed your compositional skills, the next step is to spread your wings and use some of the simple tools built into your camera to capture images that truly reflect your vision. The lessons in this chapter offer 10 techniques for dramatic action shots, silhouettes, creating wonderful landscape photos, and making your subject the center of attention. I'll also help you decide which shooting and scene modes are best for particular types of subjects, link your camera to your smart device, and give you a checklist of the best settings for common scenes.

10. MAKING EVERYTHING SHARP...

TAKING A PHOTO that is "sharp and clear" is the goal of every photographer. However, as an enthusiast, you are learning that "sharp and clear" can mean many things. Even in its most automatic modes, the Rebel T6 can capture sharp images of a variety of subjects most of the time. Adding your creativity to a photo often involves deciding *which* areas of the photo are sharp, and which are not. The eye tends to be attracted to the sharpest portions of an image. With the T6, you have a choice of sharpening almost everything in your photo (say, a landscape), or, reducing the sharpness of other parts of the image to focus attention on your main subject. In this lesson, I'll help you master the art of maximizing the range of focus (called *depth-of-field*). In **Lesson 11** (which follows), you'll find pointers for concentrating attention on a particular subject, using *selective focus*.

You'll want to increase depth-of-field when everything in your image is an important part of your composition, as, for example, in **Figure 10.1**. All portions of the image are equally sharp, so the composition uses a technique called *leading lines* (in this case the base and capital of the columns) to concentrate attention on the strolling couple. Our visual focus also is attracted to the brightest areas, so the lit hanging lamps as well as the illuminated columns themselves encourage our eyes to wander through the frame and settle on the two humans.

10.1

Figure 10.1
In many cases, you'll want to have as much of your scene in focus as possible.

Increasing the amount of depth-of-field (usually abbreviated DOF) is easy and can be accomplished in one of two ways:

- **Take a wider view.** If you're using the T6's 18-55mm f/3.5-5.6 "kit" lens, the wide-angle end of its zoom range—18mm—provides the maximum amount of DOF and the widest field of view. As you zoom in toward the 55mm setting to magnify your image, depth-of-field decreases. If you're using some other lens, the same rule applies: the greater the focal length, the less your range of sharp focus is. **Figure 10.2**, which pictures the interior of an 18th Century Spanish army barracks, was captured using an ultra-wide-angle lens.

- **Use a smaller f/stop.** The variable opening in your lens that lets light pass through to the sensor is called the *aperture* or *f/stop*. As the aperture gets smaller, the range of sharpness gets larger, producing more depth-of-field. The f/stop is actually a fraction (focal length of the lens/diameter of the opening) which is why f/2 represents a larger opening than f/4 (just as 1/2 is larger than 1/4) and f/16 is smaller than f/11. (See **Figure 10.3**.) I'll tell you more about f/stops in **Lesson 20**. All you need to know now is that smaller f/stops (larger numbers, such as f/11) provide more depth-of-field than larger f/stops (the smaller numbers, such as f/4). In **Figure 10.2**, I used the properties of the wide-angle lens, *plus* a small f/stop (f/16) to maximize DOF for the photo.

Figure 10.3 Larger numbers mean smaller apertures. Top row, from left: f/4, f/5.6, f/8. Bottom row: f/11, f/16, f/22.

Figure 10.2 An ultra-wide-angle lens provides a broader field of view in tight spaces, and maximum depth-of-field.

To achieve great depth-of-field when taking photos with your T6, just follow these steps:

1 Use a lens or zoom setting that's as wide as possible, adjusting your position so you can frame your entire subject.

2 Rotate the Mode Dial on the top-right shoulder of the T6 to the Aperture Priority (Av) position.

3 Press the ISO button (the up cross key) or press the Quick Control button and navigate to the ISO setting in the upper-right corner of the Quick Control screen. Rotate the Main Dial until ISO AUTO appears within the orange highlighted box. Press the Q button again so the camera will select an appropriate sensor sensitivity for you.

4 Tap the shutter release lightly to activate the Rebel T6's exposure meter.

5 Rotate the Main Dial to the right to choose smaller apertures (those with *larger* numbers). As you rotate the dial, the camera automatically selects a shutter speed that will produce the correct exposure at your selected aperture.

Diminishing Returns

Using the smallest possible aperture—usually f/16 or f/22 on most lenses—isn't necessarily the best idea. As I noted, smaller f/stops require longer exposures that can lead to camera or subject motion blur. In addition, lenses are their sharpest at their middle f/stop settings; f/8 or f/11 may be your sharpest, with f/16 or f/22 providing a small (but measurable) decrease in sharpness.

6 The smaller f/stops admit less light, so shutters speeds of longer duration (slower) will be selected. For example, if the shutter speed is 1/125th second when f/8 is selected, it will change to 1/60th second when you dial in f/11 (which lets in half as much light).

7 Slower shutter speeds can cause blur from camera shake or shutter movement, even though many Canon lenses (including the 18-55mm kit lens) have a feature called Image Stabilization (which compensates only for camera shake, not subject movement). When ISO AUTO is turned on, the camera will automatically boost sensor sensitivity when appropriate to reduce the amount of blur.

8 If you notice that the recommended shutter speed is 1/30th second or slower (for example, 1/15th second or 1/8th second), consider placing your camera on a firm support or a tripod if you have one. At this point, the T6 has already increased sensitivity to the maximum and must use those slower speeds. Simply placing the camera on a tree stump, fence rail, or table may be enough. Or, you can dig your elbows into your sides to brace your arms.

9 Take your photo. While the LCD monitor of the T6 is too small to effectively judge depth-of-field, after you've reviewed your images on your computer you'll get a feel for how much DOF each particular f/stop provides at a given distance.

Distance Matters

The effective depth-of-field decreases the closer you get to your subject. At a particular f/stop, you may discover that your DOF is too shallow when taking close-up pictures but is just fine when taking landscape photos in which your subject is much farther away.

As you work with this book, you'll discover that great photos can combine more than one creative technique. **Figure 10.4** uses at least five that you'll want to mix and match as you capture your own winning images. I haven't mentioned the first two on this list previously:

- **Don't shoot at eye level!** The biggest mistake beginners make is to take nearly all of their photographs from the perspective of eye level. If you want to present a subject in a new and interesting way, capture it from an unexpected angle. Shoot high by standing on a chair or rock, or shoot low, as I did for **Figure 10.4**. I laid down on the floor and placed the camera in front of me. The Canon EF-S 10-18mm f/4.5-5.6 lens at the 10mm zoom setting provided this eye-catching view.

- **Change the mood with monochrome.** I wanted an old-timey feel for the photo of this vintage passenger car, so I used the Rebel T6's Picture Styles feature to apply a warm sepia-tone effect. I'll show you how to use Picture Styles in **Lesson 24**.

- **Maximize depth-of-field.** With the camera firmly on the floor, I was able to use a long shutter speed (1/8th second) and an f/16 aperture to grab this deep-focus shot, in which virtually everything in the picture is sharp and clear.

- **Leading lines.** This image is another example of how shapes and lines can draw our eyes into a photo. This one was framed slightly off-center, adding an interesting asymmetry to the composition.

- **Bright lights.** Like moths to a flame, our eyes are first attracted to the brightest areas of an image, in this case the luminous ceiling fixtures.

Figure 10.4 Don't shoot at eye level!

WHILE DEPTH-OF-FIELD CAN provide sharp focus in all or most of your scene, it's a dual-edged sword. *Shallow* DOF can help your subject pop out against a distracting background or isolate one element in the frame while reducing other parts of the image to a soft blur. This technique is called *selective focus*.

The gentleman in **Figure 11.1** was costumed in Middle Ages finery, but surrounded by anachronistic elements, including a horde of casually dressed modern-era tourists. I used a large f/stop (*smaller numbers*, f/5.6 in this case) to preserve his medieval dignity. For **Figure 11.2**, my goal was not to obscure or hide the sunflowers in the background, but to draw attention to the one at center left. The rules for limiting depth-of-field to produce selective focus are the reverse of the ones for deep focus:

- **Take a narrower view.** Instead of working with a wide-angle lens to increase depth-of-field, use a longer zoom setting to reduce it. Your kit lens' 55mm setting might do the job (and will be superior to the wide-angle 18mm setting in this respect), but for both figures I used an EF-S 55-250mm f/4-5.6 lens, set to the 120mm zoom position for **Figure 11.1** and 200mm for **Figure 11.2**.

11.1

Figure 11.1 A blurred background eliminates distractions.

- **Use a larger f/stop.** I used f/5.6 for both figures; the larger f/stop (smaller number) provides less depth-of-field and, combined with the DOF reduction of the telephoto setting, gave me the blurry backgrounds seen. This lens, like the kit lens and most affordable zooms, has a maximum aperture that changes as you zoom in. While the largest available f/stop may not be the sharpest aperture for most lenses, it usually has enough sharpness to produce an acceptable photograph. Remember to use a high enough shutter speed to reduce blur caused by camera/lens shake and/or subject motion.

To *minimize* depth-of-field when capturing images with your T6, just follow these steps:

1 Use a telephoto lens if you have one or set your kit lens to the 55mm zoom setting.

2 Distance matters when working with selective focus, too. The closer you are, the shallower the depth-of-field. The kit lens focuses quite close (to a smidge less than 10 inches) if your subject merits a close-up look. At greater distances, a longer lens, if available, may be preferable when you're looking for a thin focus range.

3 Rotate the Mode Dial on the top-right shoulder of the T6 to the Aperture Priority (Av) position.

4 Press the ISO button (the up cross key) or press the Quick Control button and navigate to the ISO setting in the upper-right corner of the Quick Control screen. Rotate the Main Dial to select a relatively low ISO sensitivity. Outdoors during the daytime you'll find that ISO 100 will provide the best results. Indoors, try ISO 800. Press the Q button again to confirm.

5 Tap the shutter release lightly to activate the Rebel T6's exposure meter.

Figure 11.2 In this case, the sunflowers provide a harmonious background for the blossom at center left.

6 Rotate the Main Dial to the left to choose smaller apertures (those with *smaller* numbers). As you rotate the dial, the camera automatically selects a shutter speed that will produce the correct exposure at your selected aperture.

7 Note the shutter speed the camera has selected. When shooting outdoors, the chosen shutter speed will be fast enough to freeze action and counter any residual camera shake. Indoors under dim illumination, an ideal shutter speed would be 1/60th second or higher. If the T6 displays a lower shutter speed, return to Step 4 and select a higher ISO setting, say, ISO 1600 or ISO 3200.

8 If you're taking a close-up photo indoors, consider placing your camera on a firm support or a tripod if you have one.

9 Carefully adjust focus. **Figure 11.3** shows the difference selective focus can make. If, say, you were at a concert with the young lady seen at left and wanted to show her enjoying the performer, you could focus on her and allow the musician in the background blur. But if the guitar player were the most important part of the scene (perhaps you wanted to include an audience member in the shot), focus on him instead, as shown at right.

10 Take your photo. A first look on the LCD monitor of the T6 may let you confirm that the selective focus look you want has been captured, but you'll also want to review your images on your computer to learn how much DOF you have at a particular distance.

Figure 11.3 Focus on the most important subject in your image, whether it's in the foreground (left) or background (right).

Figure 11.4 in corner of image: 11.4

Depth-of-Field in Depth?

The other important thing to learn about depth-of-field is that the range of sharpness is not evenly distributed in front of and behind your image. In truth, when you focus on a particular point, only that plane is perfectly sharp. But acceptable sharpness within the range is distributed roughly one-third *in front* of the point of focus, and two-thirds *behind*, as you can see in **Figure 11.4**, which shows some choir pews in a church in Florence, Italy. This sharpness distribution is more easily visualized when seen from the side, as in **Figure 11.5**.

While you don't have to constantly think about how depth-of-field is applied while taking photos, it's useful to keep in mind that foregound objects, if they are important, will reside in a smaller physical range than those in the background. It's sometimes useful to focus a little in front of, or behind your subject when you want to have a little more of the foreground or background (respectively) in focus.

11.5

Figure 11.5 Acceptable depth-of-field is distributed one-third in front of the plane of focus, and two-thirds behind it.

Figure 11.4 Subjects in front of and behind the main subject may be wholly or partially in focus.

12. THREE KEYS TO EXCITING ACTION-FREEZING SHOTS

THE CANON REBEL T6 is a great tool for taking dynamic action photos, whether you're shooting local sports action, an air show, a rodeo, a car race, or a cavorting child. Your camera has a Sports scene mode that automatically makes all the settings for good action shots, but also includes features you can use to fine-tune your photos, such as rapid focus and continuous shooting of dynamic bursts of fast-moving sequences. This lesson will show you three keys to freezing action at the decisive moment, while **Lesson 13**, which follows, provides tips on adding a thrilling feeling of motion to your images.

There are three keys to grabbing exciting photos with the action captured at the most electrifying moment:

- **Action stopping.** The T6 has fast shutter speeds that capture a tiny slice of time, freezing a motocross contestant in mid-jump (as seen in **Figure 12.1**), a rodeo rider at the moment the bull ejects him from the saddle, or that instant when a child bravely takes his or her first leap off a diving board.

12.1

Figure 12.1 Fast shutter speeds can freeze action.

- **Fast focus.** Your camera does an excellent job of focusing automatically for most subjects. But focusing on moving subjects is more challenging; nevertheless, the T6 is up to the task. This lesson will show you how to optimize your camera's autofocus for action scenes.
- **Decisive moment.** While half the job of creating exciting sports photos is understanding the best settings for action photography, the other half is knowing when to take the picture. Grabbing a shot even a fraction of a second too soon or too late can mean the difference between a photo that's awful and one that's awesome. The T6 has a continuous shooting setting that, combined with your judgment, can help capture the crucial moment in time.

16 Top Action Shots

This lesson will include, among other things, the 16 best opportunities for getting great action photos. I'll provide tips for shooting each later in this section. But if you want to get started shooting moving subjects right away, just rotate the Mode Dial of the T6 to the Sports scene mode, represented by an icon of a sprinter. The camera will make all the settings you need, and lock out those you don't need, so the T6 is ready to go at a moment's notice. In Sports mode, the camera is set to use a fast, action-stopping shutter speed, prepare the autofocus system to follow moving objects, and enable Continuous shooting mode, which will fire away at a 3-shots-per-second clip while you hold down the shutter release button. (I showed you how to shoot

continuously in **Lesson 4**.) The built-in flash (which cannot fire continuously at a 3 fps rate) is disabled. If you make sure the main subject is in the center of the frame, the T6 will begin focusing when you press the shutter release down halfway, and then continue focusing when you hold the release down all the way and the burst is captured.

If you're more in a do-it-yourself mood, that's easy, too. Just follow these steps:

1 Rotate the Mode Dial to the Shutter Priority (Tv) position. That will allow you to specify an action-freezing shutter speed while the camera selects an appropriate f/stop for the correct exposure.

2 If you're shooting action at a distance, a telephoto lens or zoom with a range longer than the kit lens might come in useful. If your lens has an AF/MF (Autofocus/Manual Focus) switch, make sure it is set to AF.

3 Press the ISO button (the up cross key) or press the Quick Control button and navigate to the ISO setting in the upper-right corner of the Quick Control screen. Rotate the Main Dial until ISO AUTO appears within the orange highlighted box. Press the Q button again so the camera will select an appropriate sensor sensitivity for you.

4 Tap the shutter release lightly to activate the Rebel T6's exposure meters.

5 Rotate the Main Dial to the right to choose faster shutter speeds. A speed of 1/500th to 1/1000th second will stop most action, although some types of subjects lend themselves to slower speeds.

6 Press the AF button (the right cross key), highlight the AI SERVO choice in the AF Operation screen that pops up, and press SET to confirm. (See **Figure 12.2.**, upper left) Note that you can also access the AF Operations screen from the Quick Control screen. With AI SERVO, the T6 will begin focusing when you press the shutter release halfway, and then continue focusing until the shutter release is pressed down all the way and the picture is taken.

7 Press the AF Point Selection button (its labeled with an icon of a magnifying glass with a plus sign) to produce the screen seen in **Figure 12.2**, upper right. If necessary, rotate the Main Dial until Automatic Selection is shown. This tells the T6 to automatically select the focus zone from the nine available in the center of the frame. The camera generally does a very good job of spotting your main subject and zeroing in on that during autofocus.

8 Press the Q button and navigate to the Metering Mode icon (located third from the left in the fourth row from the top). Press SET to view the screen shown in **Figure 12.2**, lower left, or you can change the metering mode directly from the Quick Control screen. Rotate the Main Dial until Evaluative Metering is highlighted. Press Q again to exit the Quick Control screen or SET to exit the Metering Mode screen shown in the figure.

9 Press the Drive button (the left cross key) and rotate the Main Dial to select Continuous Shooting. (See **Figure 12.2**, lower right.) Press SET to confirm and exit.

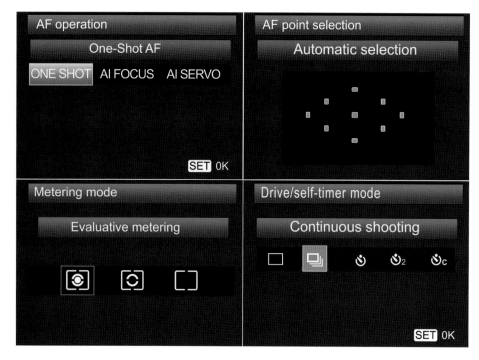

Figure 12.2 Setting AF mode (upper left), AF point (upper right), Metering mode (lower left), and continuous shooting mode (lower right).

10 Take your photos. The Rebel T6 will take pictures continuously while you hold the shutter release down completely. With AI Servo AF active, it will continue to refocus, as necessary, during the burst. If you're shooting a long sequence, the continuous shooting speed may slow down if a queue of photos accumulates faster than the T6 is able to store them to your memory card. An indicator at the far right of the bottom row in the view finder tells you how many pictures can be taken before this happens. (The pictures reside in a special storage area of the camera called the *buffer* until they are written to the card.)

The buffer in the T6 will generally allow you to take as many as 69 JPEG shots in a single burst. In practice, of course, you'll rarely take more than a half-dozen shots of an unfolding event, and so the T6's continuous shooting capabilities will easily capture a sequence like the one shown in **Figure 12.3**.

Figure 12.3 A burst shot at 3 frames per second.

The only thing the camera *won't* do for you is decide the decisive moment, the split-second when the action is at its peak. Continuous shooting can help a little, providing you with multiple shots of an event, each one-third of a second apart. However, bursts are not a panacea. A fast-ball delivered at 90 mph will travel 44 *feet* between frames, so a shot of a batter actually striking the ball is more due to luck than the speed of your camera's capture. Good timing, instincts, and knowledge of the activity can be more important. If you understand the action and can anticipate as it unfolds, your chances of getting a killer shot improve. Here are some tips for capturing specific kinds of fast-moving subjects, using what you've already learned:

- **Air shows.** There's lots of action at air shows, and it's easy to capture if you're close enough. The aircraft, by necessity, stray far outside the show venue itself as they change course or conduct their runs, so you don't necessarily need a long telephoto lens. You can frequently find a position at the periphery of the show itself that will allow you to capture great shots as the performers pass at low altitudes. The wing-walker seen in **Figure 12.4** traversed the frame less than 100 feet above the ground. Even fast-moving jets can be photographed at reasonable shutter speeds (1/500th to 1/1000th second) if you rotate (or *pan*) the camera to follow their movement.

- **Soccer.** You can follow the action up and down the sidelines or position yourself behind the goal to concentrate on the defender's fullbacks and goalie and the attacking team's wings and strikers. **Figure 12.5** shows some soccer action. I don't recommend running up and down the field to chase the action as possession changes. Soccer games usually last long enough that you can patrol one end of the field during the

Figure 12.4 Air shows make great venues for action shots.

Figure 12.5 Stay near the goal to capture soccer action.

first half, then remain there when the teams switch goals in the second half to cover the other team. However, if a game is one-sided, you'll discover that most of the action takes place around the goal that the overmatched team will be constantly defending.

- **Football.** At youth football games you may be allowed to shoot from the sidelines. If that's possible, take your pictures 10 to 20 yards from the line of scrimmage. It doesn't really matter if you're in front of the line of scrimmage or behind it. You can get great pictures of a quarterback dropping back for a pass, handing off, or taking a tumble into the turf when he's sacked. Downfield, you can grab some shots of a fingertip reception, or a running back breaking loose for a long run or crushing forward for a gain of a yard or two. Move to one side of the end zones or a high vantage point to catch the quarterback sneaking over from the one-yard line, or the tension on the kicker's face when lining up for a field goal.
- **Basketball.** One of the advantages of basketball is that the sport is more compact. The majority of the action will happen around the backboards. High angles (from up in the stands) are generally not very good, and low angles (perhaps seated in the first row) are less than flattering for an array of very tall people. Shots from almost directly under or above the rim can be an exception to these rules, however. If you can shoot from eye level close to the basket, you'll get the best shots. High school and Division III colleges may allow you to take position under the basket, where even the 18-55mm kit lens will have the right focal lengths to follow the action. (See **Figure 12.6**.) Unfortunately, gymnasiums tend to be poorly lit, so you may need to set your T6's ISO sensitivity to ISO 3200, and use a shutter speed no faster than 1/500th second.

Figure 12.6 Under the basket is often the best location to shoot roundball.

- **Baseball.** Everyone wants a seat behind home plate, but that's not where you'll want to shoot your pictures. Although the grimaces on the pitcher's face are interesting, the backstop netting will tend to diffuse your photos somewhat. The netting situation has gotten worse since many teams have extended this protection to the ends of both dugouts. I take a lot of photos at professional minor league baseball and softball games, and, lacking press privileges, I try to buy seats in the front row next to the visitor or home team's dugouts. Those vantage points let you photograph the batters at work, get good shots of the pitchers, plus the action at the bases. There tends to be more going on at the first base side, and that's a good choice if you want to photograph a right-handed pitcher after the ball is delivered. (You'll see the pitcher's back during the wind-up.) Reverse sides for a left-handed pitcher. If you keep one eye open as you peer through the viewfinder, you may be able to see the pitcher release the ball and press the shutter immediately after to catch the batter's swing.

- **Track and Field.** There are so many different events that it's hard to classify track and field as a single sport. If you can get under the bar at a pole vault or position yourself far enough behind the sand pit to shoot a long jumper without being distracting, you can come up with some incredible shots. Or, move next to the starting blocks of a dash or relay. I like to prefocus on a point where I know the athlete will be (use One-Shot AF instead of AI Servo, as described next), and then snap the picture when he or she reaches that point. (See **Figure 12.7**.)

Figure 12.7 Prefocus on one of the hurdles then press the shutter when the athlete leaps over it.

- **Golf.** Golf is one of the most intimate of sports, because it's entirely possible to position yourself only a few feet from world-famous athletes as they work amidst a crowded gallery of spectators. Distracting a golfer before a shot will get you booted from the course quickly, and digital SLRs, unlike their point-and-shoot brethren, don't have fake shutter click noises that can be switched off. That clunk you hear when the mirror flips up and the shutter trips is the real thing! You might want to move back, use a telephoto lens, remain as quiet as a mouse, and remember to time your photography to minimize intrusion. Remember, this is one sport where even the commentators on television whisper during a putt.

- **Hockey.** This form of warfare-cum-athletic event can look good from a high vantage point, because that perspective makes it easier to shoot over the glass, and the action contrasts well with the ice. However, if you can sit in the front row, you'll find a lot of action taking place only a few feet from your seat. You might want to focus manually if your dSLR's autofocus tends to fixate on the protective glass rather than the players.

- **Skating.** Skating events also take place in ice arenas, but eye level or low angles and close-ups look best. Catch the skaters during a dramatic leap, or just after.

- **Wrestling/Martial Arts.** Unless you have a ringside seat and are prepared to dodge flying chairs (in the pro version), wrestling is often best photographed from a high, hockey-like perspective. Amateur wrestling and martial arts are best when shot right at the edge of the mat.

- **Gymnastics.** Look for shots of the athlete approaching a jump or particularly difficult maneuver, or perhaps attempting a challenging move on the parallel bars or rings.

- **Rodeo.** More sports action and powerful animals, although the snorting bulls and broncs and their snorting riders are typically more rugged than beautiful. I favor rodeos where for a small additional fee (actually, double the base admission price), you can grab a table set up next to the fence and get an eye level view of the action only a short telephoto lens away. In the background, cowboys waiting to ride, and the "bullfighters" and clowns who help fallen riders add to the interest. (See **Figure 12.8.**)

- **Swimming.** Some great shots are possible at swimming events, particularly if you are able to use a fast-enough shutter speed to freeze the spray as the swimmer churns through the water. You'll get good pictures from the side if you can get down very low and close to water level. At the end of the pool, turns are fairly boring, but you can get some exciting head-on shots at the finish.

Figure 12.8 Rodeo action may be over in a few seconds, so you have to shoot fast (and often).

- **Motor sports.** Racing action will challenge your action-stopping capabilities. If you shoot these events as a car or motorcycle is headed down the straightaway toward you, a slower shutter speed can do the job. On one hand, the action can be a bit repetitive. But that can be an advantage because you have lap after lap to practice and fine-tune your technique to get the exact photo you want. Motocross and motorcycle stunt jumping can provide some especially exciting moments.

- **Horseracing.** Sports action and beautiful animals all in one sport! What could be better? As in motor sports, you might get the best pictures shooting head-on or as the steeds make a turn. Finish line photos are likely to look like those automated finish line photos used for instant replays, but if you get the opportunity, try a low angle for an interesting perspective.

- **Skiing.** It's unlikely you'll be out all over the slopes taking photos during the race, but if you can find an interesting turn or good angle at the finish line, go for it. Remember to keep your camera and batteries warm between shots and watch out for condensation on the lens when you and your camera pass from icy cold to warm conditions.

AF Modes

One-Shot AF. Also called single autofocus, this mode sets focus once and remains at that setting until the button is fully depressed, taking the picture, or until you release the shutter button without taking a shot. While it's usually the best choice for non-action, One-Shot can come in handy for sports when you want to prefocus on a particular location. The drawback is that you might not be able to take a picture at all while the camera is seeking focus; you're locked out until the autofocus mechanism is happy with the current setting. One-Shot AF/single autofocus is sometimes referred to as focus priority for that reason.

When sharp focus is achieved, the selected focus point will flash red in the viewfinder, and the green focus confirmation light at the lower right will glow steadily. If you're using Evaluative metering, the exposure will be locked at the same time. By keeping the shutter button depressed halfway, you'll find you can reframe the image while retaining the focus (and exposure) that's been set.

AI Servo AF. This mode, also known as continuous autofocus, is the mode to use for sports and other fast-moving subjects. In this mode, once the shutter release is partially depressed, the camera sets the focus but continues to monitor the subject, so that if it moves or you move, the lens will be refocused to suit. Focus and exposure aren't really locked until you press the shutter release down all the way to take the picture. You'll often see continuous autofocus referred to as release priority. If you press the shutter release down all the way while the system is refining focus, the camera will go ahead and take a picture, even if the image is slightly out of focus.

AI Focus AF. This setting is actually a combination of the first two. When selected, the camera focuses using One-Shot AF and locks in the focus setting. But, if the subject begins moving, it will switch automatically to AI Servo AF and change the focus to keep the subject sharp. AI Focus AF is a good choice when you're shooting a mixture of action pictures and less dynamic shots and want to use One-Shot AF when appropriate.

13. ADDING DYNAMIC MOTION EFFECTS

WHILE ACTION-FREEZING SHUTTER speeds can provide a breathtaking glimpse of high-speed action, sometimes a moment frozen in time can look static, or even unrealistic. A motocross rider leaning into a curve, immobilized by a fast shutter speed, may appear to be glued to the track; a speeding car pictured on a suburban street may look as if it were parked. Or, worse, a helicopter, like the one pictured at top in **Figure 13.1**, may seem to be headed for a crash after its rotors have stopped in mid-air. The solution in all these cases is to use a shutter speed that is slightly *slower* than the one needed to freeze the action, as seen at bottom in the figure. The second image was taken at 1/250th second, which was fast enough to freeze the hovering helicopter, but slow enough to allow its rotors to blur.

13.1

Figure 13.1 With a fast shutter speed, the rotors don't appear to be moving (top). A slower speed allowed them to blur slightly, for a more realistic effect.

There are three ways to create dynamic motion effects in action photographs, all of them involving slower shutter speeds. Here's a quick rundown:

Panning

If you're seated at a tennis match or NASCAR race, you'll find yourself swiveling your head from side to side to follow the action. When your camera does the same thing, it's called *panning*, derived from the term "panorama." Panning is almost always a horizontal motion, starting at right or left, and rotating in the direction of your subject's motion. Because your subject remains (more or less) in the middle of the frame, it appears to move very little, if at all, assuming your panning motion matches that of the subject. That makes it possible to capture the image using a relatively slow shutter speed. Everything else in the foreground or background has motion, relative to the camera, as you sweep the camera from side to side. The result is an image in which your main subject is (relatively) sharp, while the non-moving portions are horizontally blurred. You may have seen panned auto race photos in which the race car is tack sharp, and the track is totally blurred. The impression is one of rapid motion.

However, your panning technique does not have to be that precise to add an exciting feeling of motion to your image. **Figure 13.2**, captured at a track meet, is an example. I used a shutter speed of 1/15th second as the runner raced by. At that slow speed, the stadium in the background and the running track itself were completely blurred. But the combination of the shutter speed and panning motion rendered the athlete sharper. Nevertheless, her furiously pumping arms and striding legs/feet, which were moving faster than her body, are still quite blurred. The overall look conveys the speed of her running.

Figure 13.2 At a shutter speed of 1/15th second while panning, both runner and background are blurry, but the athlete is sharper.

For **Figure 13.3**, I used a faster 1/60th second shutter speed to capture a batter racing to first base. The background is still blurred, the athlete's arms and legs are also are blurry, but his face, helmet, and torso are relatively sharp. After you shoot action a few times using the panning technique I describe next, you'll learn which slow shutter speeds work best for you.

1 Plan your shot. It's easy for your "sweeping" motion to be too fast or too slow, so you outpace the movement, or lag behind. Make a few practice sweeps before you begin to capture your panned image.

2 You'll need to start rotating before your subject reaches the point where you press the shutter while you're following the motion. Pretend you're shooting a panorama photo. Plant your feet firmly such that the center of your picture is straight in front of you. Keep the camera as near to your body as possible (use the viewfinder rather than LCD monitor in Live View) so that the rotation point as your body twists is as close as possible to the sensor plane.

3 Set AF mode. Use AI Servo AF mode as described in the previous lesson. Evaluative metering will do the best job of exposing most panned captures.

4 Twist your body. With your feet securely anchored, twist your body as far as you can toward the position you'll be using to begin tracking your subject. That is, if your subject will approach from the left, twist as far as you can to the left. You want to be able to twist so that when your target is directly in front of you, you will be facing forward.

Figure 13.3 At 1/60th second, the base runner is less blurred.

5 Untwist while shooting. While viewing through the viewfinder, begin shooting, slowly "untwisting" to pan the camera until you're facing forward again.

6 Keep speed constant. Continue twisting smoothly toward the finish position. It's important to keep a constant speed so you can match the movement of your subject.

7 Take the photo. When your subject is directly in front of you and framed properly, press the shutter button. When shooting a moving subject, remember it's always best to have more space in front of the subject than behind, making it appear the subject is moving toward the opposite edge of the frame, and has some room to move into.

Hand-Held Blur

If the motion is fast enough, you can hand-hold the T6, use a relatively slow shutter speed, and allow the subject movement alone to produce a suitable amount of blurring. The helicopter shown earlier in **Figure 13.1** is a good example. The Korean drummer in **Figure 13.4** is another example. The stage lighting was bright enough that I was able to use an exposure of 1/30th second at f/11. The performer sat on the stage while her hands furiously beat the drum. The image stabilization (IS) built into the lens allowed me to get a fairly sharp image of the drummer and drum at that slow shutter speed with the camera hand-held, without much blur from camera movement. Image stabilization can provide the equivalent anti-shake properties of a shutter speed that is two or three times faster. So, my 1/30th second exposure worked out to be the same *in terms of camera motion* as an exposure at 1/125th second or faster. Remember that IS counters *only* camera motion; it does not compensate for subject motion (which in this case involved the drummer's arms and drumsticks). If you are using a lens that has IS and want to use a slower shutter speed to add some interesting motion blur, make sure the Stabilization switch on the lens is set to ON.

Taking advantage of IS allows you to experiment with longer shutter speeds without ruining the photo because you were unable to hold the camera steady. Image stabilization works best if your main subject isn't moving quickly, but some part of the subject or other portions of the image are moving and you'd like them to blur.

13.4

Figure 13.4 With drum sticks and hands slightly blurred, this performer's energy is reflected in the image.

Your Visible Means of Support

A third way to take advantage of slow shutter speeds to create a feeling of motion is to use a tripod or monopod. Both are sturdy supports that help hold your camera steady during a longer exposure, say, 1/15th second to several seconds (or even minutes). When you're using a tripod, everything in the frame that isn't moving and is in focus will be sharp. Anything that is moving will be blurred. You can use this capability to capture moving subjects in a variety of ways.

For example, a Ferris wheel that's isn't moving isn't very interesting, and if you photographed one using a fast shutter speed, it would appear to be stopped. But photograph that same Ferris wheel at night with your T6 mounted on a tripod, as I did for **Figure 13.5**, and the blurred lights become a captivating vivid display. If you want to capture amusement park rides on your own and can bring a tripod (county fairs are particularly accommodating in that regard), just

set up your camera, use a moderate ISO sensitivity setting such as ISO 100 (the lights are quite bright), and shoot away at various longer shutter speeds until you get the look you want. For the figure, I used 1/2-second exposure at f/16 and ISO 100. For other pictures in the same session, I tried exposures from 1/8th second to several seconds, but I liked this rendition best.

Figure 13.5 A 1/2-second exposure was used for this Ferris wheel image.

I like to use long exposures at concerts and stage performances when I can, although tripods and monopods are usually either forbidden or too obtrusive. I shot **Figure 13.6** at the dress rehearsal of a ballet performance, at which my tripod was welcome. I watched the dancer's movements as she rehearsed and realized there was a moment where she took a bow, and then paused for a second before becoming erect again. During the second rehearsal of this piece, I triggered the camera just before she began her bow and was able to capture this image with a 1/2-second exposure.

Figure 13.6 Good timing and a long shutter speed yielded this shot of a dancer taking a bow.

Finally, tripods are an excellent tool for capturing the traditional (and often clichéd) "silky" waterfall photo. **Figure 13.7** is a two-second exposure of a section of rapids in the Cuyahoga River near Cleveland, elevated, I hope, above the mundane blurred waterfall image by the roiling water of the rapids. On a later visit to a nearby stretch of the same river, I captured a picture of the Great Blue Heron pictured in **Figure 13.8**, as the bird was kind enough to remain motionless for the one-second exposure.

Figure 13.7 Long exposures are often used to add a feel of motion to waterfall images.

Figure 13.8 The flowing water helps illustrate this heron's environment.

14. EIGHT SIMPLE RULES FOR COMPOSING BEAUTIFUL LANDSCAPES

LANDSCAPE PHOTOGRAPHY ISN'T particularly equipment- or gadget-intensive. Your EOS Rebel T6 and its standard 18-55mm zoom lens will be fine in most cases. Lenses with a wider perspective or longer zoom reach are also useful, if you have one. A zoom lens gives you the flexibility you need to photograph wide-open spaces or focus in on a distant mountain. Telephotos can bring distant subjects closer and de-emphasize things in the foreground that you don't want in the picture. Wide angles, in contrast, make distant objects look as if they are farther away while emphasizing the foreground, as you can see in **Figure 14.1**. I discuss lenses further in **Lessons 42** and **43**.

Figure 14.1 To emphasize the foreground, use a wide-angle lens or zoom setting.

Landscape photos, in particular, are an opportunity for you to create thoughtful and interesting compositions. Those mountains aren't going anywhere. There are eight simple rules for composing landscape photos effectively. These rules apply to *all* aspects of photography, but are especially easy to learn when shooting landscapes, because, unless you're rushing to catch a tour bus, you generally have enough time to plan and shoot your photo carefully.

- **Simplicity.** This is the art of reducing your picture only to the elements that are needed to illustrate your idea. By avoiding extraneous subject matter, you can eliminate confusion and draw attention to the most important part of your picture. You have a zoom lens for cropping an image as you shoot, and feet for adjusting your location. Use both to help you choose a landscape composition that isn't cluttered or filled with distracting subject matter.

- **Choosing a center.** Always have one main subject that captures the eye, which, despite the name, needn't be in the center of your photo. Nor does it need to be located up front. No matter where your center of interest is located, a viewer's eye shouldn't have to wander through your picture trying to locate something to focus on. You can have several centers of interest to add richness and encourage exploration of your image, but there should be only one main center that immediately attracts the eye.

Figure 14.2 Nothing attracts the eye (left) unless there is a center of interest in the photograph (right).

Figure 14.2 shows two images shot on the Mediterranean coast on the same morning from roughly the same spot. At left are some waves crashing over rocks. There's no real center of interest, and no real reason to look at one particular rock or rivulet of water instead of another. At right, the rocks have become the center of interest and clearly dominate the image, even though an island at upper left and the risen sun at upper right balance the image vertically.

The center of interest should always be the most eye-catching object in the photograph; it may be the largest, the brightest (our eyes are drawn to bright subjects first), or most unusual item within your frame. Shoot a picture of a beautiful waterfall, but with a pink elephant in the picture, and the pachyderm is likely to get all the attention. Replace the waterfall with some spewing lava, and the elephant may become secondary.

■ **The Rule of Thirds and Orientation.** Placing interesting objects at a position located about one-third from the top, bottom, or either side of your picture makes your images more interesting than ones that place the center of attention dead center (as most amateurs tend to do). Things that are centered in the frame tend to look fixed and static, while objects located to one side or the other imply movement, because they have somewhere in the frame to go, so to speak.

Horizons are often best located at the upper third of the picture, unless you want to emphasize the sky by having it occupy the entire upper two-thirds of the image, as seen in **Figure 14.3**. Tall subjects may look best if they are assigned to the right or left thirds of a vertical composition.

The orientation you select for your picture affects your composition in many ways, too, whether your photo uses a landscape (horizontal) layout or a portrait (vertical)

orientation. Beginners often shoot everything with the camera held horizontally. If you shoot a tall building in that mode, you'll end up with a lot of wasted image area at either side. Trees, tall mountains shot from the base, and images with tall creatures (such as giraffes) all look best in vertical mode.

Figure 14.3 The Rule of Thirds is a useful guideline, but one that can be easily broken.

Recognize that many landscapes call for a horizontal orientation and use that bias as a creative tool by deliberately looking for scenic pictures that fit in the less-used vertical composition. Some photos even lend themselves to a square format (in which case you'll probably shoot a horizontal picture and crop the sides).

Figure 14.4 illustrates the kind of subject matter that can be captured in all three modes, each presenting a different view of the same scene, the Cliffs of Moher in County Clare, Ireland. The version at top emphasizes a panoramic view that shows how far the majestic cliffs project out into the Atlantic Ocean. Cropped vertically, as in the lower-left corner, the 700-foot (plus) height of the cliffs becomes the focus. The square composition at lower right provides a more static look that's less interesting than the horizontally and vertically oriented views. When capturing or cropping to a square (which is sometimes necessary because of intrusive or unwanted elements at the sides and top/bottom of the frame), try to include curves and lines that draw the viewer's eye into and around the image, as I describe next.

Figure 14.4 Horizontal compositions provide a panoramic view (top); vertical orientations emphasize height (lower left); while square compositions are static and less interesting (lower right).

- **Leading Lines.** Objects in your pictures can be arranged in straight or curving lines that lead the eye to the center of interest, often in appealing ways. Viewers find an image more enjoyable if there is an easy path for their eyes to follow to the center of interest. Strong vertical lines lead the eye up and down through an image. Robust horizontal lines cast our eyes from side to side. Repetitive lines form interesting patterns. Diagonal lines conduct our gaze along a gentler path, and curved lines are the most pleasing of all. Lines in your photograph can be obvious, such as fences or the horizon, or more subtle, like a skyline or curving road.

 Lines can be arranged into simple geometric shapes to create better compositions. **Figure 14.5** shows an image with a variety of lines. The strongest line is the curve of the main path, which leads our gaze through the picture to the Cathedral Rock formation (near Sedona, Arizona) in the background. The path's broad swathe is crossed by the shadows of the trees. The vertical lines of the trees along the path lead our eyes toward the top of the photo. This is the sort of picture that engages the viewer's attention, luring them into spending more than a few seconds exploring everything it contains.

Figure 14.5 Leading lines draw your eyes into the picture.

- **Balance.** We enjoy looking at photographs that are evenly balanced with interesting objects on both sides, rather than everything located on one side or another and nothing at all on the other side. Balance is the arrangement of shapes, colors, brightness, and darkness so they complement each other, giving the photograph an even, rather than lopsided, look. Balance can be equal, or symmetrical, with equivalent subject matter on each side of the image, or asymmetrical, with a larger, brighter, or more colorful object on one side balanced by a smaller, less bright, or less colorful object on the other.

 Figure 14.6 shows an image at top that on first glance has a balance of sorts. The light tones of the castle image at the far right are more or less offset by the darker foliage on the left side. However, because the castle is clearly intended to be the center of interest for this photo, the more you look at it, the more you get the feeling the picture is a bit lopsided.

 By taking a step back, we can include more of the road and wall leading to the castle, and a bit more of the structure on the right side, as shown in the middle version. This cropping does several things. It balances the picture, while moving the center of interest closer to one of the "golden" intersections defined by the rule of thirds. The walls and road provide converging lines that attract our eye to the castle.

 Even so, there's still something wrong with this picture. The tree branches at the right side aren't connected to anything. They appear to be growing out of the side of the picture frame. We can crop most of them out and improve the balance of the image even further, as you can see in the bottom version.

Figure 14.6 Top: The large light and dark masses on the right and left sides of the picture don't really balance each other as they should. Middle: Cropping less tightly provides a better-balanced picture with converging lines that draw our eyes to the castle. Bottom: Removing the tree branches improves the picture even further.

- **Framing.** In this sense, framing is not the boundaries of your picture but, rather, elements in a photograph that tend to create a frame-within-the-frame to highlight the center of interest. In landscape photography, trees in the foreground are often used to frame distant vistas, so much so that the technique has almost become a cliché. For **Figure 14.7**, I used the foliage in the foreground to provide a frame at the bottom of the photo, with at gap at far right framing a water bird flying past. Your frame doesn't have to be in the foreground, or even be continuous. In the figure, the dark areas of sky at the top and sides of the image combine with the foreground to frame the scene. Even though the eye is inevitably drawn to the rising sun at upper left, the "framed" bird invites exploring the right side of the picture, as well.

Figure 14.7 Using a frame to surround your subject—whether it's composed of foreground or background elements—draws attention to your center of interest.

- **Fusion/separation.** When creating photographs, it's important to ensure that unrelated objects don't merge in a way you didn't intend, as in the classic example of the tree growing out of the top of someone's head. The unsightly melding of two different parts of an image can detract from the overall composition. Mergers and acquisitions may be great when you're involved in finance, but when taking photographs, they can cause confusion. At first glance, **Figure 14.8** may look like a charming image of the Irish countryside—but we want viewers to immerse themselves in our photos, not just glance at them. At lower left, some dead branches intrude on the frame, and farther back you can see the peaks of farmhouses, silos, and other buildings partially intruding above the hillside. Other trees merge with the landscape behind them, making this a

Figure 14.8 Unsightly mergers can clutter your image and invite confusion.

cluttered, less appealing photograph. The lesson here is to carefully examine what's in your frame, and use cropping, changing your position and shooting angle, and other adjustments to achieve the simplicity I suggested in Rule 1 above.

- **Color and texture.** The hues, contrasts between light and dark, and textures of an image can become an important part of the composition, too. The eye can be attracted to bright colors, lulled by muted tones, and excited by vivid contrasts.

Color, texture, and contrasts are an important part of the composition in **Figure 14.9**. The warm sunset colors, the deep blue of the Mediterranean Sea, and the rough texture of the rocks in the foreground provide sharply contrasting elements that attract the eye and leads it through the picture from the brightest area (which typically attracts the eye first) to the foreground. When shooting in color, the hues in the photo are an important part of the composition. Texture and contrasts in tones can be effective in both color and black-and-white photos.

Figure 14.9 Dramatic color differences make landscape photos more appealing.

15. SHOOTING DRAMATIC SILHOUETTES

BEFORE THE INVENTION of photography, silhouettes became an important (and inexpensive) way of capturing a distinctive portrait of a person, easy on the subject as well the artist because of their simplicity. By depicting only the profile of the subject, dark against a light background, the shape of the hair, forehead, nose, and chin offered a recognizable image with minimal effort. (See **Figure 15.1**.)

Silhouettes have traditionally been black-on-white images, but there's no reason why they can't be produced in color, as well. Using our favorite pictorial subject, the sunset, once more, I produced the silhouette-like image shown in **Figure 15.2**, which provides a significant hint about the simple technique used to create these high-contrast images: just *underexpose* the subject against a bright background, so that it appears very dark while the background retains its radiance. In this lesson, I'll show you how to set your T6 to record silhouettes, and then provide some examples of the kinds of things you can do.

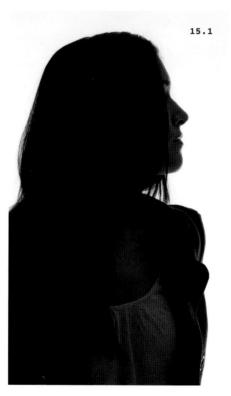

Figure 15.1 Profile silhouettes are a traditional type of portraiture.

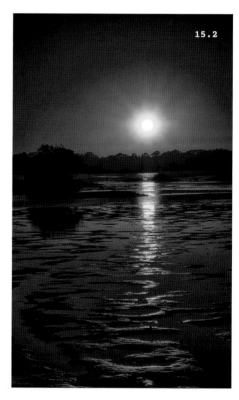

Figure 15.2 Silhouettes do not have to be strictly black-and-white renditions.

Setting Your Camera

You can adjust the Rebel T6 so that it creates silhouette-style images virtually automatically, or you can make adjustments manually that allow you to customize the effect. Just follow these steps:

1 Choose your subject. For best results, your subject should appear against a bright, uncluttered background, such as the sky or, indoors, a well- and evenly lit wall.

2 Choose an exposure mode. You can shoot a silhouette in Program (P), Aperture Priority (Av), Shutter Priority (Tv), or Manual (M) exposure modes.

- **P mode.** In this semi-automatic mode, the T6 will attempt to provide an appropriate exposure—which is not what you want. To produce the desired underexposure, press the AV/Trash button, located next to the upper-right corner of the LCD monitor, and spin the Main Dial to the left to set "minus" exposure (toward the left end of the scale, as seen in **Figure 15.3**). Try –3 to start; if your silhouette isn't contrasty enough, you can adjust to a value of –5. The camera will adjust shutter speed and/ or aperture to provide the underexposure you need.

Figure 15.3 Press the Av/Trash button and rotate the Main Dial to the left to underexpose.

- **Av mode.** If you want to ensure greater depth-of-field, use Av mode and choose an aperture that provides the focus range you need, using the guidelines I provided in **Lesson 10**. Then underexpose by pressing the AV/Trash button and rotating the Main Dial to the left, as described previously. The T6 will select an appropriate shutter speed. With most silhouettes taken outdoors, an ISO setting of 100 or 200 will yield a shutter speed fast enough to counter camera shake or subject movement. If you're making a silhouette indoors, and the background illumination is not particularly bright, you may have to use a higher ISO setting, either ISO Auto or a fixed setting up to about ISO 3200, just to avoid movement blur.

- **Tv mode.** This mode may be best for indoor silhouettes, because you can select your preferred shutter speed to avoid blur from camera shake. A speed of 1/125th second is a good choice. ISO Auto will allow the T6 to boost sensor sensitivity if required for a proper exposure at that speed. Press the Av/Trash button and rotate the Main Dial to the left as required to produce the silhouette effect. Focus carefully, because in Tv mode, the camera may be using larger f/stops (smaller numbers), which offer less depth-of-field, as I explained in **Lesson 11**.

- **M mode.** In Manual exposure mode, you're on your own in selecting an f/stop and shutter speed and ISO sensitivity. This option is probably best reserved for more advanced shooters who know exactly what they want in terms of depth-of-field and action-freezing capabilities.

3 If your silhouette subject is a human being, a longer focal length, such as the 55mm setting of the kit lens, or another zoom setting up to about 100mm, will provide the best perspective for a profile portrait.

4 Take your picture. Then examine the photo on your LCD monitor, adjust the exposure to increase/decrease the silhouette effect to your taste, and take more until you're satisfied. **Figure 15.4** shows a beach-side silhouette of a couple, which I photographed using the Rebel T6's Monochrome Picture Style to give it the traditional black-and-white look.

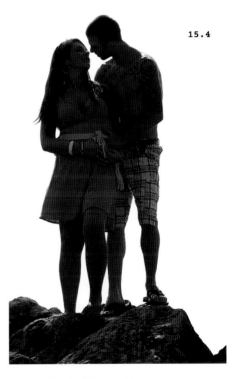

15.4

Figure 15.4 Silhouettes are a minimalist way to represent your subject.

Here are some tips for capturing dramatic silhouettes of humans and other subjects:

- **Be creative.** Change your position and/or use cropping to vary your silhouette portraits. **Figure 15.5** shows a model applying lipstick. For the photo at left, I seriously underexposed the photo and composed the image to frame her hand against the background. I increased exposure for the version at right to allow the model's features and the lipstick tube to show.

- **Not just people.** Silhouette or semi-silhouette shots can be taken of many subjects. **Figure 15.6** was captured a few hours before sunset. I underexposed by four f/stops and used the Monochrome Picture Style to create this stark black-and-white image.

- **Be on the lookout for happy accidents.** I was shooting an Alan Parsons concert when a background light flooded over guitarist Alastair Greene. It was the perfect opportunity to capture the stage side silhouette shown in **Figure 15.7**. I was using manual exposure and set an exposure of 1/250th second at f/16 to grab this image.

Figure 15.5 An almost pure silhouette (left), and a version with a little less underexposure to allow some facial detail (right).

Figure 15.6 This semi-silhouette was captured by under-exposing the image a few hours before sunset.

Figure 15.7 Backlit stage? No problem—if you're interested in shooting a silhouette.

WI-FI IS EVERYWHERE these days—including your camera. Your T6 can communicate wirelessly with your phone or tablet using either standard Wi-Fi communications or (if you have an Android device) using a Bluetooth-like NFC (Near Field Communications) link. The latter makes automatic connections simply by touching the NFC indicator on the Mode Dial side of the camera to the NFC indicator on the Android phone or tablet. To activate and begin using the T6's Wi-Fi capabilities, just follow these steps:

1 **Download App.** If you plan to link your T6 to an Android or iOS smart device, visit your device's store and download the Canon Camera Connect app to your smartphone or tablet.

2 **Enable Wi-Fi.** Navigate to the Set-up 3 menu and select Wi-Fi/NFC, press SET, and choose Enable from the next screen. If you plan to link an Android device to your camera, press the DISP. button to allow NFC connections. (NFC does not work with iOS devices.) Press SET to confirm and exit back to the previous menu.

3 **Set Camera Nickname.** The first time you use Wi-Fi Functions, you can enter a nickname for your camera on the screen that pops up (see **Figure 16.1**). For simplicity's sake, I recommend you just accept the default EOST6 nickname. Just press MENU to proceed to the next step.

4 **Select function.** Choose Wi-Fi Function from the Set-up 3 menu to access the screen shown in **Figure 16.2**. Use the cross keys to navigate to Connect to Smartphone and press SET. (The other option, with the "globe" icon, is used to connect to other connections, such as a compatible Wi-Fi printer.) You can also press the DISP. button to view technical information about your connection.

5 **Enter parameters.** Each of the two modes has its own set of parameters, described in the sections that follow.

Figure 16.1 If this screen pops up, you can enter a nickname, or just accept the default EOST6 moniker (recommended).

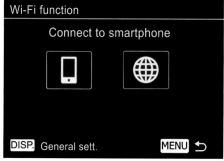

Figure 16.2 Wi-Fi Functions.

Making an NFC Connection

The sections that follow describe making Wi-Fi connections between devices, but if you have an Android phone or tablet with NFC, you can link easily just by touching the NFC icon on your T6 to the matching icon on your device. (Note that with the T6, NFC can be used only between the camera and phones and tablets or the Canon Connection Station, and not between printers or other NFC-enabled devices.)

First visit the Wi-Fi/NFC entry in the Set-up 3 menu. Select Enable and press the DISP. button to permit NFC connections. Then, all you need to do is touch the smartphone/tablet's icon to the camera's. The Camera Connect app on your device (which you have previously downloaded from the Google Play app store) makes the connection automatically.

Connecting to a Smartphone

Your T6 can use its Wi-Fi connection like a smartphone when taking stills (but not movies) using the free Canon Camera Connect application. The Rebel T6 has its own Wi-Fi "hotspot" built in. Just follow the steps listed next the first time you access Wi-Fi. Once you've connected successfully, you won't need to repeat them, and can instead use the "Send Images to Smartphone" entry in the Wi-Fi Functions screen when you want to transmit photos.

1 Enable Wi-Fi in the Set-up 3 menu, then navigate to Wi-Fi Function entry, as described earlier.

2 Choose the Connect to Smartphone option, the center icon in the top row of the Wi-Fi Function screen shown earlier in **Figure 16.2**.

3 Select Easy Connection from the Connection Method screen that appears next (see **Figure 16.3**), and press SET. OK will be highlighted, and you can press SET again to continue.

4 A "Waiting to connect" message appears. The screen displays the name of the T6's internal access point (the SSID, or *service set identifier* and an encryption key). This will be the nickname you chose for the camera earlier. The *encryption key* shown on this screen is the password you'll need to log into your camera's access point. (See **Figure 16.4**.)

5 Switch to your smartphone and use its Settings utility to connect to the camera's access point SSID displayed on the T6. You'll be asked for a password—the encryption key displayed on the camera. (**Figure 16.5** shows the screens I see on my iPhone 6s Plus.)

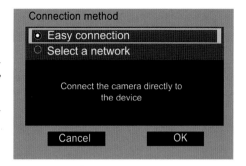

Figure 16.3 Choose Easy Connection.

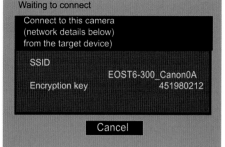

Figure 16.4 The SSID and encryption key of the camera appears.

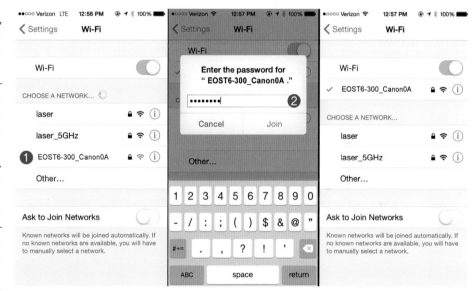

Figure 16.5
❶ Select the camera's built-in network on your smart device
❷ Enter a password

6 Once you're connected, a screen will appear on the camera's LCD with the message "Start the EOS app on the smartphone." The T6's SSID (nickname), the encryption key (password), IP address, and Mac address will also be displayed. For most of us, that data is just informational, and needed only by networking gurus with special applications for it.

7 Launch the Canon Camera Connect app. It will automatically search for camera access points and display the name of your detected camera. Tap the name of the camera on the screen of the smartphone. (See **Figure 16.6**.)

8 When pairing is complete, a message appears on the T6's LCD monitor offering to connect to the smartphone. Choose OK and press SET.

9 The current settings needed to link the T6 and your smartphone are stored in the camera and given the name SET1. You can change this name to something else, such as "David's iPhone" by highlighting the current settings label and pressing SET. The T6's text entry screen, described earlier, appears. Once settings are stored, reconnecting the camera to that smartphone is as simple as choosing the settings name from the camera, and activating the camera's access point on the phone.

10 Once the camera and smartphone are linked, you can access available functions (see **Figure 16.7**, left). You can use the phone to view images or control the camera remotely (see **Figure 16.7**, center), or change camera settings (see **Figure 16.7**, right).

11 Terminate the connection by highlighting Exit on the screen displayed on the camera and pressing SET, then confirming by choosing OK and pressing SET once again.

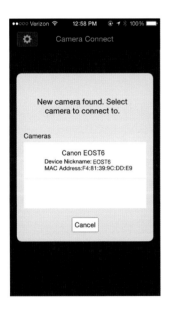

Figure 16.6 Once connected, the Camera Connect software will invite you to link up.

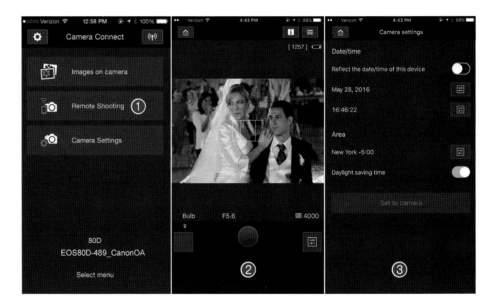

Figure 16.7
❶ Available functions
❷ Remote control
❸ Camera settings

Uploading to a Web Service

This wireless option allows you to select images and upload them to the Canon iMAGE Gateway, which is a free-of-charge service. You can register online through your computer and through this entry. Once you've become a member, you can upload photos, create photo albums, and use other Canon iMAGE Gateway services. The site also can interface with other web services you have an account with, including e-mail, Twitter, YouTube, and Facebook.

1. First, you must use your computer (not the T6) to log onto the Canon iMAGE Gateway and sign up for a free account.
2. Install the EOS Utility if you haven't done so previously.
3. Next, connect the camera and computer with a mini-B USB cable. Before you can interface with the Canon gateway wirelessly, you must connect your camera and computer using the conventional digital/USB connection.
4. Start the EOS Utility on your computer, and select Web Services Settings, as shown in **Figure 16.8**, left.
5. You'll be asked to log into the Canon iMAGE Gateway using the username and password you chose in Step 1.
6. Choose the features you want to use in the screen shown in **Figure 16.8**, center and right, and register your T6 with the Gateway. Click Finish when done.
7. Disconnect the USB cable. You can now connect to the Gateway wirelessly using your home, business, or other wireless access point, using WPS or a manual connection, using the detailed instructions in the EOS Rebel T6/EOS 1300D Wireless Function Instruction Manual.

Still images can be uploaded to the Gateway, and movies to YouTube. Images can be uploaded directly to Facebook or shared with Facebook and Twitter users by posting a link back to the Canon Image Gateway location of the files.

Figure 16.8 Using the EOS Utility.

17. PIXEL PERFECTION WITH SUPER-SMART SCENE MODES

YOUR REBEL T6 includes 9 "Basic Zone" shooting modes that can make most setting decisions for you under a variety of circumstances. That frees you to use your creativity in other ways. You can frame your image carefully, coax a human subject into a warm smile, manage a frisky pet's behavior, or contemplate the beauty of a dramatic landscape before you snap the shutter. These modes are useful even if you've mastered your camera's more advanced features, but find you need to take a picture quickly, with little time for making adjustments on your own, as the camera can automatically make all the basic settings needed for certain types of shooting situations, such as Portraits, Landscapes, Close-ups, Sports, Night Portraits, and "No-Flash zone" pictures. If you unexpectedly encounter a picture-taking opportunity and don't have time to decide exactly which settings to make, you can spin the Mode Dial to the appropriate Basic Zone mode and fire away, knowing that, at least, you have a fighting chance of getting a good photo.

These Basic Zone scene modes may give you few options or none at all. The AF mode, drive mode, and metering mode are all set for you. Some do offer a few adjustments you can make, and I'll explain those in this lesson.

Here are the modes available:

- **Scene Intelligent Auto.** All the photographer must do in this mode is press the shutter release button. Nearly every other decision is made by the camera's electronics. The camera will analyze your subject and choose one of the appropriate Scene modes described shortly. To use Scene Intelligent Auto, rotate the Mode Dial to the green A+ icon. A screen appears showing you the current battery status, image quality setting, and number of shots remaining on your memory card. (Press DISP. if it does not appear.) Just press the shutter release, and a single picture is taken each time you press the button down all the way.

 If you'd like to get in the picture yourself, press the Quick Control (Q) button and the screen seen in **Figure 17.1** appears. Rotate the Main Dial and choose Self-timer: 10 sec or Self-Timer: Continuous. If you select the latter, press SET and then use the up/down cross keys to specify the number of pictures to be taken (from 2 to 9) after the self-timer delay. Your settings remain until you change them (even if you switch the camera off).

- **Flash Off.** Absolutely prevents the flash from flipping up and firing, which you might want in some situations, such as religious ceremonies, museums, classical music concerts, and your double-naught spy activities. Flash Off otherwise functions exactly like Scene Intelligent auto and has the same Single Shot and Self-Timer options.

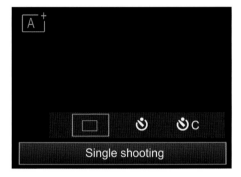

Figure 17.1 Quick Control screen in Scene Intelligent Auto/Auto (No Flash) modes.

- **Creative Auto.** Creative Auto, like the scene modes described next, allows you to change some parameters. I'll describe those parameters shortly.
- **Portrait.** This mode tends to use wider f/stops (larger numbers) and faster shutter speeds, providing blurred backgrounds (because of reduced depth-of-field) and images with no camera shake. If you hold down the shutter release, the T6 will take a continuous sequence of photos, which can be useful in capturing fleeting expressions in portrait situations.
- **Landscape.** The T6 tries to use smaller f/stops (*larger* numbers) for more depth-of-field, and boosts *saturation* slightly to give you richer, more vibrant colors, especially suitable for all types of landscape pictures.

- **Close-up.** This mode is similar to the Portrait setting, with wider f/stops to isolate your close-up subjects, and high shutter speeds to eliminate the camera shake that's accentuated at close focusing distances. However, if you have your camera mounted on a tripod or are using an image-stabilized (IS) lens, you might want to use the Creative Zone Aperture Priority (Av) mode (described in **Lesson 18**) instead, so you can specify a smaller f/stop with additional depth-of-field.

- **Sports.** In this mode, the T6 tries to use high shutter speeds to freeze action, switches to continuous shooting to allow taking a quick sequence of pictures with one press of the shutter release, and uses AI Servo AF to continually refocus as your subject moves around in the frame.

- **Food.** Attempts to make your food look good enough to eat. If you shoot under tungsten lighting, the T6 will compensate for the warmer illumination.

- **Night Portrait.** Combines flash with ambient light to produce an image that is mainly illuminated by the flash, but the background is exposed by the available light. In effect, you're getting *two* exposures in one: the flash picture and the ambient light picture. This mode uses longer exposures, so a tripod, monopod, or IS lens is a must.

More About Creative Auto

When the Mode Dial is set to Creative Auto, a screen like the one shown in **Figure 17.2** appears. The information displayed along the bottom includes a Q button reminder, your current battery status, image quality, and number of exposures remaining. You can then do one of three things:

1 **Change shooting parameters by ambience.** Press the Quick Control (Q) button and the screen shown in **Figure 17.3** appears. When the top box on the screen is highlighted, it will display the most recent "ambience" setting you've selected (Standard, unless you've made a change). Ambience is a type of picture style that adjusts parameters like sharpness or color richness to produce a particular look.

A list appears with nine ambience options: Standard, Vivid, Soft, Warm, Intense, Cool, Brighter, Darker, or Monochrome. Choose one and press SET to view the screen seen in **Figure 17.4**. Then move the highlighting down to the box below and rotate the Main Dial to change the Effect to Low, Standard, or Strong. Press the Quick Control button to exit. The various ambience effects are shown in **Figure 17.5**.

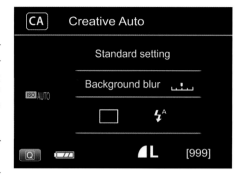

Figure 17.2 Creative Auto screen.

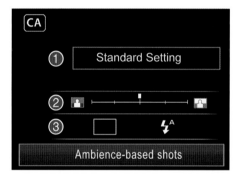

Figure 17.3
❶ Ambience settings
❷ Background blur/sharpen
❸ Drive mode/Flash settings

Figure 17.4 Setting the strength of an ambience effect.

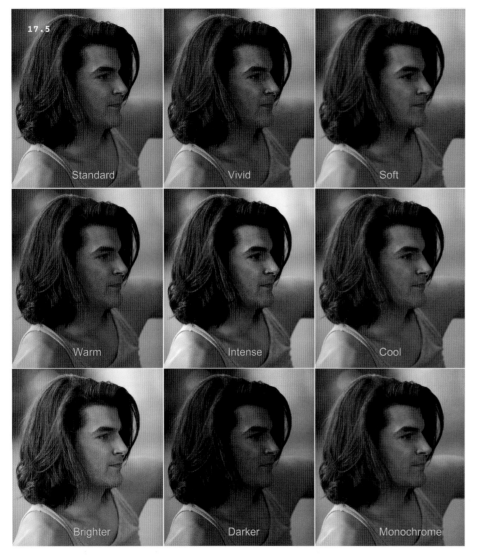

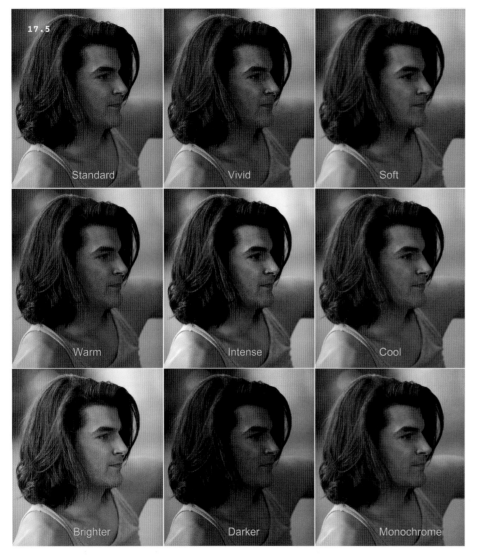
17.5

Figure 17.5 Ambience: Top row (left to right): Standard, Vivid, Soft; Middle: Warm, Intense, Cool; Bottom: Brighter, Darker, Monochrome.

2 **Alternatively, you can press the down cross key to highlight Background: Blurred↔Sharp.** Then, rotate the Main Dial to adjust the amount of background blurring. The T6 will try to use a larger f/stop to reduce depth-of-field and blur the background, or a smaller f/stop and increased depth-of-field to sharpen the background.

3 **Or, press the down cross key to highlight the bottom two settings for Drive/ Self-timer Mode or Flash Firing.** Rotate the Main Dial to highlight your choice, and press SET.

- **Drive/Self-timer.** Rotate the Main Dial to choose from Single-Shooting, Continuous Shooting, Self-Timer: 10 sec., or Self-Timer: Continuous. Press SET to confirm your choice.
- **Flash firing.** Rotate the Main Dial to choose from Auto Built-in Flash (the flash pops up when needed), Built-in Flash On (the flash always pops up), or Built-in Flash Off (the flash never pops up). Press the Q button to confirm and exit.

Find your desired ambience in Table 17.1.

Preview Ambience

If you set ambience in Live View mode, the T6 will provide a preview image that simulates the effect your ambience setting will have on the finished image.

Table 17.1 Selecting Ambience	
Ambience Setting	Effect
Standard	This is the customized set of parameters for each Basic Zone mode, each tailored specifically for Portrait, Landscape, Close-Up, Sports, or other mode.
Vivid	Produces a look that is slightly sharper and with richer colors for the relevant Basic Zone mode.
Soft	Reduced sharpness for adult portraits, flowers, children, and pets.
Warm	Warmer, soft tones. An alternative setting for portraits and other subjects that you want to appear both soft and warm.
Intense	Darker tones with increased contrast to emphasize your subject. This setting is great for portraits of men.
Cool	Darker, cooler tones. Use with care on human subjects, which aren't always flattered by the icier look this setting can produce.
Brighter	Overall lighter image with less contrast.
Darker	Produces a darker image.
Monochrome	Choose from black-and-white, sepia, or blue (cyanotype) toning.

Other Basic Zone Modes

When you select one of the Scene modes in the Basic Zone, you'll see a screen similar to **Figure 17.6**, which pictures the Landscape version. The Ambience adjustments are just like those described earlier for Creative Auto mode.

Figure 17.6 Scene mode ambience adjustments

The other options have some differences:

- **Portrait, Close-up, Sports Scene modes.** Instead of the background blur/sharpen option, you can choose from light-based settings, Default, Daylight, Shade, Cloudy, Tungsten Light, Fluorescent Light, and Sunset. You can rotate the Main Dial to cycle among them, or press SET to see the entire list.
- **Food Scene mode.** Instead of background blur/sharpen, choose Color Tone, with five settings from Cool to Warm. You can rotate the Main Dial to cycle among them, or press SET to see the entire list.
- **Night Portrait mode.** No replacement option for background blur/sharpen.
- **Operational settings.** The settings (like those described in Step 3 in the Creative Auto description above) vary among the Scene modes.
 - **Portrait, Sports modes:** Continuous shooting, Self-Timer, Continuous Self-Timer
 - **Food:** Single Shooting, Self-Timer, Continuous Self-Timer, Built-in Flash-Firing (On or Off)
 - **Landscape, Close-up, Night Portrait modes:** Single Shooting, Self-Timer, Continuous Self-Timer

18. TAKING CONTROL WITH SHOOTING MODES

IF YOU LIKE, you can use Scene Intelligent Auto, Creative Auto, or one of the Scene modes described in **Lesson 17** most of the time to take great photos. But as you become comfortable with your Rebel T6, you may want to explore one of the other exposure modes, each of which gives you more control over how your pictures look. They'll help you when you want to capture images that are darker or lighter for creative reasons, or which apply focus techniques like those described in **Lessons 10** and **11**. In this lesson, I'm going to help you master your T6's four exposure-oriented shooting modes.

Program AE Mode

Program AE mode (P) uses the T6's built-in smarts to select the correct f/stop and shutter speed using a database of picture information that tells it which combination of shutter speed and aperture will work best for a particular photo. If the correct exposure cannot be achieved at the current ISO setting, the shutter speed indicator in the viewfinder will blink 30 or 4000, indicating under- or overexposure (respectively). You can then boost or reduce ISO sensitivity (press the up cross key to access the ISO options).

Program mode is useful as an all-around exposure mode that will do an excellent job in most instances, but which allows you to make adjustments for creative purposes. For example, the T6's recommended exposure can be overridden if you want, to make your image darker or lighter. Use the EV setting feature to add or subtract exposure from the metered value. And, you can change from the *recommended* setting to an *equivalent* setting that produces the exact same exposure but using a different combination of f/stop and shutter speed.

Adding/Subtracting Exposure Values (EV)

Sometimes you'll want more or less exposure than indicated by the T6's metering system. Perhaps you want to underexpose to create a silhouette effect (as we did in **Lesson 15**), or overexpose to produce a bright, high-key look. It's easy to use the T6's exposure compensation system to override the exposure recommendations. There are two ways to make exposure value (EV) changes with the Rebel T6.

- **Fast EV Changes.** Activate the exposure meter by tapping the shutter release button. Then, just hold down the AV button (located on the back next to the upper-right corner of the LCD) and rotate the Main Dial to the right to make the image brighter (add exposure), and to the left to make the image darker (subtract exposure). The exposure scale in the viewfinder and on the LCD indicates the EV change you've made. The EV change you've made remains for the exposures that follow, until you manually zero out the EV setting with the AV button + Main Dial. EV changes work for P mode, as well as Av and Tv modes (discussed later in this lesson), but they are ignored when using M or any of the Basic Zone modes.

- **Slower EV Changes.** If you find yourself not turning the Main Dial quickly enough after you tap the shutter release button, try the second method for making EV changes with the T6. It can be a little slower, but it gives you more time to dial in your EV adjustment. Just press the MENU button and navigate to the Expo. Comp./AEB entry on the Shooting 2 menu. When the screen appears, press the left/right cross keys to add or subtract EV adjustment. The screen has helpful labels. (Darker on the left and Brighter on the right.)

Changing to Equivalent Exposures

There are times when you are happy with the exposure that the T6 has selected in P mode but want to use a faster shutter speed (say, to stop action or reduce blur from movement), a shorter shutter speed (to *increase* blur), or select a larger/smaller aperture to change the depth-of-field focus range. After all, an exposure of 1/125th second at f/11 sends the same amount of light to the sensor as one of 1/250th second at f/8 or 1/60th second at f/16. This feature is called Program Shift. Here's all you need to do:

1. **Lock in base exposure.** Press the shutter release halfway to lock in the current base exposure or press the AE lock button (*) on the back of the camera, in which case the * indicator will illuminate in the viewfinder to show that the exposure has been locked. (There is no such indicator on the LCD.)

2. **Select a different combination of shutter speed/aperture.** Spin the Main Dial to change the shutter speed (the T6 will adjust the f/stop to match) until you get the combination you want to use. Rotate to the left to achieve longer shutter speeds/smaller aperture or to the right to get shorter shutter speeds/wider apertures. The Program Shift will be canceled after taking the current picture. The feature is not available when using flash. If you want to change from the recommended settings for the next exposure, you'll need to repeat those steps.

Aperture Priority

In Av mode, you specify the lens opening used, and the T6 selects the shutter speed. Aperture Priority is especially good when you want to use a particular lens opening to achieve a desired effect. Perhaps you'd like to use a large f/stop to reduce the amount of depth-of-field and throw everything except your main subject out of focus, as seen at left in **Figure 18.1**. Or, you might want to use the smallest f/stop possible to maximize depth-of-field (the range of acceptable sharpness from the foreground to the background) when taking an interior photo, as in **Figure 18.1**, right. Or, maybe you'd just like to "lock in" a particular f/stop because it's the sharpest available aperture with that lens. For example, you could prefer to use, say, f/5.6 on a lens with a maximum aperture of f/3.5, because you want the best compromise between speed and sharpness.

A blinking 30 or 4000 shutter speed in the viewfinder indicates that the T6 is unable to select an appropriate shutter speed at the selected aperture and that over- and underexposure will occur at the current ISO setting. That's the major pitfall of using Av: you might select an f/stop that is too small or too large to allow an optimal exposure with the available shutter speeds. For example, if you choose f/4 as your aperture and the illumination is quite bright (say, at the beach or in snow), even your camera's fastest shutter speed might not be able to cut down the amount of light reaching the sensor to provide the right exposure. Or, if you select f/8 in a dimly lit room, you might find yourself shooting with a very slow shutter speed that can cause blurring from subject movement or camera shake. Aperture Priority is best used by those with a bit of experience in choosing settings. Many seasoned photographers leave their T6 set on Av all the time.

Figure 18.1 Use Aperture Priority to "lock in" a large f/stop when you want to blur the background (left). Aperture Priority allowed specifying a small aperture and maximum depth-of-field for this exposure with the camera mounted on a tripod (right).

Shutter Priority

Shutter Priority (Tv) is the inverse of Aperture Priority: you choose the shutter speed you'd like to use, and the camera's metering system selects the appropriate f/stop. Perhaps you're shooting action photos and you want to use the absolute fastest shutter speed available with your camera; in other cases, you might want to use a slow shutter speed to add some blur to a ballet photo that would be mundane if the action were completely frozen. Shutter Priority mode gives you some control over how much action-freezing capability your digital camera brings to bear in a particular situation, as you can see in **Figure 18.2**.

You'll also encounter the same problem as with Aperture Priority when you select a shutter speed that's too long or too short for correct exposure under some conditions. I've shot outdoor soccer games on sunny fall evenings and used Shutter Priority mode to lock in a 1/1,000th second shutter speed, which triggered the blinking warning, even with the lens wide open. Like Av mode, it's possible to choose an inappropriate shutter speed. If that's the case, the maximum aperture of your lens (to indicate underexposure) or the minimum aperture (to indicate overexposure) will blink.

Figure 18.2 Lock the shutter at a slow speed to introduce a little blur into an action shot, seen here in the stick at right, and the puck.

Manual Exposure

Part of being an experienced photographer comes from knowing when to rely on your Rebel T6's automation (including Scene Intelligent Auto, Creative Auto, Scene modes, or P mode), when to go semi-automatic (with Tv or Av), and when to set exposure manually (using M). Some photographers actually prefer to set their exposure manually, as the T6 will be happy to provide an indication of when its metering system judges your settings provide the proper exposure, using the analog exposure scale at the bottom of the viewfinder.

Manual exposure can come in handy in some situations. You might be taking a silhouette photo and find that none of the exposure modes or EV correction features give you exactly the effect you want. For example, when I photographed the dancers in **Figure 18.3**, there was no way any of my camera's exposure modes would be able to interpret the scene the way I wanted to shoot it. So, I took a couple test exposures, and set the exposure manually using the exact shutter speed and f/stop I needed.

You might be working in a studio environment using multiple flash units. The additional flash are triggered by slave devices (gadgets that set off the flash when they sense the light from another flash, or, perhaps from a radio or infrared remote control). Your camera's exposure meter doesn't compensate for the extra illumination, and can't interpret the flash exposure at all, so you need to set the aperture manually.

Because, depending on your proclivities, you might not need to set exposure manually very often, you should still make sure you understand how it works. Fortunately, the Rebel T6 makes setting exposure manually very easy. Just set the Mode Dial to M, turn the Main Dial to set the shutter speed, and hold down the Av button while rotating the Main Dial to adjust the aperture. Press the shutter release halfway or press the AE lock button, and the exposure scale in the viewfinder shows you how far your chosen setting diverges from the metered exposure.

Figure 18.3 I used manual exposure and experimented with settings until I got the exposure I wanted of these dancers.

19. YOUR BEST BASIC SETTINGS FOR THE MOST COMMON SUBJECTS

I SHOWED YOU how to navigate the Rebel T6's menu system back in Chapter 2 in **Lesson 6**. You'll find that the long list of options your camera provides may be confusing at first, but once you gain familiarity with your camera, you'll want to use these settings to improve your work and add creative touches. In this lesson, you'll find tips on settings to use for different kinds of shooting, beginning with recommended settings for some Shooting and Set-up menu options. You can set up your camera to shoot the main type of scenes you work with, then use the charts that follow to make changes for other kinds of images. Most will set up their T6 for my All-Purpose settings and adjust from there. Note that not all menu choices for the Shooting and Set-up menus have recommendations here. I'm listing only the most important ones that you'll want to work with most frequently.

Table 19.1 Default, All Purpose, Sports—Outdoors, Sports—Indoors

	Default	All Purpose	Sports – Outdoors	Sports – Indoors
Exposure mode	Your choice	P	Tv	Tv
Autofocus mode	One-Shot	AI Focus	AI Servo	AI Servo
AF-point selection	Automatic	Automatic	Automatic	Automatic
Drive mode	Single Shooting	Single Shooting	Continuous Shooting	Continuous Shooting
Shooting menus				
Image quality	Large/JPEG Fine	Large/JPEG Fine	Large/JPEG Fine	Large/JPEG Fine
Beep	Enable	Enable	Enable	Enable
Image review	2 sec.	2 sec.	Off	Off
Peripheral illumination correction	Enable	Enable	Enable	Enable
Auto Lighting Optimizer	Standard	Standard	Disable	Disable
Metering mode	Evaluative	Evaluative	Evaluative	Evaluative
Color Space	sRGB	sRGB	sRGB	sRGB
Picture Style	Standard	Standard	Standard	Standard
ISO Auto	Auto	Max: 1600	Max: 3200	Max: 3200
Set-up menus				
Auto power off	30 sec.	30 sec.	Disable	Disable
LCD brightness	4	4	5	4

Table 19.2 Stage Performance, Long Exposure, HDR, Portrait

	Stage Performances	Long Exposure	HDR	Portrait
Exposure mode	Tv	Manual	Tv	Tv
Autofocus mode	One-Shot	Manual	One-Shot	One-Shot
AF Point selection	Automatic	Automatic	Automatic	Automatic
Drive mode	Single Shooting	Single Shooting	Continuous Shooting	Continuous Shooting
Shooting menus				
Image quality	Large/JPEG Fine	RAW+Large/JPEG Fine	RAW+Large/JPEG Fine	RAW+Large/JPEG Fine
Beep	Disable	Enable	Enable	Enable
Image review	Off	Off	Off	2 sec.
Peripheral illumination correction	Enable	Enable	Enable	Enable
Auto Lighting Optimizer	Standard	Standard	Disable	Disable
Metering mode	Partial	Center-weighted	Evaluative	Center-weighted
Color Space	Adobe RGB	Adobe RGB	Adobe RGB	Adobe RGB
Picture Style	Vivid	Neutral	Standard	Standard
ISO	ISO 1600	ISO 800	Auto	Auto
Set-up menus				
Auto power off	30 sec.	Off	Off	Off
LCD brightness	Dimmer	Dimmer	Medium	Medium

Table 19.3 Studio Flash, Landscape, Macro, Travel, E-Mail

	Studio Flash	Landscape	Macro	Travel	E-Mail
Exposure mode	Manual	Av	Tv	Tv	P
Autofocus mode	One-Shot	One-Shot	Manual	One-Shot	One-Shot
AF point selection	Automatic	Automatic	Automatic	Automatic	Automatic
Drive mode	Single Shooting	Single Shooting	Single Shooting	Single Shooting	Single Shooting
Shooting Menus					
Image quality	RAW+Large/JPEG Fine	RAW+Large/JPEG Fine	RAW+Large/JPEG Fine	Large/JPEG Fine	Small 3
Beep	Enable	Enable	Enable	Disable	Enable
Image Review	2 sec.	2 sec.	Off	Off	2 sec.
Peripheral illumination correction	Enable	Enable	Enable	Enable	Enable
Auto Lighting Optimizer	Standard	Standard	Standard	Standard	Standard
Metering mode	Manual	Evaluative	Partial	Evaluative	Evaluative
Color Space	Adobe RGB	Adobe RGB	Adobe RGB	sRGB	sRGB
Picture Style	Standard	Auto	Standard	Auto	Auto
ISO	Auto	ISO 400	Auto	Auto	Auto
Set-up menus					
Auto power off	Off	Off	Off	30 sec.	30 sec.
LCD brightness	Medium	Medium	Medium	Medium	Medium

4

EIGHT WAYS TO MAKE GREAT SHOTS BETTER

CHAPTER 4

This chapter includes eight lessons that will quickly show you how to get great close-ups (without spending a fortune on extra gear); some techniques for conquering low-light challenges; ways to nail perfect exposure every time—and much, much more. You'll learn how to apply the Rebel T6's complement of Picture Styles, process images in your camera with the Creative Filters feature, and discover ways to get rich, saturated color images.

20. GET STUNNING CLOSE-UPS WITHOUT FUSS

ROBERT CAPA, THE noted war photographer and co-founder of the Magnum Photo agency once said, "If your pictures aren't good enough, you're not close enough!" As a budding photo enthusiast, you've probably already noticed that snapshooters tend to stand too far away from their subjects, and generally take their photos from an eye level vantage point. So, one easy way to add impact to your images is to get in close—really close—and explore the perspective of other shooting angles.

Close-up—or *macro*—photography offers unlimited possibilities for creativity, whether you're capturing images of traditional subjects, such as the flower shown in **Figure 20.1**, or scenes you construct yourself on a tabletop (see **Figure 20.2**). Fortunately, you can explore close-up photography using the equipment you already own or, perhaps, with add-on accessories that cost less than $20. An overview of your choices follows.

Figure 20.1 Flowers are traditional close-up subjects.

Figure 20.2 You can create your own scene on a tabletop.

Using the T6's Versatile Kit Lens

If the only lens you own is the 18-55mm f/3.5-5.6 kit lens, you can easily shoot close-up images, as this lens focuses down to just a smidge under 10 inches. It includes image stabilization that provides useful anti-shake features, so you can even hand-hold the camera for some macro photos. Unless you're working under bright sunlight, I do recommend using a tripod. At the 55mm telephoto end of the kit lens's range, the *maximum* aperture is f/5.6, and it's not the sharpest f/stop for that particular optic. You'll want to use an aperture of at least f/8 or f/11 to get better sharpness (use Av or M mode so you can specify the f/stop). A shutter speed of 1/125th second (or faster) is best if you are not using a tripod.

Autofocus is not necessarily the best choice for close-up photography. Depth-of-field is relatively shallow when capturing macro images, and selective focus, which I discussed in **Lesson 10**, can be a useful technique to center attention on your subject. Manual focus allows you to select the exact plane of focus. Make sure the AF/M switch on the kit lens is in the M position. Then use the thin, outermost ring on the lens (the one closest to the front element) to adjust focus. In most cases, you'll want to use the 55mm zoom setting of your lens. That allows you to maintain a reasonable distance from your subject (which may be a skittish insect) and helps avoid casting your shadow onto a scene.

Close-Up Lens Attachments Magnify Your View

To get closer, and for more flexibility, you'll want to consider purchasing a set of close-up lens attachments. These are the least expensive close-up accessories you can buy. I found a set of Vivitar-brand lenses in +1, +2, +4, and +10 strengths for $12.50 on Amazon. You can stack them together in combination, giving you, say, +3, +5, +6 and other strengths. The figures measure *optical power*, not magnification, with the larger number representing a closer focusing distance for a particular zoom setting. (You don't need to know the formula for calculating that—after you've used these attachments you'll learn the effective range of each.)

Close-up attachments are simple magnifying lenses that screw onto the front of your camera's lens. Although they are marketed as "lenses," they are closer to filters in appearance, so I tend to call them "attachments" to avoid confusion with actual interchangeable lenses.

You'll need close-up attachments with a 58mm filter size, to fit the threads on the front of your kit lens. If you are using a different lens, buy attachments that fit that optic's threads, or consider *step-down* and *step-up* rings. These are adapters that allow using accessories with one filter thread on a lens with a larger or smaller thread. I used a step-down ring to attach a 52mm thread single-element close-up lens to the 58mm thread of my kit lens for **Figure 20.3**.

Close-up lens attachments are commonly sold in sets of three or four filter-like add-ons. Although they are the least sharp option of any of the close-up accessories, they provide quite reasonable results when your main lens is stopped down to a medium f/stop such as f/11. In fact, they can produce a rather soft and dreamy look that some people think is a cool effect. However, their biggest advantage is that they are relatively inexpensive. Here are some things to look for when buying and using them:

- **Filter plus rating.** Check the filter's plus rating, such as +2 or +4. The stronger the plus rating of any close-up filter, the closer you will be able to focus with your lens.
- **Attaching to your lens.** Use close-up filters on the kit lens, or any other lens that offers the ability to add screw-on filters.
- **Fit your physically widest diameter lens.** Buy close-up filters big enough to fit the filter ring of your widest diameter lens.
- **Buy adapter rings.** As I mentioned, step up/down adapter rings allow you to attach the filters to other lenses with different filter sizes. You can't, however, put a small close-up filter in front of a lens with a wide diameter because this will not allow all the lenses to work together properly.
- **Zooms act strangely.** Close-up filters give different results depending on the focal length that you use them with. In fact, a zoom lens no longer acts like the zoom lens you used to know. As soon as you start to zoom, you will find that the subject gets out of focus.
- **No distant focus.** You cannot focus at a distance when a close-up filter is on your lens.
- **No exposure change.** Using a close-up filter has no effect on exposure.
- **Protect your filters.** Close-up filters are very susceptible to scratching because they are constantly being handled and taken on and off lenses. Handle them with care.

Figure 20.3 Close-up attachment.

Achromatic Close-Up Lenses for Even Better Quality

Achromatic close-up lenses are definitely a more sophisticated option and sharper than close-up filters. These lens attachments are highly corrected lenses (using two optical elements) that you screw into the front of your lens and fit any camera lens with the filter size (see **Figure 20.4**). You can get remarkably sharp macro shots with them.

Only a few manufacturers make these lenses, but since they screw into the front of your lens, they can be used with any brand. They will run about $80 to $200 depending on the size, but the high image quality makes them well worth the cost. Canon's own 250D and 500D Close-Up lenses (about $125 and up, depending on filter size) are held in high enough regard that owners of Nikon and Sony cameras favor them for their own work. The 250D is suited for lenses with a focal length of 30 to 135mm. The 500D is designed for lenses with a focal length anywhere from 70 to 300mm.

Broaden Your Lens Options

If you want better sharpness and are thinking of adding another lens to your kit lens, a non-zoom lens like Canon's 50mm f/1.8 STM lens might be a good choice. It's relatively inexpensive at about $125 and focuses down to about 14 inches without accessories, and even closer with a close-up attachment or when mounted on an extension tube (described next). With an f/1.8 maximum aperture, it's more than two f/stops "faster" than the kit lens, and useful for general-purpose shooting and available-light photography.

For quite a bit more ($300), you can invest in a true macro lens, like the Canon EF-S 35mm f/2.8 IS STM lens, which has a handy built-in LED macro light to illuminate your close-up subjects. It focuses down to 5 inches. Macro lenses like this one (and Canon's 60mm f/2.8 macro, which costs $100 more) are specifically designed for close-ups and have very high image quality (see **Figure 20.5**). They are a very good way to get close, but as you've seen, there are other good options, too. Some things to think about regarding interchangeable macro lenses include:

- **Infinity to macro.** With a macro lens you can focus from distant to close without adding anything to the lens or camera. Your shooting is therefore more fluid.
- **Wide apertures are sharp.** When you get to really close distances and select wide apertures, macro lenses will beat nearly any other lens in terms of quality.

Figure 20.4 An achromatic close-up lens attaches to the front of your lens.

Figure 20.5 A macro lens lets you focus from infinity to macro without accessories, so you can get shots like this one.

- **Flat-field sharpness.** All lenses have a slight curvature to their plane of focus. For many subjects, this doesn't matter. But if you're photographing flat objects, that curved field can result in centers being differently focused than edges. Macro lenses are designed for maximum flat-field sharpness.
- **Exposure changes.** Macro lenses may move the lens or optical elements away from the camera body and as it does this, it reduces the light to the sensor. The result is that your exposure will change, requiring a slower shutter speed or a wider aperture.
- **Limited focal lengths.** Macro lenses only come in a limited range of focal lengths, which can make certain types of macro photography challenging.

Getting Extra Close with Extension Tubes

Extension tubes are another inexpensive, versatile, high-quality close-up accessory. Third-party tubes can cost as little as $10 for manual exposure sets, around $26 for autoexposure kits, and from $90 to $150 for deluxe tubes from Canon, Kenko, and other vendors. If you can't afford a macro lens, be sure to look into extension tubes (see **Figure 20.6**). Even if you have a macro lens, extension tubes will increase your capabilities for close-up photography. They will work with your kit lens, or the inexpensive 50mm f/1.8 lens mentioned above. They are very affordable and can be used with all but the widest-angle lenses on a dSLR. In fact, they are ideal for telephoto lenses. They are literally tubes without any glass in them. They fit between your camera and lens and enable that lens to focus much closer. Think about these things when buying and using these accessories:

- **Buy them in sets.** You can find extension tubes sold in a set of three tubes of varying lengths. These sets tend to be much less expensive than buying extension tubes individually.
- **Almost any lens can be used.** Extension tubes can make almost any lens focus as close as a macro lens (wide-angles can be the exception) and do it relatively inexpensively.
- **Size of tube affects close focusing.** How close an extension will let you focus depends on the amount of extension in the extension tube.
- **Focal length of the lens affects close focusing.** The more telephoto your lens is, the more extension you need to use it up close. This is why extension tubes come in sets.

- **Macro zoom.** Extension tubes will make a zoom lens act like a macro zoom, too, although the zoom will change focus as you zoom.
- **Very durable and portable gear.** Since extension tubes have no optics in them, they are very rugged. A few extension tubes add little weight and take little space from a camera bag.
- **Results will vary.** Since the extension tube has no optics of its own, image quality will vary depending on the lens used with it.
- **Not all lenses work well with extension tubes.** Some quality lenses simply are not designed to be used up close and will not give great results. On the other hand, sometimes you will be surprised at how well an average lens might do up close. The only way to know is to try.
- **Exposure changes.** Extension tubes move the lens away from the camera body and so reduce the light to the sensor. The result is that your exposure will change, requiring a slower shutter speed or a wider aperture.

20.6

Figure 20.6 Extension tubes fit between your camera and lens to allow a lens to focus closer.

Shooting Your Close-up

Once you have the right equipment, capturing dramatic close-up photos is simple. Just follow these steps:

1 **Find a subject.** Flowers and bugs always make excellent subjects for macro photography, but your imagination can find dozens of other things to shoot up close and personal. I recently visited the National Packard Museum in Warren, Ohio and spent part of the day photographing hood ornaments, lanterns, and other accoutrements of these fine old motor vehicles. (See **Figures 20.7** and **20.8.**) Look around you to find all kinds of possible subjects. Close-up views of everyday objects can be fascinating.

2 **Make your settings.** Evaluative exposure metering (which you can set from the Quick Control menu) will handle most scenes, but if your subject is surrounded by very bright or very dark areas, you can try Partial or even Spot metering. Aperture Priority will let you select an f/stop that provides as much—or as little—depth-of-field that's appropriate. (Review **Lessons 10** and **11** for tips.) Take a test shot, and if the camera has selected a shutter speed that's too slow (typically, anything longer than 1/125th second), press the ISO button and boost sensitivity a little to allow a faster shutter speed. Or, consider using a tripod.

3 **Use Manual focus.** Set the lens A/MF switch to Manual and then focus on the precise part of the image you want to be sharpest. For **Figure 20.7**, I focused on the Goddess of Speed's nose.

4 **Frame carefully.** Macro photos, unlike most other types, often have the most important element smack dab in the middle of the frame. But don't shy away from other compositions, whether using the Rule of Thirds or your own creative instincts, as seen in **Figure 20.8.**

5 **Take the photo—and review.** Take the picture, and then immediately check it out on the T6's LCD monitor. You may not be able to detect focus on the tiny screen, but you can judge exposure and framing easily. I'll have some exposure tips in **Lesson 21**, which follows this one.

Figure 20.7 Manual focus allows precision.

Figure 20.8 Close-up subjects are often centered in the middle of the frame.

21. THREE PATHS TO PERFECT EXPOSURE

IN ITS AUTOMATIC and semi-automatic modes, the EOS Rebel T6 provides excellent exposure under most conditions. However, you can easily adjust the settings the camera makes when you want your photos to be a little darker or lighter, or when the T6's exposure setting falls short of ideal. I explained some of the techniques at your disposal in earlier lessons, including the use of Exposure Value (EV) changes to create silhouettes in **Lesson 15**, using Scene modes in **Lesson 17**, and selecting the right exposure mode in **Lesson 18**. In this Lesson, you'll learn some simple ways to perfect exposure using the powerful trio of metering methods, histograms, and automatic ISO selection.

Choosing a Metering Method

As you've learned, the exposure modes, including Program (P), Shutter Priority (Tv), Aperture Priority (Av), or Manual (M) options, plus Auto and Creative Auto tell the T6 *which controls* to apply to achieve correct exposure—shutter speed, aperture, or both. The camera's *metering method* options tell the camera exactly which *areas* of your image to measure to calculate that exposure. There are three metering methods, which I'll describe next. You can select any one of the three if you're working with P, Tv, Av,

or M exposure modes. If you're using Auto or Creative Auto, Evaluative metering is selected automatically and cannot be changed.

1 There are two ways to specify a metering method.
 - Press the MENU button and navigate to the Shooting 2 menu (a camera icon with two dots next to it). The third entry is Metering mode. Highlight it, press SET, and choose one of the three modes described below.
 - Use the Quick Control button (Q) to access the Quick Control screen and navigate to the metering mode section at the bottom of the screen. Then rotate the Main Dial to change the metering mode directly (see **Figure 21.1**).

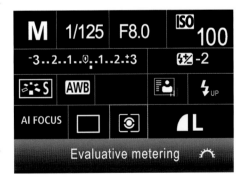

Figure 21.1 The Quick Control screen is the fastest way to change the metering mode (and many other common settings).

2 With either of these two methods, you'll be choosing one of these options: Evaluative, Partial, or Center-weighted.
 - **Evaluative.** The T6 slices up the frame into 63 different zones, shown as blue rectangles at left in **Figure 21.2**. The point zones used are linked to the autofocus system (the 9 autofocus zones are also shown in the figure). The camera evaluates the measurements, giving extra emphasis to the metering zones that indicate sharp focus to make an educated guess about what kind of picture you're taking, based on examination of thousands of different real-world photos. For example, if the top sections of a picture are much lighter than the bottom portions, the algorithm can assume that the scene is a landscape photo with lots of sky. This mode is the best all-purpose metering method for most pictures. I'll explain how to choose an autofocus/exposure zone in the section on autofocus operation later in this chapter. See **Figure 21.2**, right, for an example of a scene that can be easily interpreted by the Evaluative metering mode.

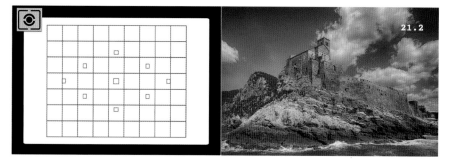

Figure 21.2 Left: Evaluative metering uses 63 zones marked by blue rectangles, linked to the autofocus points shown as red brackets. Right: An evenly lit scene like this one can be metered effectively using the Evaluative metering setting.

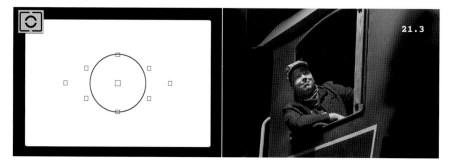

Figure 21.3 Left: Partial metering uses a center spot that's roughly ten percent of the frame area. Right: Partial metering allowed measuring exposure from the central area of the image, while giving less emphasis to the darker areas surrounding the trainman.

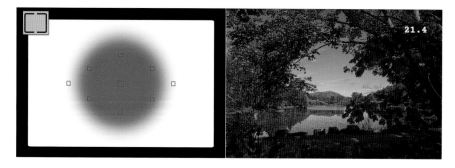

Figure 21.4 Left: Center-weighted metering calculates exposure based on the full frame but emphasizes the center area. Right: Center-weighted metering calculated the exposure for this shot from the large area in the center of the frame, with less emphasis on the surrounding foliage.

- **Partial.** This metering method uses roughly 10 percent of the central image area to calculate exposure, which, as you can see at left in **Figure 21.3**, is a rather large spot, represented by the blue circle. The status LCD icon is shown in the upper-left corner. Use this mode if the background is much brighter or darker than the subject, as in **Figure 21.3**, right.
- **Center-weighted.** In this mode, the exposure meter emphasizes a zone in the center of the frame to calculate exposure, as shown at left in **Figure 21.4**, on the theory that, for most pictures, the main subject will be located in the center. Center-weighting works best for portraits, architectural photos, and other pictures in which the most important subject is in the middle of the frame, as in **Figure 21.4**, right. As the name suggests, the light reading is *weighted* toward the central portion, but information is also used from the rest of the frame. If your main subject is surrounded by very bright or very dark areas, the exposure might not be exactly right. However, this scheme works well in many situations if you don't want to use one of the other modes.

3 Press the SET button to confirm your choice.

DISPLAYING HISTOGRAMS

To view histograms on your screen, press the DISP. button (to the right of the Q button) while an image is shown on the LCD. Keep pressing the button until the histogram(s) are shown. The display will cycle between several levels of information, including flashing highlights and two screens that show histograms. One histogram (see **Figure 21.5**) shows overall brightness levels; the second one (see **Figure 21.6**) shows tonal values for the red, green, and blue "channels" that make up the color information of your image, plus a brightness histogram. During histogram display, you'll also see a thumbnail of your image at the top-left side of the screen. To change your default histogram type from Brightness to RGB, use the Histogram setting in the Playback 2 menu.

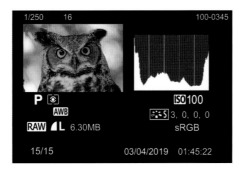

Figure 21.5 Display with a brightness histogram in the upper-right corner.

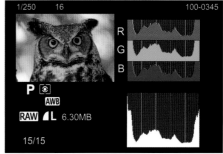

Figure 21.6 Display with RGB (color) histograms and a brightness histogram.

Fixing Exposures with Histograms

You can't always judge exposure just by viewing the image on your T6's LCD after the shot is made. Ambient light may make the LCD difficult to see, and the brightness level you've set can affect the appearance of the playback image. Instead, you can use a histogram, which is a chart displayed on the Rebel T6's LCD that shows the number of tones being captured at each brightness level. You can use the information to provide correction for the next shot you take. The T6 offers two histogram variations: one that shows overall brightness levels for an image and an alternate version that separates the red, green, and blue channels of your image into separate histograms.

Interpreting a Histogram

Even if you're fed up with looking at pie charts, Venn diagrams, and other graphs in PowerPoint presentations, you'll find histograms easy to interpret, simply by looking at their shape. Both the brightness and RGB histograms are charts that use a curved, mountain shape to represent all the tones in your image, from totally black (on the left edge) to completely white (on the right edge). The more pixels at a given level, the taller the bar at that position. If no bar appears at a particular position on the scale from left to right, there are no pixels at that particular brightness level.

A typical histogram's mountain-like shape has most of the pixels bunched in the middle tones, with fewer pixels at the dark and light ends of the scale. Ideally, though, there will be at least some pixels at either extreme, so that your image has both a true black and a true white representing some details.

To put histograms to work, you simply need to learn how to spot histograms that represent over- and underexposure, and then add or subtract exposure using an EV modification to compensate, giving you a perfectly exposed picture. **Figure 21.7** sums up everything you really need to know.

At top in the figure is a histogram for an image that is badly underexposed. You can guess from the shape of the histogram that there are many dark tones to the left of the graph. When you see an abrupt cut-off at the left edge of the histogram, you'll know that some of the available dark tones have not been captured: they've been "clipped" off. There's plenty of room on the right side of the top histogram for additional pixels to reside without having them become overexposed. So, in this case, all you have to do is add exposure (using EV compensation if you're using P, Av, or Tv mode, or by manually adjusting your shutter speed or aperture in M mode).

Once you've added some exposure, the histogram will look more like the one in the center. If you haven't added enough exposure, you'll be able to see that in the histogram of your follow-up picture and make an additional adjustment. In the corrected center histogram, the tones are comfortably contained completely within the boundaries of the chart.

The bottom example in the figure shows an image that is overexposed. The mountain shape is the same, except that it has been shifted so far to the right that all the lighter tones and about half of the middle tones have wandered off the right edge. They, too, are "clipped." In this case, *reduce* exposure using EV adjustments or by changing your shutter speed and/or aperture in M mode.

Figure 21.7 Top: This histogram shows an underexposed image. Center: Here, exposure is perfect. Bottom: This version is overexposed.

Adjusting Exposure with ISO Settings

Shutter speed and aperture aren't your only way of adjusting exposure! You can also change the ISO sensitivity setting. Sometimes photographers forget about this option, because the common practice is to set the ISO once for a particular shooting session (say, at ISO 100 for bright sunlight). Boosting the ISO is sometimes seen as a necessary evil, because as the ISO increases, so does the grainy effect photographers dub *noise*. However, the Canon EOS Rebel T6 produces good results at ISO settings up to ISO 800, and acceptable results at ISO 1600 and 3200.

ISO adjustment happens to be a convenient alternate way of adding or subtracting EV when shooting in Manual mode, and as a quick way of choosing equivalent exposures when in Auto or semi-automatic modes. For example, I've selected a Manual exposure with both f/stop and shutter speed suitable for my image using, say, ISO 200. I can change the exposure in full-stop increments by pressing the ISO button (the up cross key) and spinning the Main Dial one click at a time. The difference in image quality/noise at the base setting of ISO 200 is negligible if I dial in ISO 100 to reduce exposure a little or change to ISO 400 to increase exposure. I keep my preferred f/stop and shutter speed, but still adjust the exposure.

Or, perhaps, I am using Tv mode and the metered exposure at ISO 200 is 1/500th second at f/11. If I decide on the spur of the moment I'd rather use 1/500th second at f/8, I can press the ISO button and spin the Main Dial to switch to ISO 100. Of course, it's a good idea to monitor your ISO changes, so you don't end up at ISO 1600 accidentally. ISO settings can, of course, also be used to boost or reduce sensitivity in particular shooting situations. The Rebel T6 can use ISO settings from ISO 100 up to 6400. An additional setting, ISO 12800, is available if you activate it using the C.Fn I-2 ISO Expansion option in the Set-up 3 menu. I *do not* recommend doing that, or even using ISO 6400, because of excess visual noise. I'll show you how to tame noise in **Lesson 23**.

Automatic ISO

The T6 can adjust the ISO automatically as appropriate for various lighting conditions. In Basic Zone modes, ISO is normally set between ISO 100 and ISO 3200. When you choose the Auto ISO setting, the T6 adjusts the sensitivity dynamically to suit the subject matter. In Basic Zone Full Auto, Landscape, Close-Up, Sports, Night Portrait, and Flash Off modes, the T6 adjusts ISO between ISO 100 and ISO 3200 as required. In Portrait mode, ISO is fixed at ISO 100, because the T6 attempts to use larger f/stops to blur the background, and the lower ISO setting lends itself to those larger stops.

When using flash, Auto ISO produces a setting of ISO 800 automatically, except when overexposure would occur (as when shooting subjects very close to the camera), in which case a lower setting (down to ISO 100) will be used. If you have an external dedicated flash attached, the T6 can set ISO in the range of ISO 800 to ISO 1600 automatically. That capability can be useful when shooting outdoor field sports at night and other "long distance" flash pictures, particularly with a telephoto lens, because you want to extend the "reach" of your external flash as far as possible (to dozens of feet or more), and boosting the ISO does that. Remember that if the Auto ISO ranges aren't suitable for you, individual ISO values can also be selected in any of the Creative Zone modes.

WANT TO HEDGE your bets? Do it easily with bracketing, a useful method for taking several consecutive pictures, each at a slightly different exposure, improving the odds that one will be exactly right. Your Rebel T6 is smart enough to do this automatically for you when using three of the Creative Zone modes, if you ask, using the simple procedure I'm going to describe in this lesson.

During bracketing, the camera takes three consecutive photos: one at the metered "correct" exposure, the next one with *less* exposure, and one final shot with *more* exposure. **Figure 22.1** shows an example using a large two-stop "increment" between each exposure. That is, the center version was given two f/stops *less* exposure, while the version at right was given two f/stops *extra* exposure. In practice, you won't use such a large increment—a fraction of a stop is often enough.

STOPS VS. F/STOPS

Here's a minor bit of photo jargon that will come in handy. When photographers refer to f/stops, they are always talking about the aperture of the lens. However, the term *stop* (without the f/) can mean an aperture increment *or* an increment of shutter speed. So, if you're told to provide an extra stop of exposure, you can either use a larger aperture (f/stop) *or* a slower shutter speed. Conversely, one stop *less* exposure can mean a smaller aperture or a *faster* shutter speed.

Figure 22.1 A large bracketing increment provides a dramatic difference between shots.

Bracketing Step-by-Step

I'm going to show you *how* to bracket first, then explain your other options in more detail. Just follow these steps:

1 You can always access auto exposure bracketing (AEB) from the Shooting 2 menu, as seen in **Figure 22.2**.

2 However, it's usually easier to press the Q button and select Exposure Comp/AEB Setting from the Quick Control menu. When the exposure scale is highlighted, press SET to access the adjustment screen. (See **Figure 22.3**.)

3 Rotate the Main Dial. Two bracketing indicators flanking the center indicator (which should be at 0 if you haven't previously made any exposure compensation or bracketing settings) will separate, as seen in **Figure 22.4**, upper left.

4 The farther the flanking bars are spread apart, the larger the increment. By default, each increment represents one-third of a "stop". (The default increment can be changed from 1/3 stop to 1/2 stop using Custom Function I: Exposure Level Increments in the Set-up

3 menu, but I don't recommend beginners making any Custom Function changes at all.)

5 The bars can be separated up to two full stops, as shown in **Figure 22.4**, upper right.

6 By default, the bracketing is evenly distributed on either side of the metered exposure, represented by the down-pointing arrow with a zero inside it.

7 If you find that the metered exposure makes your image too bright, you can bias the bracketing toward *less exposure*, which means less exposure will be given to each shot in

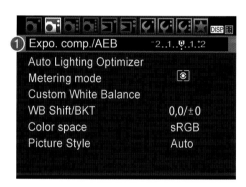

Figure 22.2
1 Exposure compensation/Autoexposure bracketing menu entry.

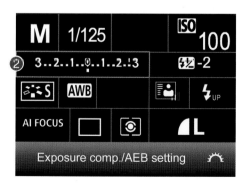

Figure 22.3
2 Exposure compensation/Autoexposure bracketing Quick Control menu option.

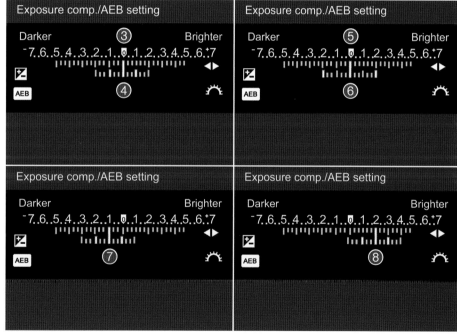

Figure 22.4
3 Autoexposure bracketing center indicator
4 One-stop bracketing increment
5 Autoexposure bracketing center indicator
6 Two-stop bracketing increment
7 Bracketing biased toward underexposure
8 Bracketing biased toward overexposure

the bracket set, including the "correct" metered shot. Press the left cross key to move the bracketing indicator toward the Darker end of the exposure scale, as seen in **Figure 22.4**, lower left.

8 If your metered image is too dark, and you want all your bracketed photos, you can bias the bracketing toward *more exposure*. Press the right cross key to move the bracketing indicator to the right, toward the Brighter end of the exposure scale, as seen in **Figure 22.4**, lower right. In either case, the bracketing can vary within the range plus or minus seven full stops. You'll rarely need that much bracketing compensation, however.

Here are some other considerations to keep in mind while bracketing:

- **One press or three.** In single shooting mode, you'll need to press the shutter release three times to take the three bracketed shots. I recommend pressing the Q button and changing to continuous shooting mode from the Quick Control screen. Then, all three shots in the bracketed set will be taken one after another when you press the shutter release down all the way.

- **Av mode.** The shutter speed will change with each shot. Use Aperture Priority mode when you want to keep the same f/stop for all three bracketed shots, say, to maintain a fixed range of focus (depth-of-field).

- **Tv mode.** The aperture speed will change. Use Shutter Priority when you want to keep a fixed shutter speed during the three bracketed exposures. That can be useful in lower light situations, where you want a certain shutter speed, say, 1/125th second to counter subject or camera movement.

- **P mode.** The T6 uses its built-in intelligence to change either shutter speed or aperture—or both—to achieve an appropriate bracketed set of exposures. If you like Program mode and don't have a need for a particular shutter speed or aperture, the P setting can work well under all but low lighting situations.

- **M mode.** If bracketing is activated and you're using Manual exposure mode, the T6 will snap a single picture in single shooting mode or take three in a row in continuous shooting mode. However, no bracketing will take place in either case. All exposures will be at the shutter speed and aperture you specified.

- **Auto ISO.** If you have selected Auto ISO and one or more of the bracketed exposures aren't possible using the selected shutter speed or aperture, the camera may elect to substitute an ISO sensitivity adjustment instead.

LOW-LIGHT PHOTOGRAPHY CAN be one of the most challenging creative hurdles you'll encounter, but also can result in some of the most exciting pictures you take. Any snapshooter can capture decent pictures in full daylight or indoors where there is plenty of illumination. Because low-light photography calls for some extra, easy-to-master techniques, it's one avenue to getting shots that are unique, compelling, and not captured in everyday photography.

Three keys to low-light shooting involve tools such as long exposures (or "fast" lenses), tripods and other supports, and the correct application of noise-busting techniques that counter the visual noise that can plague high ISO shooting (as discussed in **Lesson 21**) and long exposures.

Three Ways to Take Long Exposures

In **Lesson 13**, I recommended using long exposures as a technique for adding a feeling of motion to action shots. Slower shutter speeds are also an excellent tool for handling scenes with low levels of illumination. Faster lenses (those with larger maximum apertures) are an expensive option—you may need to go out and buy an additional lens at a hefty cost. But a slower shutter speed can cost you nothing (although you may need to purchase a tripod). Changing from a shutter speed of 1/60th second to 1/15th second gives you two extra stops of exposure—which is much cheaper than switching your kit lens and its maximum f/3.5 aperture for one with a two-stop improvement to f/1.8.

There are actually three common types of lengthy exposures: *timed exposures, bulb exposures*, and *time exposures*. The EOS T6 offers only the first two, but once you understand all three, you'll see why Canon made the choices it did. Because of the length of the exposure, all the following techniques should be used with a tripod to hold the camera steady. I'll discuss your other support options in the next section.

- **Timed exposures.** These are long exposures from 1 second to 30 seconds, measured by the camera itself. To take a picture in this range, simply use Manual or Tv modes and use the Main Dial to set the shutter speed to the length of time you want, choosing from preset speeds of 1.0, 1.3, 1.6, 2.0, 2.5, 3.2, 4.0, 5.0, 6.0, 8.0, 10.0, 13.0, 15.0, 20.0, 25.0, or 30.0 (when using the default 1/3-stop increments). If you've specified 1/2-stop increments for exposure adjustments using C.Fn 1 (Exposure Level Increments), your choices will be 1.0, 1.5, 2.0, 3.0, 4.0, 6.0, 8.0, 10.0, 15.0, 20.0, or 30.0 seconds. I recommend keeping the "finer" 1/3-stop increments.

 The advantage of timed exposures is that the camera does all the calculating for you. There's no need for a stopwatch. If you review your image on the LCD and decide to try again with the exposure increased or decreased, you can dial in the correct exposure with precision. The disadvantage of timed exposures is that you can't take a photo for longer than 30 seconds.

- **Bulb exposures.** This type of exposure is so-called because in the olden days the photographer squeezed and held an air bulb attached to a tube that provided the force necessary to keep the shutter open. Traditionally, a bulb exposure is one that lasts as long as the shutter release button is pressed; when you release the button, the exposure ends. To make a bulb exposure with the T6, set the camera on M using the Mode Dial, then rotate the Main Dial all the way past the 30-second shutter speed to the Bulb position. Then, press the shutter button to start the exposure, and release it again to close the shutter.

- **Time exposures.** You can take time exposures (as opposed to *timed* exposures) with the T6, but you'll need an add-on timer that plugs into the remote-control port on the left side of the camera. Inexpensive timers are offered by third parties. Canon's own option is rather pricey: the Timer Remote Controller TC-80N3 costs about $135 and you'll also need the Remote Controller Adapter RA-E3, which adds another $30 to the tariff. A third option is to use any compatible plug-in remote control, such as the Canon Remote Switch RS-60E3 and use that to open/close the shutter for an interval you determine manually.

The advantage of time exposures is that you can take an exposure of virtually any duration, exactly like Bulb exposures as described above. Third-party timers usually have a feature that allows you to take a number of exposures at intervals you specify. For **Figure 23.1** I took 60 separate 60-second exposures over a period of about hour and then merged them all in Photoshop to create this star trail image.

Figure 23.1 Many 60-second exposures were combined to create this star trail image.

Steady as She Goes

As I've noted elsewhere in this book, a tripod is an invaluable accessory for a number of reasons. You can set your camera on a tripod when you want to use the self-timer to get in the photo yourself. A steady support comes in handy when you want to take several pictures with the exact same framing. Long exposures also often call for use of a tripod or its single-legged cousin, the monopod. While the latter isn't especially useful for exposures longer than a second (in most cases), both tripods and monopods can be useful for exposures in the 1/2-second to 125th-second range, giving you extra steadiness for exposures under low-light conditions.

However, you don't necessarily need a tripod in low-light situations when using slower shutter speeds. You can try one of these remedies instead:

- **Rely on Image Stabilization.** Your 18-55mm kit lens and many other lenses offer built-in image stabilization (IS) that can counter camera shake (but not subject motion). Experiment to see just how slow you can set the shutter and still get a sharp picture. To test, take a photo of a pin-point light source, such as a distant street light, at your target shutter speed. Or, you can do as I did and drill a few holes in a piece of sheet metal in the shape of a cross. I painted it black and shot test pictures with a light source placed behind the sheet. (See **Figure 23.2**.) Then, in an image editor, examine the point source. If its circles are round and sharp, the shutter speed is fast enough. You can use this test to evaluate your IS or your own hand-holding technique.

- **Brace your arms.** Just drawing your arms into your body and bracing yourself may supply enough steadiness to give you sharp images under low light levels. You can use the point-source light test described earlier to check your results. Note that, like mileage, your results may vary. Some can hand-hold their cameras at 1/30th second, while others still end up with slight camera blur at 1/125th second.

- **Use a flat surface.** If you can set your camera down on a table, a tree stump, or even a flat rock you can take longer exposures without camera shake. If you're not trying to capture a decisive moment, use your self-timer, as described in **Lesson 5**, to take the photo.

- **Increase your ISO setting.** Boosting the ISO setting can let you use more reasonable shutter speeds (and f/stops) under low light. You can use ISO 3200 in a pinch, or even ISO 6400 if getting a noisy picture is preferable to no picture at all. Reducing noise is discussed in the next section.

Figure 23.2 Exposure of a back-illuminated target at 1/125th second (upper left); 1/30th second (upper right; 1/15th second (lower left), and one-second (lower right).

Dealing with Noise

As I said in **Lesson 21**, visual image noise is that random grainy effect that some like to use as a special effect, but which, most of the time, is objectionable because it robs your image of detail even as it adds that "interesting" texture. Noise is caused by two different phenomena: high ISO settings and long exposures, both common elements of low-light photography.

High ISO noise commonly first appears when you raise your camera's sensitivity setting above ISO 800. Noise may become especially visible at ISO 1600, and is usually more significant at ISO 3200. If you've activated ISO Expansion using Custom Setting C.Fn 2, the H setting (ISO 12800 equivalent), noise will usually be quite bothersome. This kind of noise appears as a result of the amplification needed to increase the sensitivity of the sensor. While higher ISOs do pull details out of dark areas, they also amplify non-picture information randomly, creating noise.

A similar noisy phenomenon occurs during long exposures. The longer exposures allow more photons to reach the sensor, increasing your ability to capture a picture under low-light conditions. However, the increased exposure times also increase the likelihood that some pixels will register random phantom photons as the sensor heats up. That heat can be mistaken for photons.

Fortunately, Canon provides a built-in noise reduction feature for all exposures longer than one second. This feature compares the image you took with a blank frame and subtracts those representing noise. Of course, noise reduction can reduce the amount of detail in your picture, as some image information may be removed along with the noise. So, you might want to use this feature with moderation. Some types of

images don't require noise reduction, because the grainy pattern tends to blend into the overall scene.

To activate your T6's long exposure noise reduction features, go to the Custom Functions in the Set-up menu, choose C.Fn II: Image, and select either C.Fn II-4: (Long Exposure Noise Reduction) or C.Fn II-5: (High ISO Speed Noise Reduction). You can also apply noise reduction to a lesser extent using Photoshop or another image editor, as all of them have their own noise-reduction features built-in.

Your Long Exposure NR options include:

- **0: Off.** Disables long exposure noise reduction. Use this setting when you want the maximum amount of detail present in your photograph, even though higher noise levels will result. This setting also eliminates the extra time needed to take a picture caused by the camera's internal noise reduction processing. If you plan to use only lower ISO settings, the noise levels produced by longer exposures may be acceptable. Because the noise-reduction processing used with settings 1 and 2 effectively doubles the time required to take a picture, this is a good setting to use when you want to avoid this delay when possible.

- **1: Auto.** The Rebel T6 examines your photo taken with an exposure of one second or longer, and if long exposure noise is detected, a second, blank exposure is made and compared to the first image. Noise found in the "dark frame" image is subtracted from your original picture, and only the noise-corrected image is saved to your memory card.

- **2: On.** When this setting is activated, the T6 applies dark frame subtraction to all exposures longer than one second. You might want to use this option when you're working with high ISO settings (which will already have noise boosted a bit) and want to make sure that any additional noise from long exposures is eliminated, too. Noise reduction will be applied to some exposures that would not have caused it to kick in using the Auto setting.

Your high ISO speed noise reduction options apply noise reduction that is especially useful for pictures taken at high ISO sensitivity settings. The default is 0 (Standard noise reduction), but you can specify 1 (low) or 2 (strong) noise reduction, or disable noise reduction entirely. At lower ISO values, noise reduction improves the appearance of shadow areas without affecting highlights; at higher ISO settings, noise reduction is applied to the entire photo. Note that when the 2: Strong option is selected, the maximum number of continuous shots that can be taken will decrease significantly, because of the additional processing time for the images.

- **0: Standard.** At lower ISO values, noise reduction is applied primarily to shadow areas; at higher ISO settings, noise reduction affects the entire image.

- **1: Low.** A smaller amount of noise reduction is used. This will increase the grainy appearance but preserve more fine image detail.

- **2: Strong.** More aggressive noise reduction is used, at the cost of some image detail, adding a "mushy" appearance that may be noticeable and objectionable. Because of the image processing applied by this setting, your continuous shooting maximum burst will decrease significantly.

- **3: Disable.** No additional noise reduction will be applied.

24. SIX DIFFERENT LOOKS WITH T6 STYLES

YOUR REBEL T6 lets you shoot with style… Picture Styles, that is. They are built-in settings that can tweak images as you take them in various ways, applying an amount of sharpness, degree of contrast, color richness, and the hue of skin tones. Picture Styles can be used with monochrome and black-and-white images, too; you can apply filters, or tone them with sepia, blue, purple, or green tone overlays.

The Canon Rebel T6 has six preset color Picture Styles, for Auto, Standard, Portrait, Landscape, Neutral, and Faithful pictures, and three user-definable settings called User Def. 1, User Def. 2, and User Def. 3, which you can define to apply to any sort of shooting situation you want, such as sports, architecture, or baby pictures. They are visible from the Picture Style entry in the Shooting 2 menu. See **Figure 24.1** for the

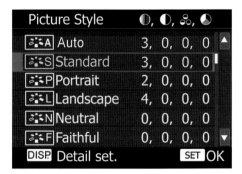

Figure 24.1 Ten different Picture Styles are available from this scrolling menu; these six, plus Monochrome and three User Def. styles not shown.

main Picture Style menu. (You have to scroll down on the camera to see all the styles.) Any of these styles can be applied *only* to JPEG images shot using the Creative Zone modes (P, Tv, Av, and M). Scene Intelligent Auto will use only the Standard Picture Style, and Creative Auto can access only Standard, Portrait, Landscape, and Monochrome modes (which I'll explain shortly). Scene modes also use Picture Styles, but they are pre-set and cannot be changed by the user.

While the six "canned" styles have pre-defined values, you can adjust their settings to your preference to give you more vivid colors, or soft, muted colors and less sharpness to create a romantic look. Perhaps you'd like a setting with extra contrast for shooting outdoors on hazy or cloudy days. The parameters applied when using Picture Styles follow.

- **Sharpness.** This parameter determines the apparent contrast between the outlines or edges in an image, which we perceive as image sharpness. You can adjust the sharpness of the image between values of 0 (no sharpening added) to 7 (dramatic additional sharpness). When adjusting sharpness, remember that more is not always a good thing. A little softness is necessary (and is introduced by a blurring "anti-alias" filter in front of the sensor) to reduce or eliminate the moiré effects that can result when details in your image form a pattern that is too close to the pattern, or frequency, of the sensor itself. The default levels of sharpening (which are,

for most Picture Styles, not 0) were chosen by Canon to allow most moiré interference to be safely blurred to invisibility, at the cost of a little sharpness. As you boost sharpness (either using a Picture Style or in your image editor), moiré can become a problem, plus, you may end up with those noxious "halos" that appear around the edges of images that have been oversharpened. Use this adjustment with care.

- **Contrast.** Use this control, with values from −4 (low contrast) to +4 (higher contrast), to change the number of middle tones between the deepest blacks and brightest whites. Low-contrast settings produce a flatter-looking photo, while high-contrast adjustments may improve the tonal rendition while possibly losing detail in the shadows or highlights.

- **Saturation.** This parameter, adjustable from −4 (low saturation) to +4 (high saturation) controls the richness of the color, making, say, a red tone appear to be deeper and fuller when you increase saturation, and tend more toward lighter, pinkish hues when you decrease saturation of the reds. Boosting the saturation too much can mean that detail may be lost in one or more of the color channels, producing what is called "clipping."

- **Color tone.** This adjustment has the most effect on skin tones, making them either redder (0 to −4) or yellower (0 to +4).

- **Filter effect (Monochrome only).** Filter effects do not add any color to a black-and-white image. Instead, they change the rendition of gray tones as if the picture were taken through a color filter. I'll explain this distinction more completely in the sidebar "Filters vs. Toning" later in this section.
- **Toning effect (Monochrome only).** Using toning effects preserves the monochrome tonal values in your image but adds a color overlay that gives the photo a sepia, blue, purple, or green cast.

The predefined Picture Styles are as follows:

- **Auto.** The camera adjusts the color tones automatically, producing vivid hues.
- **Standard.** This Picture Style applies a set of parameters, including boosted sharpness, that are useful for most picture taking, and which are applied automatically when using Basic Zone modes other than Portrait or Landscape.
- **Portrait.** This style boosts saturation for richer colors when shooting portraits, which is particularly beneficial for women and children, while reducing sharpness slightly to provide more flattering skin texture. The Basic Mode Portrait setting uses this Picture Style. You might prefer the Faithful style for portraits of men when you want a more rugged or masculine look, or when you want to emphasize character lines in the faces of older subjects of either gender.

- **Landscape.** This style increases the saturation of blues and greens and increases both color saturation and sharpness for more vivid landscape images. The Basic Zone Landscape mode uses this setting.
- **Neutral.** This Picture Style is a less-saturated and lower-contrast version of the Standard style. Use it when you want a more muted look to your images, or when the photos you are taking seem too bright and contrasty (say, at the beach on a sunny day).
- **Faithful.** The goal of this style is to render the colors of your image as accurately as possible, roughly in the same relationships as seen by the eye.
- **Monochrome.** Use this Picture Style to create black-and-white photos in the camera. If you're shooting JPEG only, the colors are gone forever. But if you're shooting RAW or JPEG+RAW, you can convert the RAW files to color as you import them into your image editor, even if you've shot using the Monochrome Picture Style. Your T6 displays the images in black-and-white on the screen during playback, but the colors are there in the RAW file for later retrieval.

Selecting Picture Styles

Canon makes selecting a Picture Style very easy. You can use the Picture Style entry in the Shooting 2 menu (shown earlier in **Figure 24.1**), but I recommend simply using the Quick Control screen instead. Press the Q button and navigate to the Picture Styles section (it's the left-most icon on the third row from the top), and press SET. Then use the cross keys to scroll through the list of available styles on the screen that appears, shown in **Figure 24.2**. The current settings for a particular style are shown when you've highlighted that style. Press SET to activate the style of your choice.

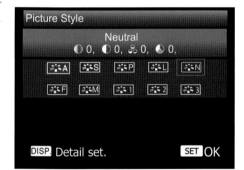

Figure 24.2 Choose Picture Style from the Quick Control menu to choose a style from this fast-access screen.

Suit Yourself

The current settings of the highlighted Picture Style are shown as numeric values on the menu screen, using uniform scales, with seven steps (from 1 to 7) for sharpness. Contrast and saturation (color richness) can be adjusted plus/minus four steps clustered around a zero (no change), so you can change from low contrast/low saturation, –4, to high contrast/high saturation, +4. The color tone scale ranges from –4/reddish to +4/yellowish. The individual icons at the top of **Figure 24.2** represent (left to right) Sharpness, Contrast, Saturation, and Color Tone.

You can change one of the existing Picture Styles or define your own when the Picture Style screen shown in **Figure 24.2** is visible. Press the DISP. button to produce the screen shown in **Figure 24.3** (for the standard styles) or **Figure 24.4** (for the Monochrome style). If you want to create your own style from scratch, you'll need to visit the Picture Styles entry in the Shooting 2 menu and scroll down to one of the three User Def styles shown in **Figure 24.5**. Follow these steps:

1 **Choose a style to modify.** Use the cross keys to scroll to the style you'd like to adjust.
2 **Activate adjustment mode.** Press the DISP. button to choose Detail Set. If you're coming from the Shooting 2 menu, as I noted, the screen that appears next will look like the one shown in **Figure 24.5** for the five color styles or three User Def. styles.
3 **Choose a parameter to change.** Use the cross keys to scroll among the four parameters, plus Default Set. at the bottom of the screen, which restores the values to the preset numbers.
4 **Activate changes.** Press SET to change the values of one of the four parameters.
5 **Adjust values.** Use the cross keys to move the triangle to the value you want to use. Note that the previous value remains on the scale, represented by a gray triangle. This makes it easy to return to the original setting if you want.
6 **Confirm changes.** Press the SET button to lock in that value, then press the MENU button three times to back out of the menu system.

Any Picture Style that has been changed from its defaults will be shown in the Picture Style menu with blue highlighting the altered parameter. You don't have to worry about changing a Picture Style and then forgetting that you've modified it. A quick glance at the Picture Style menu will show you which styles and parameters have been changed.

Making changes in the Monochrome Picture Style is slightly different, as the Saturation and Color Tone parameters are replaced with Filter Effect and Toning Effect options. (Keep in mind that once you've taken a photo using a Monochrome Picture Style, you can't convert the image back to full color.) You can choose from Yellow, Orange, Red, Green filters, or None, and specify Sepia, Blue, Purple, or Green toning, or None. You can still set the Sharpness and Contrast parameters that are available with the other Picture Styles.

Figure 24.3 Each parameter can be changed separately for the predefined styles.

Figure 24.4 Sharpness, contrast, filter effect, and toning effect can be set for the Monochrome style.

Figure 24.5 Adjusting the User Def styles must be done from the Picture Styles entry in the Shooting 2 menu.

FILTERS VS. TONING

Although some of the color choices overlap, you'll get very different looks when choosing between Filter Effects and Toning Effects. Filter Effects add no color to the monochrome image. Instead, they reproduce the look of black-and-white film that has been shot through a color filter. That is, Yellow will make the sky darker and the clouds will stand out more, whereas Orange makes the sky even darker and sunsets more full of detail. The Red filter produces the darkest sky of all and darkens green objects, such as leaves. Human skin may appear lighter than normal. The Green filter has the opposite effect on leaves, making them appear lighter in tone. **Figure 24.6**, left shows the same scene shot with no filter, then Yellow, Green, and Red filters.

The Sepia, Blue, Purple, and Green Toning Effects, on the other hand, all add a color cast to your monochrome image. Use these when you want an old-time look or a special effect, without bothering to recolor your shots in an image editor. **Figure 24.6**, right shows the various Toning Effects available.

Figure 24.6 Left: No filter (upper left); Yellow filter (upper right); Green filter (lower left); and Red filter (lower right). Right: Select from among four color filters in the Monochrome Picture Style, including Sepia (top left); Blue (top right); Purple (lower left); and Green (lower right).

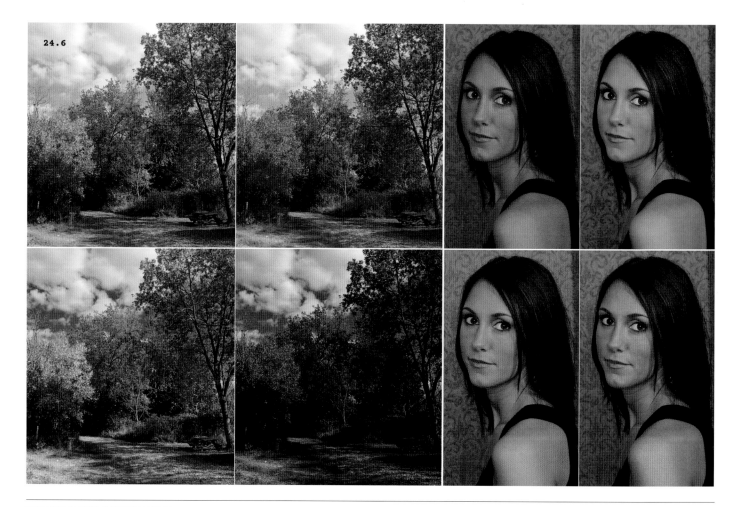

25. WAXING ARTISTIC WITH CREATIVE FILTERS

WHILE PICTURE STYLES are useful when you're *taking* a picture, the T6's Creative Filters feature lets you apply interesting effects to images you've already taken. You can process an image using one of these filters and save a copy alongside the original. Using Creative Filters has several advantages. You can apply them on the spot, without the need to import your picture into an image editor. That can be helpful when you're on vacation and want to spiff up a few images to e-mail to the folks back home. Even better, Creative Filters offer several effects that you can't easily achieve within an image editor, such as the Miniature Effect (which I'll explain shortly.)

One thing to keep in mind is that if you are shooting RAW (only) or RAW+JPEG the filter effect will be applied to the RAW image, but then saved as a JPEG file. Just follow these steps:

1 Navigate to the Playback 1 menu and choose Creative Filters. Press SET.
2 You can then select the image to process from the screen that pops up. You'll be taken to a screen that allows you to choose an image to modify. You can scroll through the available images with the cross keys or press the Reduce button to view thumbnails and select from those. Only images that can be edited are shown. Press SET.

3 Choose the filter you want to apply from a list at the bottom of the screen using the left/right cross keys. The available filters (Grainy B/W, Soft Focus, Fish-eye Effect, Toy Camera, and Miniature Effect) appear along the bottom. Press SET.
4 Use the left/right cross keys again to adjust the amount of the effect (or select the area to be adjusted using the miniature effect). The T6 will show you a preview of the filter effect you have selected. Choose SET once more to save your new image.

The five effects include the following. Four of them (Grainy B/W, Soft Focus, Fish-eye, and Toy Camera Effect) are shown in **Figure 25.1**.

- **Grainy B/W.** Creates a grainy monochrome image. You can adjust contrast among Low, Normal, and Strong settings.
- **Soft Focus.** Blur your image using Low, Normal, and Strong options.
- **Fish-eye Effect.** Creates a distorted, curved image.
- **Toy Camera Effect.** Darkens the corners of an image, much as a toy camera does, and adds a warm or cool tone (or none), as you wish.
- **Miniature Effect.** This is a clever effect, and it's hampered by a misleading name and the fact that its properties are hard to visualize (which is not a great attribute for a visual effect). This tool doesn't create a "miniature" picture, as you might expect. What it does is mimic tilt/shift lens effects that angle the lens off the axis of the sensor plane to drastically change the plane of focus, producing the sort of look you get when viewing some photographs of a diorama, or miniature scene. Confused yet? All you need to do is specify the area of the image that you want to remain sharp (see **Figure 25.2**, left) and you'll end up with a version like the one shown in **Figure 25.2**, right.

Figure 25.1 Grainy B/W (top left), Fish-eye (top right), Soft Focus (bottom left), Toy Camera Effect (bottom right).

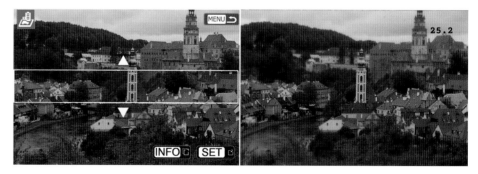

Figure 25.2 Specify the sharp area of your image (left). The resulting Miniature Effect image looks like a tiny town, perhaps for a toy train layout (right).

26. THREE ROUTES TO MORE COLORFUL IMAGES

EVERYONE LOVES COLORFUL images, and some very creative photographers have built entire careers on capturing images with full, vibrant colors. (If you want to be blown away by some awesome examples, Google Pete Turner, one of the very first masters of color photography.) While it's a fine line between rich, colorful images and garish, many subjects can come to life if you take the time to take one of these three routes to more vivid color.

- **Experiment with Picture Styles.** As I explained in **Lesson 24**, Picture Styles are an easy way to apply settings that improve the sharpness, contrast, saturation, and color tone of your images. As I described earlier, you can modify one of the T6's existing "canned" Picture Styles or create a User Def style that's all your own. For **Figure 26.1**, I took the Landscape style (which already has lots of saturation built-in to boost colors) and moved the Saturation slider all the way to the right (as described in the earlier lesson). I also dialed up the contrast a bit to further enhance the colors.

Figure 26.1 Using a Picture Style with boosted contrast and saturation can bring colors to life.

- **Choose colorful subjects.** One surefire way to get colorful images is to select a subject that already overflows with rich hues, such as the Native American dancer I photographed for **Figure 26.2**. His painstakingly constructed hand-made tribal attire was soaked in brilliant colors, and the high-contrast direct sun lighting brought them to life.

- **Tweak in an image editor.** The bird at top in **Figure 26.3** was illuminated by soft lighting under a shade tree. His colors were too good to resist, so I enhanced them in my image editors. I nudged the contrast of the image to make the image more vivid, then used the Vibrance setting found in most image editors. This tool increases the intensity of muted colors, while not touching those hues that are already fully saturated. That helps avoid a garish look. If Vibrance doesn't work, you can try the standard Saturation tool found in all image editors but use it carefully, so the enhanced colors don't become unrealistic. That sort of overkill can ruin a portrait by causing ghastly skin tones.

Figure 26.2 Colorful subjects can easily give you images that pop and command attention.

Figure 26.3 Use your image editor to enhance dull colors and create a lively, bright look.

27. GET HIGH—OR LOW

IN LESSON 14 I offered my Number One rule that beginning photographers need to learn as quickly as they can: *Don't shoot everything at eye level*. I presented one example captured by lying flat on the floor of an antique railroad passenger car. Don't fret if you're not willing to stoop to conquer your photographic challenges. I have some other tricks up my sleeve. Try out these simple techniques:

My Favorite Thing

You may smile at all the camera-phone photographers who walk around with selfie sticks—but they are actually onto something useful. That selfie stick not only allows them to shoot themselves while avoiding the opportunity to interact with another human being, the stick itself offers a way to shoot images from other vantage points.

I carry a lightweight tripod with me quite often, and sometimes don't even use it for its intended purpose. A tripod makes a perfect selfie-stick substitute. It was a dreary morning in Old Town Square in Prague (or *Staroměstské náměstí* in Praha if you want to sound like a seasoned traveler). The view from eye level was a bit boring, so I put my camera on a tripod (without unfolding the legs) and held it up a good six feet over my head. I used the self-timer to take the actual photograph seen in **Figure 27.1**. I had to take several to get a good one, because

Figure 27.1 Raising a tripod overhead allows capturing all Old Town Square in Prague without climbing the stairs of any of the buildings facing the "náměstí."

aiming the camera at tripod's length is hit or miss (and the T6 sadly does not have a tilting LCD for a live view capture at an angle).

I used the same trick in the vintage dining room of an historic building, raising the tripod overhead while standing at the room's entrance. It was actually the only way I could have captured all the wonderful furniture and artifacts seen in **Figure 27.2**.

How Low Can You Go?

Figure 27.3 pictures Église Sainte-Marie, in Church Point, Nova Scotia, one of the largest and tallest *wooden* buildings in all of North America. The spire rises more than 190 feet (roughly 18 stories tall). It was almost impossible to capture the imposing height of this structure using the widest lens I had, so I did the next best thing. I stood on the church steps, pointed my camera skyward, and shot this image.

Just Get High

Another solution is to simply look for higher vantage points. I wanted to photograph the interesting building seen in **Figure 27.4**, but the surrounding streets were too tightly packed together to allow photographing more than a small portion of the structure at one time. The solution was nearby. Shooting through a broken window provided a type of "framing" for my image. I decided to focus on the window frame itself instead of the building to add an air of mystery to my subject in the background, which is cloaked in mild blur.

Figure 27.2 The tripod trick works indoors, too.

Figure 27.3 Getting down low can provide you with an interesting vantage point for architectural photos.

Figure 27.4 Shooting through a window allowed framing the structure seen over the rooftop.

5

SEVEN GREAT CREATIVE OUTLETS

CHAPTER 5

At this point, you've mastered many of your camera's most useful features. Now you're ready to apply what you've learned while exploring some of those picture-taking occasions that inspired you to purchase your EOS Rebel T6 in the first place. Whether it's travel photography, stage shows presented by your favorite professional (or amateur) performers, or family group pictures, you'll find lots of ways to preserve memories with your versatile digital camera. This chapter offers tips on seven of the most popular creative opportunities.

28. PRESERVE TREASURED TRAVEL MEMORIES

ONE OF THE most enjoyable things about travel photography is the chance to try out photo techniques. You can capture new and exciting subjects in places you've never visited before or photograph favorite travel destinations from a new perspective. Each visit gives you the chance to capture the sights and activities in interesting ways.

Perhaps you'd like to try your hand at photographing interesting architecture and monuments you encounter. Maybe you'll want to delve deeply into people pictures as you capture candid images of interesting folk—whether they are local denizens or members of your travel party. Because you're relaxed, surrounded by compelling sights, sounds, and smells, and equipped with a digital camera, you'll want to photograph as many different types of subjects as possible.

You've seen lots of travel photography in your lifetime, so it's easy to fall into the trap of just duplicating the kinds of shots you've seen before. Did you travel thousands of miles just to photograph your family waving at the camera while standing in front of the Grand Canyon? Is it tempting to see just how much of that expansive vista you can cram into a single photograph? Are you photographing everything from eye level, reproducing the same view that millions of other tourists have captured with their cameras? Before we get started, perhaps you just need to be reminded of the most common travel photography traps that even the most avid photographer falls into at times.

- **Selfies.** Although selfies have emerged as a smartphone mania, travel photographers have been posing with themselves or members of their party with the Great Pyramid of Giza or Great Wall of China as a backdrop since before the advent of digital photography. Your T6 and a self-timer (or cooperative third party) can create superior selfies. But when you get home, you'll be more interested in showing friends and family where you've been rather than visual proof you were actually there. Take a few, if you must, but remember to concentrate on capturing the sights you traveled afar to visit. (See **Figure 28.1**.)

Figure 28.1 If you shoot only selfies, you'll miss some wonderful opportunities.

- **Standing too far away.** Most amateur travel photographers stand too far from their subjects when they take their photos or use a zoom setting that is too wide. That isn't so bad if the frame is at least filled with interesting subject matter, but all that extra view often goes to waste, as you can see in **Figure 28.2**. That image might make an acceptable "establishing" shot, except for the disconnected foliage that forms the picture's frame, but if it's the only photo you have of Prague Castle, you're missing the opportunity to showcase an amazing thousand-year-old architectural marvel. If you take a picture from too far away, you'll need to crop the image heavily to remove the extraneous area, wasting valuable pixels, and spending more time processing your pictures in an image editor than you need to. Move in close or use your zoom lens to frame a photo that portrays your subject from a reasonable distance.

- **Not varying your angles.** As I've noted earlier in this book, so many photos are taken from eye level, when a much better and more interesting vantage point can be gained from above or below your subject. Changing your shooting angle—from side to side or up and down—gives you an interesting perspective and a new take on subjects that have been photographed millions of times by thousands of tourists.
- **Overuse of flash.** Even dimly lit indoor scenes can be photographed successfully if you place your digital camera on a steady surface and use the self-timer to trip the shutter. Flash may be prohibited in most tourist sights, and its use when allowed is usually not a good idea. The light streaming in through windows has character and shows the interior as the visitor sees it. Electronic flash can spoil a photo's mood.

- **Shooting only horizontally oriented photos.** It's amazing how many people shoot only landscape-format travel pictures—even when they're not photographing landscapes! Some subjects (the Washington Monument comes to mind) almost force you to rotate the camera 90 degrees and snap a vertically oriented picture, but creative photographers go beyond the obvious and find vertical compositions everywhere.
- **Capturing sites without insight.** Ireland is more than the Cliffs of Moher; Rome is more than the Coliseum; Australia has more to see than the Sydney Opera House. Too many photographers concentrate on monuments and scenery and forget to capture the true spirit of the places they visit, which is likely to reside in the culture, foods, and the people themselves. Indeed, humans can be the most interesting and revealing subjects of your journey, so I am devoting the next section to people photography.

With the "don'ts" out of the way, it's time to look at the "do's" of travel photography with your Rebel T6. Keep these things in mind if you want to create unusual views of what may be familiar subjects.

Figure 28.2 Photos taken from too far away usually contain a lot of extraneous elements that detract from the image.

Populating Your Pictures with People

Even if you're not an avid photographer of people, travel provides an excellent opportunity to rekindle your interest in capturing folks in the act of being themselves. While human beings are basically the same everywhere, their cultures, habits, and appearance can vary enough to make the people in the places you visit new and exciting photographic subjects.

At times, including people in your photos may not be entirely voluntary. You might find that a landmark, such as the Great Pyramid of Giza, is literally crawling with visitors during your photo session. The base of the Eiffel Tower is cluttered with queues of sightseers and kiosks and, since mid-2018, has been ringed by an unsightly fence. If you *do* want a few pictures without humans, either visit a landmark at an unusual hour when there are fewer people around or use an imaginative angle to exclude tourists from your photo. Many of them will not only intrude on your photos but will be doing things like posing for clever pictures in which they seem to be pushing over la tour Eiffel or preventing the Leaning Tower of Pisa from tumbling to the ground.

Certainly, if you want to picture Mt. Fuji or Bryce Canyon or the St. Louis Gateway Arch in their pristine glory, first take a few pictures relatively uncluttered by human forms, if you like. But then try a few that include people. Avoid lining up members of your group or having an individual gawk or point at the landmark. Use your creativity to find a way to include a person in the photograph in a natural way. For example, showing someone overwhelmed by the sheer size of the Gateway Arch, shot from underneath the Arch and looking upward, could make a dramatic image.

Urban areas you'll encounter in your travels do have a special charm of their own and have fostered the genre called "street photography." The pace is more hurried, the ambiance a little grittier, and the variety of photo subjects almost infinite. You can spend a year photographing everything within a one-block area and still not exhaust all the possibilities. Smaller towns offer lots of photographic opportunities, too. Your travel shooting can draw on a cornucopia of possibilities.

The focus of street-life photography is often on the people, but there's a lot more to explore. Old buildings, monuments, storefront windows, or kiosks packed with things for sale all present interesting photographic fodder. Or you can concentrate on the streets themselves, the bustle of traffic and pedestrians, or whistle-blowing bicycle messengers. The animals that populate the streets, including stray dogs, voracious

28.3

Figure 28.3 Two views of the Mont des Arts in Brussels.

pigeons, and darting squirrels are worthy of photographic study. Take refuge in the peace of an urban park and capture the contradictions of an island of natural beauty hemmed in by tall buildings.

The view from Mont des Arts in the center of Brussels, Belgium, is one of the most photographed in the city, and virtually the same image as the one at left in **Figure 28.3** can be seen on countless postcards and tourist guide books. However, even with crowds of people enjoying the lush garden, the scene can appear sterile and formal. Add the combination busker and salesman shown at right in the figure, and the image becomes more human and interesting. A donation of a euro or two made both the performer and picture-snapping visitor happy. The talented musician I found in in Ravenna, Italy (which I believe was named after my home town in Ohio) didn't care whether he was being paid to play or pose for **Figure 28.4**.

Figure 28.4 A talented musician in Ravenna, Italy.

One key to successful people photography is to blend in. One of my favorite cities in the world is Toledo, Spain, and over the years I've spent a total of more than three months in the UNESCO World Heritage site. I always spend a few afternoons and evenings in Plaza Zocodover, where I take a seat at the low wall that partially encloses the roughly triangular "square." Surrounded by hundreds of locals going about their business or enjoying their evening *paseo*, as well as gawking visitors, I blend right in and nobody notices, or minds, my picture taking. Whether you're scoping out a public square in the United States or a foreign country, you'll find endless photo opportunities. You don't need exotic locations to get great pictures.

You don't need any special equipment: your Rebel T6 is a perfect tool (especially for blending in: you'll probably encounter other Canon shooters as you work). Your kit lens has enough range to shoot wide-angle views, as well as tighter images of your fellows, and you can use other lenses if you have them. I put a wide-angle lens to work to capture **Figure 28.5**, which shows the Zoco *de noche*. While the plaza is well-lit enough to shoot hand-held with a sensitivity setting of ISO 1600, in this case I mounted my camera on a tripod, because I wanted to use a small f/16 aperture. You'll find that using the smallest possible f/stop when there are bright street lamps or other small sources of illumination in the frame, you'll get a multi-pointed star effect—without the need for a star filter!

Of course, photographing people on the streets as you travel has become more complex in the 21st century. Security concerns have tightened restrictions on photography around certain buildings, including most government installations. Paparazzi have given impromptu

Figure 28.5 A small f/stop creates a star-effect in nighttime scenes.

people photography something of a sour reputation as an intrusive invasion of privacy. In parts of some cities, a few denizens may be engaging in activity that they don't want photographed. If you want to be successful on the streets, here are some guidelines:

- **Tell a story.** Some of the best photos of street life are photojournalist-style images that tell a story about the people and their activities in the urban area you picture. Taking the time to shoot in one location for a lengthy period can help you use your photographs to tell a story. During one day in Plaza Zocodover, I spotted the couple shown in **Figure 28.6** get their exercise by walking around the perimeter of the plaza multiple times (the better to be seen and to encounter their friends) before strolling off on a side street to their final destination. Their relationship added a moving tale to my travel photography.

- **Ask permission to shoot people on the street.** You don't need to walk up to every photo subject and say, "Hi, I'm a photographer. May I take your picture?" A simple quizzical nod and a gesture with your camera will alert your subject that you'd like to snap a photo. If you're met with a smile or ignored, go right ahead and shoot. Should your victim turn away from you, glare, or flash a finger salute, that's your signal to back off. Members of some cultures—even in the United States—don't like to be photographed. In a few countries, it may even be illegal to photograph police or soldiers, and there are other sensitivities you may encounter.

Figure 28.6 Every picture tells a story.

- **Show people at work.** You might be tempted to photograph members of your traveling party, and perhaps a few interestingly garbed local folks. I've found that some of the most rewarding pictures I've taken were simply of people at their jobs, such as the metal-worker and store owner shown in **Figure 28.7**, or the artist in the Plaza Mayor of Madrid, painting his latest masterpiece (see **Figure 28.8**.)

Figure 28.7 Capture people at their jobs.

Figure 28.8 A painter creating a work of art.

- **Leverage your personality.** Recognize that photographers, including yourself, fall into one of several different personality types. Some people approach street photography more tentatively or tend to blend into the background. That's a useful approach, because you don't become part of the "story" you're trying to tell. Other folks have an outgoing way that lets them photograph people aggressively without offending or alarming their subjects. Some photojournalists operate in that mode. I was in Bergamo, Italy, during a G7 agricultural summit, complete with visiting dignitaries and brass marching bands, and shifted into full photojournalism mode to capture the excitement. My pictures included the stern fellow policing the streets (**Figure 28.9, left**) as well as a television reporter interviewing one of the participants (**Figure 28.9, right**).

Figure 28.9 Even amateur photographers can shoot like a photojournalist.

- **Never photograph children without asking the adult they are with.** If the child is unaccompanied, look for another subject. Granted, you'll miss some cute kid shots, but the chance of being mistaken for a bad person is too much to risk. The only possible exception to this rule might be if you are a female photographer, preferably accompanied by children of your own.
- **Don't act in a suspicious way.** Photographing with a long lens from a parked car is a good way to attract unwanted attention to yourself. In fact, any kind of furtive photography is likely to ensure that your street-shooting session is a short one.
- **Travel light.** When working in cities, you'll be on foot much of the time, scooting between locations by bus or taxi. You won't want to be lugging every lens and accessory around with you. Decide in advance what sort of pictures you're looking for and take only your digital camera and a few suitable lenses and accessories.
- **Cities are busy places: Incorporate that into your pictures.** Don't be afraid to use blur to emphasize the frenetic pace of urban life. Slower shutter speeds and a camera mounted on a monopod can yield interesting photos in which the buildings are sharp, but pedestrians and traffic all have an element of movement.
- **Learn to use your wide-angle settings.** The tight confines of crowded streets probably mean you'll be using wide-angle lenses a lot. Experiment with ways to avoid perspective distortion, such as shooting from eye level, or exaggerate it by using low or high angles.

Four Sure-Fire Travel Techniques

I'll finish this lesson with some sure-fire tips you can use to spice up your travel photography.

- **Concentrate on details.** The "big picture" is easy to capture while traveling, and usually involves the most common sights and monuments. If you want your travel photos to be especially interesting, zoom in on some detail that hasn't been photographed by a thousand other tourists. In a town like Milan, Italy, where residents rely heavily on motorcycles and scooters, a shot of a line of saddles (**Figure 28.10**, left) can be symbolic. Or, a detail like the votive candles I discovered in Bucharest, Romania, sums up the religious history of the city quite well. (**Figure 28.10**, right.)

- **Use Reflections.** The Lincoln Memorial or Washington Monument seen mirrored by the Reflecting Pool on the Mall in Washington, D.C., are almost clichés of their own. But you can try for a different angle—perhaps higher or lower than customary—to put your own stamp on an image, even of well-known reflected landmarks such as the Taj Mahal. You might find pools of water near other monuments, too, which can be used to create an unusual look. (See **Figure 28.11**.)

Figure 28.10 Details as simple as motorcycle saddles (left) or votive candles (right) can tell a story of their own.

Figure 28.11 The canals of Bruges, Belgium, provide an opportunity to put interesting reflections to work.

- **Choose your angles.** Often, it's smart to get extra close, or farther away, or send your gaze skyward. You'll often find well-worn paths and bare spots at the locations favored for photographing popular landmarks. Some even have helpful "Picture Spot" signs to make sure you don't miss the traditional vantage point. That should be your cue to get closer or farther away, and to zoom in or out with a longer telephoto or shorter wide-angle lens. Or, if you're trying to get a different look at Galleria Vittorio Emanuele II in Milan, use your widest lens or zoom setting and point your camera upward. (See **Figure 28.12**.)

Figure 28.12 Cast your gaze skyward for an unusual angle.

- **Create a Panorama.** If you enjoy working in an image editor, try taking three or four shots of a single landmark, starting a little to the left of the landmark and overlapping your photo a little each time. Then assemble all your photos into a panorama to provide a broader view of a familiar subject. A simpler alternative is to simply back enough to get a wide view of your subject, and crop it into a narrow, panoramic strip like the one shown in **Figure 28.13**.

Figure 28.13 You can hone your image-editing skills assembling your own panorama images.

29. CAPTURE THE EXCITEMENT OF CONCERTS AND PERFORMANCES

YOUR PHOTOS MAY not make the cover of *Rolling Stone*, but your Rebel T6 is fully capable of capturing the pulse of rock, the power of classical music, and the excitement of theater or dance performances in photographs. In one sense, concert and performance photography is a type of photojournalism. The goal is to capture a moment or series of moments and tell a story. The keys are getting close enough, and then using the right techniques to create a photo of the performer that you can be proud of. Even if you're shooting one of your kids in a middle-school production of *The Three Musketeers*, the objective is the same.

Getting close enough to the action is probably the only difficult part of concert and performance photography. Local bands and school productions are usually a piece of cake. Indeed, if you have a camera like the T6 and know how to use it, you may find yourself pressed into service as the "official" photographer for many events. If you have a hankering to shoot nationally touring acts and professional productions, you may need a little help. Here are some tips:

- **Volunteer your time.** As a parent or interested bystander, you may find that you've been "volunteered." If not, offering to help out can be your key to up close and personal access to shooting on-stage performances. One folk music venue in my area—which hosts Grammy-winning acts several times a month—has a staff that is mostly volunteers. I help out there with my photography to gain

better access at shows. One local dance troupe also makes use of unpaid help. By agreeing to set up a studio in their practice space and shoot images for their brochures, I was able to capture some excellent posed images, like the ones shown in **Figure 29.1**, with the bonus of a professional choreographer on hand to direct the shoot.

29.1

Figure 29.1 Volunteer your time to shoot publicity shots for local performers.

- **Attend dress rehearsals and sound checks.** For plays, dances, concerts, and other types of performances, you may be able to gain access to a dress rehearsal or sound check. It's important not to disturb the practice/tune-up session. By staying out of the line of sight of the choreographer or director, you can usually shoot to your heart's content from some of the choice seats stage right or left. I've photographed many dress rehearsals of a nationally respected professional dance company in Cleveland.

- **Look for side projects/nostalgia tours in small venues.** It's unlikely you'll be able to shoot any arena acts in your local stadium, but multiple Rock & Roll Hall of Fame members have brought their side projects to a 600-seat theater in Kent, Ohio, where I have a regular aisle seat in Row 2. To date, I am one of the few to have heard the song "Ohio" (which deals with the May 4, 1970 student shootings at Kent State University), sung in Kent in separate performances by Crosby, Stills, *and* Nash (but *not* yet by Neil Young, who is only the guy who wrote the tune). (See **Figure 29.2**.)

Nostalgia tours are great for those old enough to have developed a solid hankering for the Good Old Days. Dave Mason, shown in a black-and-white capture in **Figure 29.3**, survived playing in Traffic, accompanied Jimi Hendrix on guitar for the recording of *All Along the Watchtower,* and says he could live quite well from the royalties off Joe Cocker's version of his *Feelin' Alright.* Yet, I was able to photograph him from eight feet away as he toured small venues recently.

Figure 29.2 Rock legend David Crosby visited Kent, Ohio, to play "Ohio."

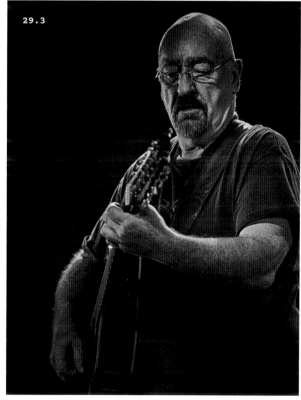

Figure 29.3 I used the Monochrome style to shoot Rock Hall member Dave Mason.

- **Shoot up-and-coming bands.** I have no way of knowing whether the Cleveland band featuring electrifying songstress Jackie La-Ponza will make it big nationally, but that doesn't make the band any less exciting to shoot, as you can see in **Figure 29.4**. And if local talent does score on the national scene, you'll have some photos to really brag about.

- **Photograph tribute bands.** It's about 50 years too late to be photographing the Beatles but cover and tribute bands with look-alike personalities and sound-alike repertoires are plentiful. Select the right angles, and your pictures could—almost—be the real thing. Indeed, Tim Owens, a singer who grew up six miles from me, ended up transferring directly from frontman for local tribute band British Steel to replace Rob Halford in Judas Priest. You never know.

- **Take pictures for charity.** Last summer, I was lucky enough to be the "official" photographer for Rock United, a fundraiser for United Way of Cleveland, which gave me "all access" (and free admission!) in exchange for some photographs supplied on DVD to the sponsors. Community service is a great way to get up close for the best pictures.

- **Explore genres.** I started out photographing rock and blues bands, because that's the type of music I played as a failed musician. I *liked* other types of music, but it was really a revelation when I began photographing folk artists like Loudon Wainwright III, Western/swing bands like Riders in the Sky and Asleep at the Wheel, and bluegrass artists like Ralph Stanley and the Gibson Brothers. After photographing blues legend James Cotton and Celtic virtuosos Enter the Haggis in the same month, I discovered that "alternate" acts were just as interesting to photograph. You can expand your musical and photographic horizons simultaneously.

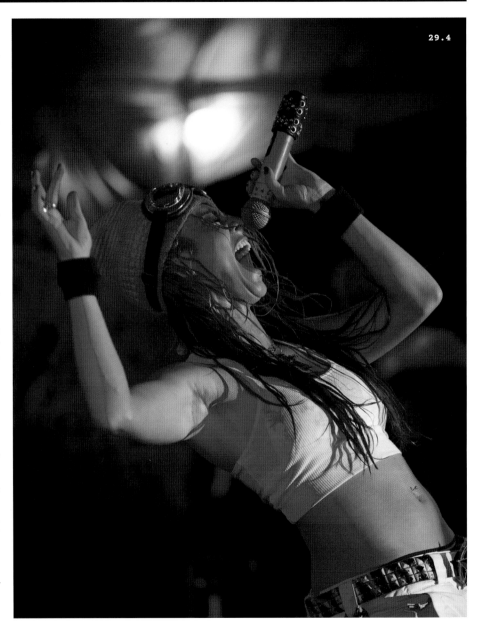

Figure 29.4 Local performers can be as exciting as national bands.

Arming for Battle

I am fond of reassuring aspiring photographers that you can take almost any picture with almost any camera. Your Rebel T6 will do a good job, assuming you can get close enough to the stage, using the tips I provided above. Additional lenses and a few accessories (such as an optional monopod) can make grabbing the picture you want somewhat easier and more convenient. But, in all cases, the most important tools you have are your T6, your feet, and your brain. Maneuver yourself into the right spot and shoot creatively, and you'll end up with a winning photograph regardless of what equipment you have available.

That said, this section will list some of those "conveniences" that particularly lend themselves to photography of concerts and performances. Don't fret if you're missing some of these: you still have your feet and brain to rely on.

- **A faster or longer lens.** Your 18-55mm kit lens will work for performances, such as plays or dances, where you can stand back and shoot the entire stage. At many musical performances (especially those where the audience is dancing in the aisles), you can get right up to the stage and shoot individual performers with your zoom set to 55mm. But, as you'll recall, the kit lens has an f/5.6 maximum aperture at 55mm. A stage that is spot lit will still be bright enough that you can get good pictures at 1/125th second at f/8. However, colored gels over the lights (used to set a mood) will cut down on the amount of illumination drastically. In that case, an accessory lens (as explained in **Lesson 43**) can come to your rescue. A relatively inexpensive 50mm f/1.8 lens (about $125) gives you three extra stops of exposure. That is, when illumination is dim, you can shoot at 1/125th at f/1.8 rather than 1/15th second at f/5.6. (Big difference!)

If you can afford to spend around $350, Canon's 85mm f/1.8 USM medium telephoto lens will give you both a wider aperture and a little more telephoto reach from your shooting position. My favorite concert lens is a 70-200mm optic, and you can find them used for as little as $400.

- **Low-light performance.** Most stages are illuminated by spots and other lights, so you can usually get by with ISO settings of ISO 800 to ISO 1600. Those are well within the *relatively* "low noise" performance range of your T6, particularly since a little visual noise in a concert or performance photograph is not usually very objectionable. Noise tends to show up worst in backgrounds, and, in stage performances, the backgrounds are dimly lit, either masking the noise or making it easy to remove with noise reduction or simple blurring techniques in your image editor.

- **Image stabilization or a monopod.** At one time, I photographed many concerts using a monopod. You'll find that a monopod (as opposed to a tripod) can be used without interfering with the other paying customers' enjoyment of the performance, as long as you don't sling it around like a weapon. (And the venue allows you to use one.) More recently, I've left the monopod at home and relied on image stabilization. The bulk of my concert photos are taken at 1/180th second at f/4 and ISO 3200. I can slow down the shutter to 1/60th to 1/15th or even a full second if I want to incorporate subject motion in my shot, as with my shot of James Cotton (see **Figure 29.5**). But, even if you want to allow the subject to blur, it's generally a good idea for the camera itself to be steady, so everything else in the shot is sharp and clear. Either a monopod or image stabilization will provide the steadiness you need.

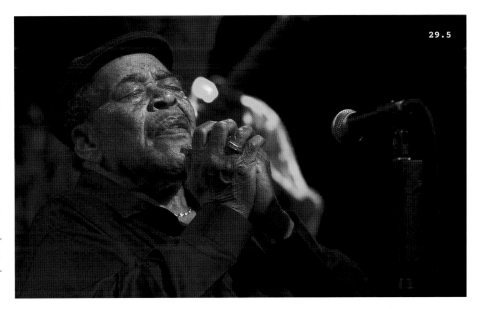

Figure 29.5 Image stabilization and a shutter speed of 1/30th second let me capture blues harp legend James Cotton.

Location, location, location is important in fields other than real estate. Even if you've got a good seat, if you're free to move around, you'll want to do so. Otherwise, every shot you take will have the same point of view. I like to shoot the first half of a concert from my second-row aisle seat (in my favorite venue, the rows are staggered so there is no one in front of me in the first row). I can shoot most members of the band from this position (except, usually, for the drummer), study how they work, and plan how I'll be shooting when I do get up and roam. It's usually pretty easy to move to the side of the stage to shoot images like the one shown in **Figure 29.6**. You'll find that the more you move around, the better the variety in your photographs.

Techniques

I'm going to finish off this lesson with a compendium of a few of my favorite techniques for photographing performances. This is one type of photography where creativity is given a premium, and there is no penalty for going over the top. The most extreme techniques you can dream up just might be the ones that make it to the cover of a CD or end up gracing a poster.

- **Selective focus to blur surroundings.** Indoors on stages, you'll rarely have to worry about backgrounds. Outdoors, especially at festivals, you'll find lots of distractions that can intrude on your photo. Bad backgrounds can be especially detrimental when you've got a musician performing while some gawker behind them sucks down a cotton candy. As I explained in **Lesson 11**, selective focus can be an interesting creative technique as well, as you can see in **Figure 29.7**. For this picture, I used a large aperture to blur everything around the euphonium player I was focusing on.

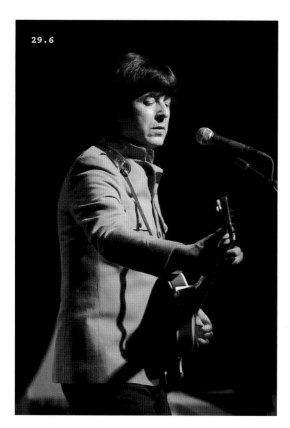

Figure 29.6 Tribute bands can allow you to live out your Beatlemania fantasy.

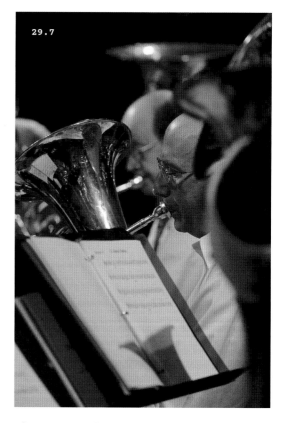

Figure 29.7 Blur the background—or foreground—to reduce distractions.

- **Continuous shooting secrets.** I explained the use of continuous shooting in **Lesson 4**. I especially love shooting bursts at performances for several reasons. First, I've found that, even with image stabilization and an acceptably fast shutter speed, some camera blur still creeps in. That's often the case when I swivel the camera to reframe slightly or am less than gentle when I press the shutter release. With the camera set on 3 fps burst mode, I often find that one of the *center* pictures is the sharpest, because it's captured after the initial movement has subsided. Continuous shooting also captures a variety of different shots of performers who are playing their instruments quite rapidly.

- **Telephoto compression.** A long lens can be used to compress the distance between objects in the frame, as was the case with **Figure 29.8**. Drummers, who generally sit at the back of the stage, are notoriously hard to photograph anyway (unless they're seated on a raised platform). So, a long lens and a bit of compression caused by a telephoto focal length can give you a special shot.
- **Use framing.** Carefully composing your image so that one subject is framed by another is an effective technique for isolating and featuring an individual, as I did for the drummer in **Figure 29.8**.

- **Grainy image? No problem!** I tend to shy away from recommending image editors to fix problems that should have been corrected in the camera, but I am willing to make exceptions for concert photography. Rock music, in particular, has a long history of special effects, dating back to Frank Zappa's signature solarized photo on the cover of his 1966 album *Freak Out!* So, faced with excess grain in my photo of John Popper of Blues Traveler, I rescued the image by applying a bit of gritty posterization for **Figure 29.9**.

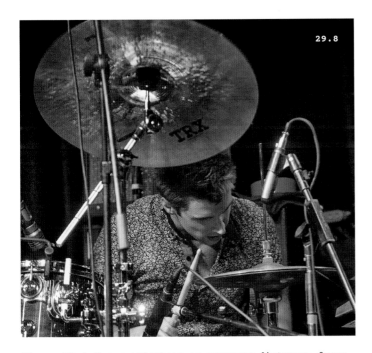

Figure 29.8 Use a telephoto to compress distance; frame to feature an individual performer.

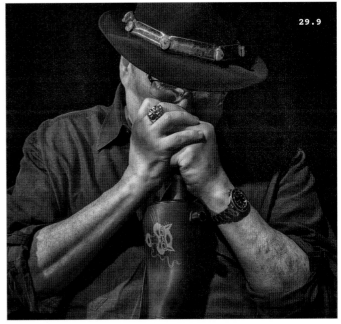

Figure 29.9 A little touch-up in your image editor can disguise grain or other problems.

- **Mood lighting.** A recent show I shot with Todd Rundgren featured constant backlighting, lasers, and smoke. Again, no problem! The weird colors are part of the mood of the performance, so I shot what I saw and didn't worry about making color or exposure corrections. (See **Figure 29.10**.)

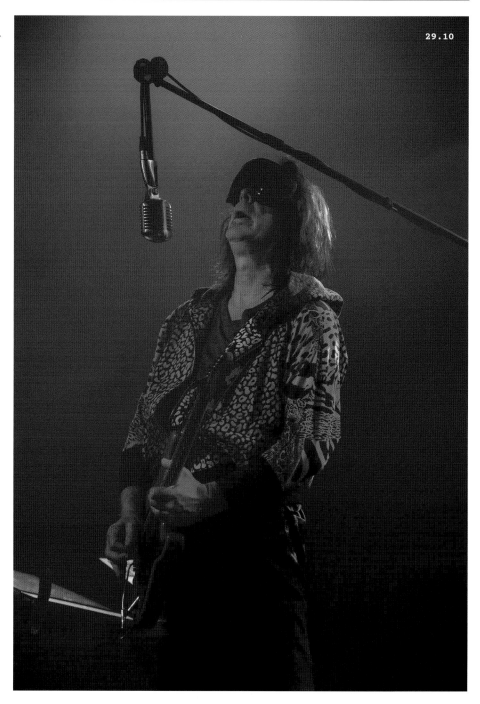

29.10

Figure 29.10 Stage lighting adds to the mood.

30. CELEBRATING MEMORABLE EVENTS AND FESTIVITIES

SPECIAL EVENTS ARE activities of limited duration where there are a lot of people and lots of things going on. They include county fairs, parades, festivals like Mardi Gras or Carnivale, as well as weddings (who hasn't traveled cross-country to attend a nuptial?), Civil War reenactments, car shows, and many other celebrations. They may last a few hours, a full day, or as much as a week. Anywhere you travel, you're likely to encounter some sort of festival or event. In the United States alone you can travel across the country all summer doing nothing but visiting county fairs. Overseas, you discover that each small town or village probably has its own special day to celebrate a local hero or religious figure, and entire countries or regions have holidays with an amazing variety of photo opportunities.

Whether it's the Fourth of July or Oktoberfest, you'll find lots of things to shoot at these events, usually with a lot of color, and all involving groups and individuals having fun. If you want your creativity sparked by a variety of situations, taking your Rebel T6 to an event as a spectator or participant is a good place to start.

It sometimes helps to think of an event as an unfolding story that you can capture in photographs. War re-enactments, like the Civil War and World War II events shown in **Figure 30.1**, often stage historically (semi) accurate battles, giving you the opportunity to record soldiers in their encampments, preparing for the conflict, and then engaging with the enemy. With a little planning, you can tell a story with an interesting

beginning, an absorbing middle, and a dramatic climax. Take photos that embody the theme of the event, including overall photographs that show the venue and its setting. Grab shots of the broad scope, the number of people in attendance, and the environment where the event takes place. Then zero in on little details, such as individuals enjoying moments, booths at an

amusement park, a dignitary giving a speech, or an awards ceremony. Tell a story that transports the viewer to the event.

Indeed, planning is essential for lining up and capturing the best shots. You can scout parade routes in advance or prepare to shoot fireworks well ahead of the first burst. Events like Renaissance fairs or festivals usually have

Figure 30.1 Re-enactments of Civil War (left) or World War II (right) engagements can provide a cornucopia of picture possibilities.

a schedule of events you can work from, which can usually be obtained by writing for one in advance or by visiting the organizer's website. A program lets you spot scheduling conflicts and separate the must-see events from those you'll catch if you have time.

Don't overlook some great chances for behind-the-scenes photographs. As thrilling as Civil War reenactments at the actual battle sites are, the re-enactors often set up authentic camping sites for themselves and their families, with 19th-century sleeping and cooking equipment. Hot air balloon ascensions have become part of many different holiday celebrations, and while the actual liftoffs are exciting, there's plenty to photograph of the aeronauts preparing their balloons for flight.

Public events not only serve as photo opportunities but give us a chance to document our life and times in a way that will be interesting in years to come. For example, popular music concerts today are quite different from those staged during the late 1960s. Customs and fashions at weddings change over the years. Clothing worn even just 25 years ago can seem exotic or retro today. Give some consideration to photos that are interesting today, as well as those you'll take for posterity.

Here are some general tips for shooting events, some of which I've covered in other lessons, but which can be especially applied to event and festival photography:

- **Pack light to increase your mobility.** Your Rebel T6 and kit lens may be all you need. However, if you've purchased lenses or other accessories, consider toting an add-on or two to increase your versatility. Take along a lens with a wider field of view than the kit lens's 18mm setting, to capture overall scenes and medium shots in close quarters, and, if possible, a short telephoto for more intimate photos or for capturing

jousts or other active subjects. At festival concerts, for example, you'll want a longer telephoto to shoot the action on stage and probably a monopod to steady your hand for longer exposures in low light. If flash is permitted, you might want a higher-powered external unit to extend your shooting range.

- **Get there early.** Although security is tight at some events, particularly festivals that have big-name acts (even if you have a backstage pass), shows and events at smaller venues with less-well-known participants can be more photographer-friendly, particularly if you arrive early and are able to chat as equipment is unloaded and being set up. (Don't get in the way!) At other kinds of events, getting there early lets you scout the area and capture some interesting photos of floats or exhibits as they are prepped.

- **Most events look best photographed from a variety of angles.** Don't spend the whole performance planted in one place, or right at street level for a parade, or around the barbeque grill at a festival cookout. Roam around. Shoot from higher vantage points and from down low. Use both wide-angle and telephoto lenses. The world's largest conclave of twins, triplets, and other multiples takes place each August in Twinsburg, Ohio (natch), and while there is a parade, talent show, and other schedule of events, I've found the best photographs result from simply roaming around the festival grounds and shooting candid photos of the participants. (See **Figure 30.2**.)

Figure 30.2 Candid photos showing participants having a good time are priceless.

- **Ask for permission before photographing adults or children who aren't performing.** As I've noted before, sometimes a gesture or a nod will be all you need to do to gain the confidence of an adult. It's always best to explicitly ask for permission from a parent or guardian before photographing a child.
- **For outdoor events, plan for changing light conditions.** Bright sunlight at high noon calls for positioning yourself to avoid glare and squinting visitors. Late afternoon through sunset is a great time for more dramatic photos. Night pictures can be interesting, too, if you bring a tripod or monopod, or can use flash.
- **Seek out bright colors and vivid contrasts.** Festivals are a time for dress-up and costumes. You can usually find some colorfully garbed participants and performers who will eagerly pose for pictures that really pop. The female jester shown in **Figure 30.3** and her dog were wonderful subjects for an impromptu portrait. I used a custom Picture Style (as explained in **Lesson 24**) and popped up my camera's built-in flash (check out **Lesson 32**) to fill in the dark shadows on her face.

Figure 30.3 Bright colors and imaginative costumes make compelling images.

The techniques and opportunities at events and festivals vary, depending on the type of event. So here are some event-specific tips you can put to work:

- **Balloon ascensions.** Check the weather before you go. Hot-air balloons are grounded in bad weather or even when there are significant wind gusts. You may be allowed to join the crews on the field as they prepare their craft for launch, giving you the opportunity to shoot up through the skirt of the balloon as the propane burners emit flame to heat the air that fills the envelope. At night, you may have the opportunity to shoot "glows," in which the tethered balloons are illuminated in a spectacular way. At many festivals, the skies will be filled with hot-air balloons as they all launch, so your T6 and kit lens will be fine. You might want to take to the road to follow a few to get more shots of the balloons passing over the surrounding countryside. (See **Figure 30.4**.)

- **Car shows.** These get-togethers are more than a chance to see and photograph beautiful vehicles. If you love cars, you'll be able to chat with the owners, most of whom have spent long hours and much money restoring or customizing their vehicles to show condition. Generally, the owners will be present alongside the car (on ensconced in a comfortable lawn chair) and eager to talk about their pride and joy. (They'll take frequent breaks to go admire other vehicles on display.) The cars themselves present several challenges for the photographer. First, it can be tricky to photograph the vehicle itself (as seen in **Figure 30.5**) because the best cars are usually surrounded by adoring auto fans, have their hoods up to show off pristine engines, and probably have at least a few cardboard placards describing the vehicle. There may be a "look but don't' touch" policy in effect, because one show-goer's "touchy-feely" is a "bangy-scratchy" to many a car owner. A friendly chat will often convince the auto's owner to make some adjustments (such as closing the hood) that will allow you better pictures. You can promise to share some of the photos you take to elicit even more cooperation, but it's a safe bet that proud owners are already photographing their cars often. Wide-angle lenses and settings are your best bet, because the vehicles are usually parked close together (and you may have little room to back up for a better view of the front end).

Figure 30.4 Hot air balloons can be shot from the launch field, or anywhere along their airborne route.

Figure 30.5 Make friends with the vehicle owners and they'll make adjustments (such as closing the car's hood) so you can take better pictures.

- **Air shows.** Summer and fall are prime times for traveling air shows. They can range from major events showcasing specialty acts and military aviators like the Air Force Blue Angels or Army Golden Knights, to smaller productions featuring restored vintage aircraft. All are held at airports, many with wonderful locations (like Burke Lakefront Airport on the shores of Lake Erie in Cleveland). There are usually prime locations to view and shoot the festivities (the airport equivalent of front-row 50-yard line), but great shots can also be captured from peripheral sites as the aircraft swoop by. Use panning techniques (as described in **Lesson 13**) to follow the action and you can usually get away with shutter speeds as slow as 1/125th to 1/250th second. A lens longer than your kit lens's 55mm maximum zoom can help you get closer to the action, but you'll find that there are many low passes over the runway and performances of barnstorming planes that can be captured without the need of a really long telephoto. (See **Figure 30.6**.)

- **County fairs and amusement parks.** I showed you how to shoot amusement park rides at night in **Lesson 13**, but there are lots of other things to grab your attention at county fairs and amusement parks. Animal displays, demolition derbies, concert performances, craft booths, and food stands all make good subjects. I like photographing the mobile food vendors at night, because they are usually festooned with colorful neon signs designed to attract hungry fair-goers.

Figure 30.6 Much air show action takes place at fairly low altitudes, as these planes soar scarcely 100 feet above the tarmac.

- **Fireworks.** You'll almost always need a tripod to shoot fireworks, because the best shots will be of one second or longer in duration. You'll find plenty of opportunities to try your hand at shooting pyrotechnics each summer, because they are often featured after baseball games and other major events (and not just clustered around the Fourth of July). Arrive at the venue long before dusk so you can camp out in a good spot and have time to set up your T6 and tripod while there is still daylight. The display will be overhead if you're close enough, so you won't have to worry about intervening trees or other obstacles. In the old days, I would have recommended taking along a small flashlight, so you could see and adjust your camera's controls. These days, however, you can easily just resort to the flashlight app on your smart phone.

You can use a wired cable release, such as the Canon Remote Switch RS-60E3 described in **Lesson 23**. However, if you're careful not to jar the camera, you can also trip the shutter at the appropriate time by gently pressing the shutter release.

Start out with an exposure of one or two seconds at f/8 or f/11 (the fireworks are very bright) and trigger the shutter a beat or two after you see the rocket's red glare as the missiles launch skyward. Review your images on the T6's LCD screen. You can increase the exposure time to three or four seconds if the pace of the display is such that you think the longer exposure will let you capture more bursts in a single photograph, as I did with **Figure 30.7**.

30.7

Figure 30.7 With the camera mounted on a tripod, an exposure of a second or two can capture multiple bursts.

31. EASY TECHNIQUES FOR ENDEARING PHOTOS OF KIDS

KIDS SEEM TO enjoy being photographed, perhaps even more than the grown-ups. The first — and best — advice for child photography is to take lots of pictures, many more than you think you'll need, and as often as possible. Years later, you may find that a casual shot you didn't think much of at the time is one of your favorites. Photography of your *own* children and grandchildren is always a joy, but taking pictures of these same kids that everyone will enjoy is more of a challenge.

Children are never too young for photography, although capturing a newborn or infant in a happy mood may be tricky, and those too young to sit by themselves unaided may need some support, as you can see in **Figure 31.1**. Many kids are natural hams, but especially rambunctious when experiencing new places, say, on vacation or during a trip to an amusement park. Others are painfully shy and become even more withdrawn in unfamiliar surroundings. If you want to get photos of younger children that involve something more interesting than mugging for the camera, make your shooting sessions something special. Let them participate in planning the shot. Children are always easier to photograph if you get them involved in the photographic process. Making the session a game or even letting them take a few pictures of you can be a good way of breaking the ice. After a few shots, let them look at the pictures that have been taken on your Rebel T6's LCD monitor. You'll find them much more cooperative and enthusiastic.

Figure 31.1 Children are never too young to have their picture taken!

You don't need to be a parent to work with children—although it helps. Here are some techniques that can make children more comfortable:

- **Favorite clothing.** While it's tempting to have the kids wear new clothes for a photo session, they'll be more relaxed and unconfined for your photos if they wear favorite outfits that are clean and attractive, but not stiff and new. If the child needs a haircut, schedule it week before, if possible. Then when you set up your shoot, a good combing or brushing and well-scrubbed face helps the child look his or her best. Mom, dad, or grandparents should be spiffed up, too, because the whole family will want to get in a few shots.

- **Take your photos in fun spots.** Most areas will have a park or playground that can serve as a good backdrop for pictures of the kids. Or use a historic building as your setting, letting the children explore the steps or interesting nooks and crannies before you shoot. Better yet, capture the kid having a good time. The young lady in **Figure 31.2** didn't even know she was being photographed.

- **Have some props available for the child to hold for a few pictures.** The kids probably have a few favorite toys on the trip or may have acquired some souvenirs. Letting them hold the toy as you shoot will help them relax. (See **Figure 31.3**.)

Figure 31.2 Capture the child having fun.

Figure 31.3 Use a favorite toy to get the kid in a good mood.

- **Get down.** Get down low when you shoot a young child and capture a few pictures from the kid's viewpoint. The new perspective may surprise you.

- **Use soft light.** Choose a slightly overcast day or open shade for flattering lighting. Kids generally have great skin, but they also manage to collect nicks and scratches from just being a kid. Soft light minimizes these "defects." The young man in **Figure 31.4** was relaxing on a window ledge in an alley, just off the main square in a town in Spain, and his parents asked me to take this photo. (When photographing strangers, *especially* children, get permission from a parent first!)

- **Fill in those shadows.** The difference between an amateur snapshot of a child and a good-looking candid portrait is often whether or not the shadows are inky-dark, or bright and full of detail. You need soft shadows to model the contours of the face, but you don't want dark pits under the eyes, nose, or chin. Use your T6's pop-up internal flash to fill in shadows.

- **Let the kid shoot you.** If the child is 5 or older, you can help him or her relax and participate in the shoot more readily if you let the youngster become a co-conspirator. Have a point-and-shoot digital camera ready, or even allow the child to use your T6 to snap off a few pictures of you. Show off the results. Then, it's *your* turn to take a few.

- **Get close.** Use the kit lens's 55mm zoom lens setting and fill most of the frame with the child's head and shoulders, while allowing enough of the surroundings to show the location. (See **Figure 31.5**.) For most kids, a medium close-up shows their personality best. Plus, your shots will be different and more interesting than the typical full-length shot in front of a castle or monument that most parents take of their kids on vacation.

Figure 31.4 Use soft lighting for a flattering portrait.

Figure 31.5 Get close and fill the frame with the child.

- **Include the parents and grandparents.** Especially if you're one of them. Too many kids look through their family albums years later and ask, "Where were you, dad (or mom) when we visited Disney World?" You might enjoy looking at photos of your child more than pictures of yourself, but the time comes when everyone involved wants to see the kids and parents pictured together. And don't forget the grandparents! (See **Figure 31.6**.)

Figure 31.6 Include parents in the photo (and grandparents, if available!).

32. MASTERING YOUR T6'S BUILT-IN FLASH

UNTIL YOU DELVE into the situation deeply enough, it might appear that serious photographers have a love/hate relationship with electronic flash. You'll often hear that flash photography is less natural looking, and that the built-in flash in most cameras should never be used as the primary source of illumination because it provides a harsh, garish look. Available ("continuous") lighting is praised, and built-in flash photography seems to be roundly denounced.

In truth, however, the bias is against *bad* flash photography. Your T6's internal flash can prove quite useful as an adjunct to existing light, particularly to illuminate dark shadows using a technique called *fill flash*. The important thing to remember is that any exposure using flash is actually *two* exposures in one. The available, or "ambient" light provides part of the exposure while the second, flash exposure provides the rest. In some cases, such as very dark surroundings, the electronic flash provides virtually all of the light used to produce the picture. In others, particularly in broad daylight or other bright surroundings, the flash may simply provide a bit of extra light to fill in dark areas and balance the exposure. **Figure 32.1** is an example of balanced flash providing a bit of fill light that illuminates the shadow areas of the subject's face.

32.1

Figure 32.1 The camera's built-in flash can provide flattering shadow fill light outdoors on bright days.

Knowing that flash pictures are two exposures in one can help you avoid one of the situations that lead to *bad* flash photography. For example, if you are taking pictures indoors, the ambient illumination is likely to be much warmer than daylight-balanced flash. If the interior light is strong enough you can run into a situation where a subject's highlights appear orangish while the shadows, illuminated by an electronic flash designed to mimic daylight, take on a bluish tinge. Changing the white balance can't fix mixed illumination of that sort. You must avoid such situations, or resort to more complicated solutions, such as putting an orange tinted filter over the flash so it "matches" the interior illumination. Also, if you're taking a picture in which the subject is moving, the two exposures may result in a ghost image: a sharp one exposed by the burst from the flash, and a second, blurred image produced by the ambient light. (See **Figure 32.2**.) When that happens, the solution is to decrease the ambient lighting (if you can) or use a faster shutter speed (which may not be possible, because the built-in flash of the T6 can be used only with shutter speeds of 1/200th second or slower).

32.2

Figure 32.2 Ghost images can result when using flash indoors or outdoors under illumination bright enough to cause an unwanted secondary exposure.

Basic Zone Flash

When the T6 is set to one of the Basic Zone modes (except for Landscape, Sports, or Flash Off modes), the built-in flash will pop up when needed to provide extra illumination in low-light situations, or when your subject matter is backlit and could benefit from some fill flash. The flash doesn't pop up in Landscape mode because the flash doesn't have enough reach to have much effect for pictures of distant vistas in any case; nor does the flash pop up automatically in Sports mode, because you'll often want to use shutter speeds faster than 1/200th second and/or be shooting subjects that are out of flash range. Pop-up flash is disabled in Flash Off mode for obvious reasons.

If you happen to be shooting a landscape photo and do want to use flash (say, to add some illumination to a subject that's closer to the camera), or you want flash with your sports photos, or you *don't* want the flash popping up all the time when using one of the other Basic Zone modes, switch to an appropriate Creative Zone mode and use that instead. In this lesson, I'm going to explain some of the most basic options you have at your disposal when working with flash. You'll see that the adjustments you need to make are simple and easy to do. I'll offer some tips on which modes to use, and when.

Creative Zone Flash

When you're using a Creative Zone mode, you'll have to judge for yourself when flash might be useful and flip it up yourself by pressing the Flash button on the top right of the camera. (You can also raise the flash using the Flash Up option in the Quick Control screen.) The behavior of the internal flash varies, depending on which Creative Zone mode you're using.

- **P.** In this mode, the T6 fully automates the exposure process, giving you subtle fill flash effects in daylight, and fully illuminating your subject under dimmer lighting conditions. The camera selects a shutter speed from 1/60th to 1/200th second and sets an appropriate aperture.

- **Av.** In Aperture Priority mode, you set the aperture as always, and the T6 chooses a shutter speed from 30 seconds to 1/200th second. Use this mode with care, because if the camera detects a dark background, it will use the flash to expose the main subject in the foreground, and then leave the shutter open long enough to allow the background to be exposed correctly, too. If you're not using an image-stabilized lens, you can end up with blurry ghost images even of non-moving subjects at exposures longer than 1/30th second, and if your camera is not mounted on a tripod, you'll see these blurs at exposures longer than about 1/8th second even if you are using IS.

 To disable use of a slow shutter speed with flash, access C.Fn I-3: Flash Sync. Speed in Av mode, and change from the default setting (0: Auto) to either 1: 1/200-1/60sec. auto or 2: 1/200sec. (fixed).

- **Tv.** When using flash in Tv mode, you set the shutter speed from 30 seconds to 1/200th second, and the T6 will choose the correct aperture for the correct flash exposure. If you accidentally set the shutter speed higher than 1/200th second, the camera will reduce it to 1/200th second when you're using the flash.

- **M/B.** In Manual or Bulb exposure modes, you select both shutter speed (30 seconds to 1/200th second) and aperture. The camera will adjust the shutter speed to 1/200th second if you have set a faster speed and then try to use the internal flash. The E-TTL II system will provide the correct amount of exposure for your main subject at the aperture you've chosen (if the subject is within the flash's range, of course). In Bulb mode, the shutter will remain open for as long as the release button on top of the camera is held down, or the release of your remote control is activated.

Flash Range

The illumination of the Rebel T6's built-in flash varies with distance, focal length, and ISO sensitivity setting.

- **Distance.** The farther away your subject is from the camera, the greater the light fall-off, thanks to the inverse square law. Keep in mind that a subject that's twice as far away receives only one-quarter as much light, which is two f/stops' worth.

- **Focal length.** The built-in flash "covers" only a limited angle of view, which doesn't change. So, when you're using a lens that is wider than the default focal length, the frame may not be covered fully, and you'll

experience dark areas, especially in the corners. As you zoom in using longer focal lengths, some of the illumination is outside the area of view and is "wasted." (This phenomenon is why some external flash units, such as the 600EX-RT, "zoom" to match the zoom setting of your lens to concentrate the available flash burst onto the actual subject area.)

- **ISO setting.** The higher the ISO sensitivity, the more photons captured by the sensor. So, doubling the sensitivity from ISO 100 to 200 produces the same effect as, say, opening up your lens from f/8 to f/5.6.

Using FE Lock and Flash Exposure Compensation

If you want to lock flash exposure for a subject that is not centered in the frame, you can use the FE lock button (*) to lock in a specific flash exposure. Just depress and hold the shutter button halfway to lock in focus, then center the viewfinder on the subject you want to correctly expose and press the * button. The pre-flash fires and calculates exposure, displaying the FEL (flash exposure lock) message in the viewfinder.

Then, recompose your photo and press the shutter down the rest of the way to take the photo.

You can also manually add or subtract exposure to the flash exposure calculated by the T6 when using a Creative Zone mode. The easiest way is to use the Quick Control screen (see **Figure 32.3**). You can highlight the entry, as shown, and then rotate the Main Dial to set +2/−2 stops to add or subtract from the exposure the camera calculates. Do this if your pictures are too dark or too light, or if you are using the flash as fill and want more or less fill light in your shadows. A flash exposure compensation icon will appear in the viewfinder to warn you that an adjustment has been made. As with non-flash exposure compensation, the compensation you make remains in effect for the pictures that follow, and even when you've turned the camera off, remember to cancel the flash exposure compensation adjustment by reversing the steps used to set it when you're done using it. Note that the amount of flash exposure compensation is *not* shown on the exposure scales in the viewfinder or LCD monitor information screens; only ambient light exposure and compensation are displayed.

These are the main adjustments you need to make when using your T6's built-in flash. The only other change you might want to make as you gain experience using your camera, is to specify which metering mode the camera uses for flash exposures. I explained metering modes in **Lesson 21**.

You'll need to navigate to the Flash Control entry at the bottom of the Shooting 1 menu, and press SET. In the menu that pops up, you'll find the Built-in Flash Function Setting option shown at left in **Figure 32.4**. Choose that and select E-TTL II metering from the screen that appears at right in the figure. You can then choose the type of exposure metering the T6 uses for electronic flash. You can select the default Evaluative metering, which selectively interprets the 63 metering zones in the viewfinder to intelligently classify the scene for exposure purposes. Alternatively, you can select Average, which melds the information from all the zones together as an average exposure. You might find this mode useful for evenly lit scenes, but, in most cases, exposure won't be exactly right, and you may still need some flash exposure compensation adjustment.

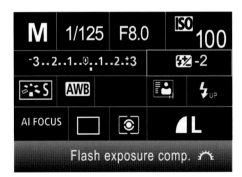

Figure 32.3 Set flash exposure compensation using the Quick Control menu.

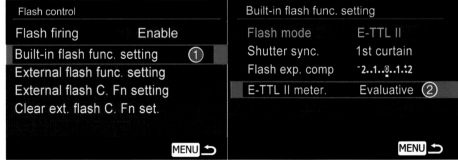

Figure 32.4
① Flash Control menu
② Built-in Flash Function Setting menu

33. TWELVE SIMPLE RULES FOR GROUP SHOTS

SOONER OR LATER, you'll be taking photos of groups, which for purposes of discussion I'll say is any collection of more than one person (and, perhaps, a pet or two). At home you'll be capturing friends and family. As the budding photographer in your organization, you may be asked to take a group shot of colleagues. If you're traveling, you'll often want to shoot a photo of the group you're traveling with. In all cases, resist the urge to line everybody up in a single row and fire away. Instead, try to capture the members of your group doing something interesting.

Photographs in which two or more members of your group are lined up in a row are deadly dull. Select your location carefully so individuals can be posed with their heads at slightly different heights. Choose a site that lends itself to having some members standing and some seated. For small groups, a few stools may do the job. For larger groups, stairs, risers, a hillside with some interesting rocks, or a combination of picnic tables and benches may serve as your stage. Or, you can pose them standing on a conveniently placed staircase, as seen in **Figure 33.1**. Outdoors, daylight may serve as your illumination, particularly if you can find a shady spot that's facing a reflective structure (such as a building) that can cast light into the shadows. On-camera flash rarely works with groups larger than five or six people, because there often is not enough light to cover the full

Figure 33.1 Groups should be posed with the members' heads at different heights.

area of the group, and those in the back receive significantly less exposure than those in the front.

For any group larger than four or five people, it's a good idea to have one member of your group serve as an assistant to help you arrange your group. It's easier to tell your helper, "Have Uncle Joe move closer to Aunt Mary, and ask the twins to switch places with their parents" than to shout these instructions to your group. Your assistant can assemble the group around the main subject, and then help you group the remaining folks into classic diamond arrangements (described in a tip that follows) that provide the most interesting compositions. Make sure that you and your helper are

communicating with the group at all times, however. If those in your crowd feel they are on their own while you fiddle with the posing and camera, their attention will wander.

The more people you have in a group photo, the more likely it is that someone will blink during the exposure or turn his or her head at the worst possible moment. It's almost impossible to detect these problems on a tiny LCD review image. When you're ready to shoot, ask your group if everyone can see the camera clearly. That request alerts them not to look away. It's always a good idea to take at least as many pictures as there are people in the group, up to about eight or ten shots. Multiple photos increase your chances of getting one in which everyone is looking at the camera and smiling acceptably.

If you're using flash, ask the group to watch for the color of the flash when it goes off. After you take the picture, ask if anyone saw a red flash instead of white. If they saw red, they saw the flash through their closed eyelids and you need to shoot at least one more. Finally, although you should warn your group when you're about to take a picture, don't use a countdown or some precise tip-off. Many folks flinch or blink at the exact moment they think a photo is about to be taken.

Before you get started shooting groups, check these things first:

- **Check for subjects in disarray.** Photos of large groups consist of pictures of individuals, and each person in your shot will want to look his or her best. Take the time to review your posing, looking for unfortunate expressions, wrinkled clothing, mussed hair, and so forth, for each person in the group.

- **Check for any lighting errors.** Look carefully for shadows cast on people's faces (particularly if you're using an off-camera flash), glare off glasses or jewelry, and other lighting problems. If someone is wearing glasses tilting the glasses downward slightly on their nose and asking them to raise their chin can help avoid reflections bouncing back to the camera lens.

- **Take many more photos than you think you'll need.** You never know: This might be the last time this particular group is all together. As long as you have everyone in front of your camera, take the time to shoot lots of photos. After all, as a digital photographer, you don't have to pay extra for film, processing, and proofs.

- **Record who is in the picture.** The photos of the people you shoot today may be of interest for much longer than you think, possibly 30 to 40 years in the future, even though your digital files will probably have to be copied from DVD to whatever media replaces them in a dozen years (or less!). Unless everyone in the photo is a close relative, write down the names of those in the photo for posterity. You can also do that even if each person *is* a close friend or family member. Can you name every single person in your kindergarten class photo today — even though you might have attended school with those kids for several years? Can you guarantee that your group photo won't fall into the hands of some family or company archivist in the future who *doesn't* personally know each individual, but wants to have their names anyway? Jot down the names now and help out your descendants.

Posing Tips

The goal of portraiture is to make subjects look the best that they can look. Here are a few techniques you can use to achieve this goal. **Figure 33.2** is an example of what *not* to do.

- **Avoid having all the heads in the same horizontal plane.** Arrange members of your group so their faces are at different heights. However, you'll want to avoid the haphazard arrangement seen in **Figure 33.2**. The cast members of the play in the back row are seemingly distributed at random, and in an unbalanced way at that, with most prominent figures at far right. While you don't have to line up people in order of height, a more pleasing arrangement will group at least some of similar height together, which was actually done with the front row. Even with that, those in front should have been centered in front of those in the back row.

- **Overlap.** Ask your group to pose with their bodies at a slight angle from vertical so their faces aren't ramrod straight and overlap them at their shoulders. That will give you a more compact grouping, such that even if you're shooting full-length portraits, the frame will be composed tightly enough to allow each person's face—their most important aspect—to be large and recognizable. This technique becomes more important as the group size increases. Overlapping for a tighter composition works for two-person portraits, as well, as you can see in **Figure 33.3**.

- **Pose your group in geometric shapes.** The diamond formation is a classic arrangement, with one person at the top, one at the bottom, and two at either side (at slightly different heights). You can arrange even large groups into diamonds and

sub-diamonds to create an interesting composition. Triangles and diamonds are dynamic shapes, compared to groups arranged into tight squares that appear to be static. See **Figure 33.4**.

- **The edges of hands are more attractive than the back or palms of the hands.** Have your subjects hold their hands in their laps, or perhaps resting on the shoulder of another member of the group. Keep the hands away from faces.

- **Use an upright hand** to show how you want your individual subjects to move their heads, rather than just telling them to turn this way or that. Your hand can rotate around your wrist to indicate you'd like them to turn at the neck tilt, to indicate movement toward or away from a particular shoulder, or pivot forward and back tomahawk style to show when you need them to lean toward or away from the camera.

- **Make sure your subjects' eyes** are looking in the same direction their noses are pointed.

- **Use the fewest number of rows** to make the most of your depth of field.

- **Develop some patter.** If you shoot groups frequently, develop some patter to keep your group engaged and attentive while you set up and shoot. Humor can help, too. For example, to diffuse impatience during multiple shots, a comment like, "You're doing fine, but I have to keep doing this until I get it right!" can help.

Figure 33.2 Avoid lopsided arrangements like this one.

Figure 33.3 Overlap those in your groups to create a tighter composition.

Figure 33.4 Arrange groups into diamond shapes for a pleasing composition. Larger groups can be organized into several different well-arranged geometric shapes.

YES, YOU COULD pay big bucks for a digital projector to present your best shots in riveting shows your friends, colleagues, and neighbors would flock to see. But you can also avoid flocking your audience altogether, because your Rebel T6 has a built-in slide show capability that is a great deal more versatile than you might think. You can specify which shots to display on the camera's tiny LCD (which may be sufficient for presenting your productions to one or two unwary people you ambush near the water cooler). But you can also showcase your shots on a high-definition television or monitor, complete with cool transitions and music accompaniment. In this lesson, I'll show you how to accomplish this magic.

All you need to do is specify which images on your memory card to review, one after another, without the need to manually switch between them. To activate, just choose Slide Show from the Playback 2 menu. During playback, you can press the SET button to pause the "slide show" (in case you want to examine an image more closely), or the DISP. button to change the amount of information displayed on the screen with each image. For example, you might want to review a set of images and their histograms to judge the exposure of the group of pictures.

To set up your slide show, follow these steps:

1. **Begin set up.** Choose Slide Show from the Playback 2 menu, pressing SET to display the screen shown in **Figure 34.1**.

2. **Choose image selection method.** Use the up/down cross keys to navigate to All Images, and press SET. Then press the up/down cross keys to select which images to include in your slide show. Choose from:

 - **All Images.** All the still pictures *and* movies on your memory card will be included in the show.

 - **Rating.** When this option is highlighted, you can elect to display only the images on your card with a specific star rating. You can, say, choose only with images that have five stars, those with one, two, three, or four stars, or all images that have been given any star rating (which will exclude only those you didn't rate). I'll explain how to apply a Rating later in this lesson. Press the DISP. button to view a selection screen where you can specify the rating you want to use to select your images.

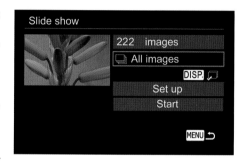

Figure 34.1 Set up your slide show using this screen.

 - **Stills/Movies.** If you select either of these, only stills or movies (respectively) will be included in your show.

 - **Folder.** Press the DISP. button and you can choose a specific folder on your memory card that has the stills and/or movies you want to include in your show.

 - **Date.** Press the DISP. button to view a screen showing a list of all the dates on which you took the photos on your memory card. You can elect to choose one specific date and display only those images.

3 **Press SET to activate that selection mode.** You'll be returned to the screen shown in **Figure 34.1**.

4 **Highlight Set Up and press SET.** You'll see the screen shown in **Figure 34.2**.

5 **Choose Display Time.** Press SET to produce a screen with playing time (1, 2, 3, 5, 10, or 20 seconds per image). Set your display time to short value if you want to zip through a series of images, or a longer time to allow your viewers to savor your wonderful work. The actual display time may vary depending on the images you have selected. You can always pause your slide show by pressing the SET button, and a second time to resume playback. Press MENU to return to the previous screen.

6 **Optional: Highlight Repeat.** Press SET and choose to Enable to Disable repeat display of your show. You might have set up your T6 at a trade show and want to repeat your slide show for as long as your battery (or optional AC adapter) provides power. While your slide show is active, the T6's auto power off feature is disabled. Press MENU to return to the previous screen.

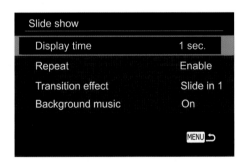

Figure 34.2 Add options using this screen.

7 **Optional: Select Transition.** Your T6 has built in optional effects, including two Slide In choices and three Fade options. If you want one, select it here and press MENU to return to the previous screen.

8 **Optional: Music.** Straight from the factory, your T6 does not have any music files to play during your slide show. To add those files so you can select them here, you'll need to download and install the free EOS Utility software. Load the software on your PC or Mac, select Register Background Music from the main screen, and follow the instructions to find and add music files to your collection. You can register a total of 20 tracks, each up to 29 minutes, 59 seconds long. The software shows you how to copy the files to your memory card, where they must reside along with the images in your slide show.

9 **Start the show.** Highlight Start and press SET to begin your show. (If you'd rather cancel the show you've just set up, press MENU instead.)

10 **Use show options during display.** Press SET to pause/restart; DISP. to cycle among the four information displays described in the section before this one; MENU to stop the show.

Rating

As I noted earlier, you can use star ratings applied to your images or movies to select them for slide shows. But the feature is far more versatile than that. Ratings are applied using the Rate option in the Playback 2 menu. If you wish, use the ratings to indicate what you perceive is the quality level of a particular image, giving each one, two, three, four, or five stars, or turn the rating system off.

In addition to slide show selection, you can use ratings for other purposes. The Image Jump function also found in the Playback 2 menu can display only images with a given rating. Suppose you were photographing a track meet with multiple events. You could apply a one-star rating to jumping events, two-stars to relays, three-stars to throwing events, four-stars to hurdles, and five-stars to dashes. Then, using the Image Jump feature, you could review only images of one particular type.

With a little imagination, you can apply the rating system to all sorts of categories. At a wedding, you could classify pictures of the bride, the groom, guests, attendants, and parents of the couple. If you were shooting school portraits, one rating could apply to First Grade, another to Second Grade, and so on. This feature has many more applications than you might think. To use it, just follow these steps:

1 Choose the Rating menu item from the Playback 2 menu.

2 Use the cross keys to select an image or movie. Press the Reduce button to display three images at once. Press the Magnify button to return to a single image.

3 When an image or movie is visible, press the up/down buttons to apply a one- to five-star rating. The display shows how many images have been assigned each rating so far.

4 When finished rating, press the MENU button to exit.

6

CAPTURING MOVIES AND LIVE VIEW

CHAPTER 6

Your Rebel T6's closely linked live view and movie-shooting capabilities are what we call a *killer feature.* By that, I mean that including those capabilities in your camera has managed to virtually kill off an entire category of consumer product: the camcorder. Who needs a camcorder when a digital SLR like the T6 can shoot full HD 1080p video *and* stills in one compact camera? Live view and video capture in your camera are actually two sides of the same coin. In both modes, the T6 is able to present to you on the LCD monitor the exact image being seen by the sensor, in real time. You have the choice of capturing still photos at the camera's full 18 MP resolution, or of recording many frames per second at two high-definition resolutions, and the web-friendly 640 × 480 (VGA) reduced resolution (suitable for uploading and emailing). This chapter demystifies live view and movie shooting with seven easy lessons.

WHEN LIVE VIEW and movie-capture capabilities were first added to digital SLRs in 2008, even photo enthusiasts weren't quite sure whether they wanted those features or not. After all, most of them owned a camcorder that did a fairly decent job of producing video. But the features were embraced quite quickly, due to the elimination of the need to carry an extra piece of equipment, and the ease of producing higher resolution video than was typical for camcorders of that era. Today, most people have a smartphone in their pocket that captures stills and video easily. That, oddly enough, has made the features of the T6 even more attractive because of the increased flexibility a camera with a zoom and interchangeable lenses offers.

Here are important points to consider about live view:

- **Preview your images on a TV.** Connect your EOS T6 to a standard-definition television using the video cable (or to an HDTV with the optional HDMI cable), and you can preview your image on a large screen.
- **Preview remotely.** Link the camera and TV screen, and you can preview your images some distance away from the camera.
- **Shoot from your computer.** Canon has downloadable software you can use to control your camera from your computer, so you can preview images and take pictures or movies without physically touching the EOS T6.

- **Shoot from tripod or hand-held.** Of course, holding the camera out at arm's length to preview an image is poor technique, and will introduce a lot of camera shake. If you want to use live view for hand-held images, use an image-stabilized lens and/or a high shutter speed. A tripod is a better choice if one is available.
- **Watch your power.** Live view uses a lot of juice and will deplete your battery rapidly. Canon estimates that you can get several hundred shots per battery when using live view, depending on the temperature. Expect slightly fewer exposures when using flash. The optional AC adapter is a useful accessory.

Activating Live View

To use live view, you really don't need to make any settings—unless you (or someone else) may have accidentally or intentionally turned the feature off. In that case, you need to visit the Shooting 4 menu when using a Creative Zone mode. (See **Figure 35.1**.) When you're using a Basic Zone mode, only the first three choices listed below are available, and they are found in the Shooting 2 menu instead. The entries include:

- **Live View Shoot.** Enable/disable live view shooting here. As I mentioned, disabling live view does not affect movie shooting, which is activated by rotating the Mode Dial to the Movie position.

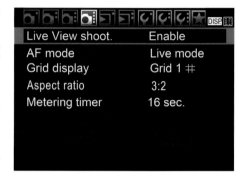

Figure 35.1 In Creative Zone modes, Live view function settings can be found in the Shooting 4 menu.

- **Autofocus Method** (**FlexiZone—Single AF, Face Detection Live Mode, and Quick mode**). This option, explained shortly, lets you choose between phase detection, contrast detection, and contrast detection with "face" recognition. These autofocus modes are different from the ones used when using the optical viewfinder.
- **Grid Display** (**Off, Grid 1, Grid 2**). Overlays Grid 1, a "rule of thirds" grid, on the screen to help you compose your image and align vertical and horizontal lines; or Grid 2, which consists of four rows of six boxes, which allow finer control over placement of images in your frame.

- **Aspect Ratio.** Choose from the default 3:2, or select 4:3, 16:9, or 1:1 proportions. In general, you'll want to stick to the standard 3:2 aspect ratio used for still photography. You might want to opt for the 16:9 aspect ratio if you're also shooting video and want your still photos to match the high-definition video frame.

- **Metering Timer** (**4 sec. to 30 min.**). This option allows you to specify how long the EOS T6's metering system will remain active before switching off. Tap the shutter release to start the timer again after it switches off. This choice is not available when using a Basic Zone mode.

Activating Live View

Once you've enabled live view, you can continue taking pictures normally through the T6's viewfinder. When you're ready to activate live view, press the Live View/Movie Shooting button on the back of the camera, to the immediate right of the viewfinder window (and marked with a red dot). The mirror will flip up, and the sensor image will appear on the LCD. (See **Figure 35.2**.)

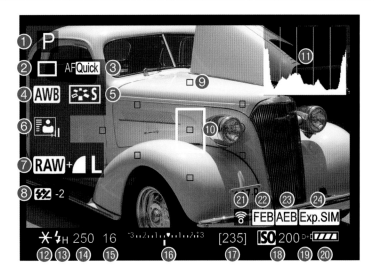

Figure 35.2
1. Shooting mode
2. Drive mode
3. AF mode
4. White balance
5. Picture Style
6. Auto Lighting Optimizer
7. Image recording quality
8. Flash compensation
9. AF point (Quick mode)
10. Magnifying frame
11. Histogram
12. AE lock
13. Flash ready
14. Shutter speed
15. Aperture
16. Exposure level indicator/ AEB bracketing range
17. Shots remaining
18. ISO speed
19. Highlight tone priority
20. Battery check
21. Eye-Fi card transmission status
22. Flash exposure bracketing
23. Autoexposure bracketing
24. Exposure simulation

36. THREE WAYS TO FOCUS IN LIVE VIEW AND MOVIES

THERE ARE THREE different ways to autofocus when using live view or movie modes. Two of them are quite different from what you've become accustomed to when framing your images using the optical viewfinder. That's because FlexiZone (Single) and (Face Detection) Live Mode focus using the actual image on the sensor. The third, Quick Mode, uses the separate AF mechanism built in the floor of the mirror box, which is exactly how autofocus works when viewing through the optical viewfinder.

While the two sensor-based focusing modes (using what is called *contrast detection*) are a bit slower than the rangefinder-like technology used for Quick Mode (called *phase detection*), they are potentially more accurate. Plus, you have the advantage of watching the actual sensor image as it is sharply focused. You can, of course, slide the AF/M switch on your lens to the M position and focus manually, if you like. In this lesson, you'll learn about the Rebel T6's three live view/movie mode AT options, and when to use them.

Focusing in Live View

Press the shutter button halfway to activate autofocus using the currently set live view autofocus mode. As I mentioned, those modes are Live mode, Live "face detection" mode, and Quick mode. You can also use manual focus. I'll describe each of these separately.

Select the focus mode for live view from the entries in the Shooting 4 menu, described earlier and shown in **Figure 35.1**. You can also change focus mode while using live view by pressing the Q button and highlighting the focus options with the cross keys. Then press the SET button and use the left/right cross keys to choose one of the following three focus modes. Press SET again to confirm your choice.

FlexiZone—Single

This mode applies contrast detection, using the relative sharpness of the image as it appears on the sensor to determine focus. This method usually takes longer than Quick mode, described shortly. Use FlexiZone—Single for scenes not containing humans. It is accurate and reasonably fast. To autofocus using FlexiZone—Single mode, follow these steps:

1 **Set lens to autofocus.** Make sure the focus switch on the lens is set to AF.
2 **Activate live view.** Press the Start/Stop button.
3 **Choose AF point.** Use the cross keys to move the AF point anywhere you like on the screen, except for the edges. Press the SET button to return the AF point to the center of the screen.
4 **Select subject.** Compose the image on the LCD so the selected focus point is on the subject.
5 **Press and hold the shutter button halfway.** When focus is achieved, the AF point turns green, and you'll hear a beep if the sound has been turned on in the Shooting 1 menu. If the T6 is unable to focus, the AF point turns orange instead.
6 **Take picture.** Press the shutter release all the way down to take the picture.

(Face Detection) Live Mode

This mode also uses contrast detection, using the relative sharpness of the image as it appears on the sensor to determine focus. The T6 will search the frame for a human face and attempt to focus on the face. Like Live mode, this method usually takes longer than Quick mode. Use this mode when photographing scenes that contain human faces, as it does a good job of zeroing in on people in your images, regardless of where they may be in the frame. To autofocus using Live (face detection) mode, follow these steps:

1 **Set lens to autofocus.** Make sure the focus switch on the lens is set to AF.
2 **Activate live view.** Press the Start/Stop button.
3 **Face detection.** If you've selected face detection using the AF button or Quick Control screen, a frame will appear around a face found in the image. If more than one face is found, a frame with notches that look like "ears" appears. In that case, use the cross keys to move the frame to the face you want to use for focus. If no face is detected, the AF point will be displayed, and focus will be locked into the center.

4 **Troubleshoot (if necessary).** If you experience problems in Live (face detection) mode, press the SET button to switch to FlexiZone (Single). You can then press the cross keys to move the AF point to your subject. When you're ready to switch back to (Face Detection) Live Mode, press the SET button again. Face detection is far from perfect. The AF system may fail to find a face if the person's visage is too large/small or light/dark in the frame, tilted, or located near an edge of the picture. It may classify a non-face as a face.
5 **Press and hold the shutter release halfway.** When focus is achieved, the AF point turns green, and you'll hear a beep. (See **Figure 36.1**.) If the T6 is unable to focus, the AF point turns orange instead.
6 **Take picture.** Press the shutter release all the way down to take the picture.

Figure 36.1 The T6 can detect faces during autofocus.

Quick Mode

This mode uses phase detection, which relies on the autofocus system built into the floor of the mirror box. It temporarily interrupts live view to allow the EOS T6 to focus the same AF system used when you focus through the viewfinder. Because the step takes a second or so, you may get better results using this autofocus mode when the camera is mounted on a tripod. If you hand-hold the T6, you may displace the point of focus achieved by the autofocus system. It also simplifies the operation if you use One-Shot focus and center the focus point. You can use AI Servo and AF or Manual focus point selection, but if the focus point doesn't coincide with the subject you want to focus on, you'll end up with an out-of-focus image. Just follow these steps:

1 **Set lens to autofocus.** Make sure the focus switch on the lens is set to AF.
2 **Activate live view.** Press the Start/Stop button.
3 **Choose AF point.** Press the Q button, and then press the up or down cross key to make the focus point selectable. It will be illuminated in orange.
4 **Move the focus point.** Press the Q button, then the Up button, and then rotate the Main Dial to cycle the focus point around among the 9 available points. It will rotate around each individual point on the outer edge, then illuminate all 9 (which tells the T6 to automatically select one of the points, and finally return to the center point).

5 **Select subject.** Compose the image on the LCD so the selected focus point is on the subject.

6 **Press and hold the shutter release halfway.** The LCD will blank as the mirror flips down, reflecting the view of the subject to the phase detection AF sensor.

7 **Wait for focus.** When the T6 is able to lock in focus using phase detection, a beep (if activated) will sound. If you are hand-holding the T6, you may hear several beeps as the AF system focuses and refocuses with each camera movement. Then, the mirror will flip back up, and the live view image reappears. The AF focus point will be highlighted in green on the LCD.

8 **Take the picture.** Press the shutter release *all* the way down to take the picture. (You can't take a photo while Quick mode AF is in process, until the mirror flips back up.)

Manual Mode

Focusing manually on an LCD screen isn't as difficult as you might think, but Canon has made the process even easier by providing a magnified view. Use Manual focus mode for close-ups and shots where you want to apply selective focus to isolate or call attention to your subject, as described in **Lesson 11**. Just follow these steps to focus manually.

1 **Set lens to manual focus and activate live view.** Make sure the focus switch on the lens is set to MF.

2 **Move magnifying frame.** Use the cross keys to move the focus frame that's superimposed on the screen to the location where you want to focus. You can press the SET button to center the focus frame in the middle of the screen.

3 **Press the Magnify button.** The area of the image inside the focus frame will be magnified 5X. (See **Figure 36.2**.) Press the Magnify button a second time to increase the magnification to 10X. A third press will return you to the full-frame view. The enlarged area is artificially sharpened to make it easier for you to see the contrast changes and simplify focusing. When zoomed in, press the shutter release halfway and the current shutter speed and aperture are shown in orange. If no information at all appears, press the DISP. button.

4 **Focus manually.** Use the focus ring on the lens to focus the image. When you're satisfied, you can zoom back out by pressing the Reduce button.

Figure 36.2 You can manually focus the center area, which can be zoomed in 5X or 10X.

37. PREVIEW YOUR RESULTS WITH FINAL IMAGE (EXPOSURE) SIMULATION

ONE OF THE best features of live view and movie modes is that what you see *is* what you get, because the image you're viewing on the LCD monitor is the actual image the sensor is capturing in real time. That's a sharp contrast to what you're looking at when you're using the optical viewfinder—the viewfinder image is always bright. It shows you when an image is in focus or out of focus but doesn't display depth-of-field. **Note:** You can create a depth-of-field preview button in the Set-up 3 menu, under Custom Functions (C.Fn) 9. Just assign the SET button to 4: Depth-of-field preview. The SET button's functions when using menus remains the same.

Exposure Simulation applies many of the shooting settings you make to the preview image on the LCD monitor. When Exp. Sim. is displayed in non-flashing form on the live view screen, it indicates that the LCD screen image brightness approximates the brightness of the captured image. If the Exp. Sim. display is blinking, it shows that the screen image does *not* represent the appearance of the final image. When using flash or bulb exposure, the Exp. Sim. indicator is dimmed out to show you that the LCD image is not being adjusted to account for the actual exposure. Exposure simulation is not a feature that can be turned on or off with this camera; however, you can show or hide the indicator by pressing the DISP. button to change to a different information view.

The T6 applies any active Picture Style settings to the LCD image, so you can have a rough representation of the image as it will appear when modified. Sharpness, contrast, color saturation, and color tone will all be applied. In addition, the camera applies the following parameters to the live view image shown:

- White balance/white balance correction
- Shoot by ambience/lighting/scene choices
- Auto lighting optimization
- Peripheral illumination correction
- Highlight Tone Priority
- Aspect ratio
- Depth-of-field when DOF button (if you have defined one) is pressed

The exposure simulation features are one of my favorite reasons for using live view in the first place.

38. SHOOTING MOVIES

THE CANON EOS T6 can shoot standard and full HDTV movies with monaural sound at 1280 × 720 and 1920 × 1080 resolution. In some ways, the camera's Movie mode is closely related to the T6's live view still mode. In fact, the T6 uses live view–type imaging to show you the video clip on the LCD as it is captured. Many of the functions and setting options are the same, so the information in the previous lessons will serve you well as you branch out into shooting movies with your camera.

To shoot in Movie mode, just rotate the Mode Dial to the Movie position. Press the Live View/Movie Shooting button to begin/end capture.

That's quite simple, but there are some additional things you need to keep in mind before you start:

- **Choose movie recording size resolution.** The T6 can capture movies in 1920 × 1080, 30 fps; 1920 × 1080, 24 fps (both Full High Definition); 1280 × 720, 60 fps (Standard Definition); and 640 × 480, 30 fps (VGA resolution). I'll explain movie resolution and frame rates next.

- **Use the right card.** You'll want to use a sufficiently fast memory card, which means a Class 10 card (your T6 does not benefit from faster UHS-I or UHS-II cards). Slower cards may not work properly. Choose a memory card with at least 8GB capacity (16GB or 32GB are preferable and don't cost much more). If the card you are working with is too slow, a five-level thermometer-like "buffer" indicator may appear at the right side of the LCD, showing the status of your camera's internal memory. If the indicator reaches the top level because the buffer is full, movie shooting will stop automatically.

- **Use a fully charged battery.** Canon says that a fresh battery will allow about up to one hour, fifty minutes of filming at normal (non-winter) temperatures.

- **Image stabilizer uses extra power.** If your lens has an image stabilizer like the kit lens, it will operate at all times (not just when the shutter button is pressed halfway, which is the case with still photography) and use a considerable amount of power, reducing battery life. You can switch the IS feature off to conserve power. Mount your camera on a tripod, and you don't need IS anyway.

- **Silent running.** You can connect your T6 to a television or video monitor while shooting movies and see the video portion on the bigger screen as you shoot. However, the sound will not play—that's a good idea, because, otherwise, you could likely get a feedback loop of sound going. The sound will be recorded properly and will magically appear during playback once shooting has concluded.

Resolution and Frame Rates

The T6 offers several different resolution and frame rate options, which you can select from the Movie Recording Size entry of the Movie 2 menu. Resolution represents the image recording size of each frame of your movie and indicates the sharpness/quality of the video. Your choices range from 1920 × 1080 (full high definition) to 640 × 480 (VGA). The frame rate is the number of frames captured per second. In general, you can stick with the 1920 × 1080/30 fps setting for virtually all of your movies. Here is a list of each resolution option and why you might want to use it:

- **1920 × 1080.** Full HD is the maximum resolution available with your T6. Many monitors and most HD televisions can display this resolution, and you'll have the best image quality when you use it. Use this resolution for your "professional" productions, especially those you'll be editing and converting to nifty-looking DVDs. However, the top-of-the-line resolution requires the most storage space, approximately 330 megabytes per minute, yielding about 44 minutes of "shooting time" on a 16GB memory card. (The maximum length of a single continuous clip is nearly 30 minutes.)

- **1280 × 720.** "Standard HD" provides less resolution and can be displayed on any monitor or television that claims HDTV compatibility. If your production will appear only on computer monitors with 1280 × 720 resolution, or on HDTVs that max out at 720p, this resolution will be fine. You can use this option to save space on your memory card, or if you have no need for the highest resolution full HD mode.

- **640 × 480.** This is so-called VGA resolution, suitable for display on computer monitors and, possibly, old standard-definition televisions. (Remember the ones with CRT tubes instead of LCD, LED, or plasma displays?) This lower-resolution format is less demanding of your storage, too, requiring about 82 megabytes per minute capture, and providing more than three hours of video clips on a single 16GB card. You can use this resolution for productions destined for display on the Internet, and other similar uses, although most destinations, including YouTube, work very well with full HD and standard HD formats.

You really have only one choice to make in terms of frame rates. The standard HD format's frame rate is fixed at 60 fps, which provides smooth video at this lower resolution. When using VGA resolution, the frame rate is fixed at 30 fps. Your option comes when selecting full HD, which can be captured using *either* 30 fps or 24 fps. You choose resolution and frame in the Movie Recording Size entry of the Movie Shooting 2 menu, which is available *only* when the Mode Dial is rotated to the Movie position.

The difference lies in the two "worlds" of motion images: film and video. The standard frame rate for motion picture film is 24 fps, while the video rate, at least in the United States, Japan, and those other places using the NTSC standard is 30 frames per second (or more accurately, *fields per* second). Computer-editing software can handle either type, and convert between them. The choice between 24 fps and 30 fps is determined by what you plan to do with your video.

The short explanation is that, for technical reasons I won't go into here, shooting at 24 fps gives your movie a "film" look, excellent for showing fine detail. However, if your clip has moving subjects, or you pan the camera, 24 fps can produce a jerky effect called "judder." A 30 fps or 60 fps rate produces a home-video look that some feel is less desirable, but which is smoother and less jittery when displayed on an electronic monitor. I suggest you try both and use the frame rate that best suits your tastes and video-editing software. Just remember: 24 fps for *detail*, 30 fps for *action*.

Note: the 30 fps and 60 fps rates are used in countries where the *NTSC* television standard is in place, such as North America, Japan, and Korea. In countries where the PAL standard reigns, such as Europe, Russia, China, Africa, and Australia, the equivalents are 25/50 fps.

Other Movie Settings

As I mentioned, the Movie Settings menus can be summoned by the MENU button only when the T6 has been set to Movie mode (rotate the Mode Dial to the Movie position). The five settings on the Movie 1 menu (see **Figure 38.1**) include:

- **Movie Exposure.** Choose Auto to allow the camera to select the exposure for you. In Manual mode, the settings are much like Manual still photo exposure mode.

 First, rotate the Main Dial to change the shutter speed. Note that the frame rate will not change, and will remain at 60, 30, or 24 frames per second, but the amount of time each *frame* is exposed during that interval will be adjusted. For technical reasons, you'll get the best results using a shutter speed that is *no briefer* than about twice the frame rate—for example, 1/125th second with 60 fps and 1/60th second at 30 fps or 24 fps. You can use a higher shutter speed to adjust the exposure, however, if, say, you want to use a larger f/stop.

 Hold down the Av button and rotate the Main Dial to adjust the aperture. You can use manual control over the shutter speed and aperture to depart from automatic exposures to provide a specific mood, or because you need a particular shutter speed for aperture.

For most shooting, however, you'll probably want to set Movie Exposure on Auto.

- **AF Method (FlexiZone—Single, Face Detection Live, or Quick Mode).** This option, explained earlier in the live view lesson, lets you choose between phase detection, contrast detection, and contrast detection with "face" recognition. In movie modes, none of these autofocus modes will track a moving subject.

- **AF w/Shutter Button During Movie Recording.** You can choose Enable, to allow refocusing during movie shooting, or Disable, to prevent it. Refocusing after you've begun capturing a movie clip can be a good thing or a bad thing, so you want to be able to control when it happens. If you select Enable, then you can refocus during capture by pressing the shutter button. Refocusing will take place *only* when you press the shutter button; the T6 is not able to refocus continually as you shoot.

 Changing the focus during capture can be dangerous—your image is likely to go out of focus for a fraction of a second while the camera refocuses. That might not be bad if you plan on editing your movie and can remove the out-of-focus part of the clip. But refocusing during a shot can be disconcerting. Note that even if you've set the

T6 to Quick mode focus, it will use phase detection only at the *beginning* of the clip; subsequent refocusing will be performed using the FlexiZone—Single mode. Most of the time, I set this parameter to Disable to avoid accidentally refocusing during a shot.

- **Movie Recording Shutter/AE Lock Button.** Use this choice to specify what happens when you press the shutter release halfway or use the AE lock button. The default behavior is to have the autoexposure *and* autofocus locked when the shutter button is depressed halfway. I recommend leaving the setting at the default. If you like, you can assign exposure lock to the shutter release, and AF activation to the AE lock button (marked with the asterisk at the upper-right edge of the T6). A full list of your options for this entry are shown in **Table 38.1**, in case you need to know them.

- **Movie Recording Highlight Tone Priority.** Choose Enable to improve the detail in highlights in your movie clips, say, when shooting under high-contrast lighting conditions. Use Disable if you'd like to keep the standard tonal range, which is optimized for middle gray tones. If you enable this feature, then a feature called the *Auto Lighting Optimizer* is disabled, and your ISO speed range is limited to ISO 200 to ISO 12800.

Table 38.1 Shutter/AE Lock Button Functions

Option	Shutter release half-press	AE lock button function	Purpose
AF/AE lock	Activates autofocus	Locks exposure	Autofocus and lock exposure separately; normal operation.
AE lock/AF	Locks exposure	Activates autofocus	Lock exposure, then AF after reframing.
AF/AF lock, No AE lock	Activates autofocus	Hold while taking a still photo to shoot at current AF setting	Avoid refocusing when taking a still while shooting a movie.
AE/AF, No AE lock	Meters but does not lock exposure	Activates autofocus	Exposure metering continues after shutter is half-pressed; initiate autofocus when desired.

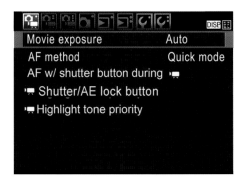

Figure 38.1 The Movie 1 menu has five entries.

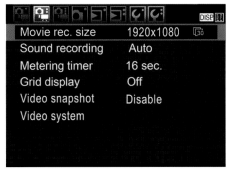

Figure 38.2 The Movie 2 menu has six entries.

The Movie 2 menu has six entries (see **Figure 38.2**):

- **Movie Rec. Size.** Choose 1920 × 1080 at 30 fps or 24 fps; 1280 × 1080 at 60 fps; or 640 × 480 at 30 fps, as described earlier.
- **Sound Recording.** Choose Auto, Manual, or Disable. At the Auto setting, the camera will adjust the sound levels; select Manual and you can use the left/right cross keys to adjust the recording level, with a volume unit meter at the bottom of the screen. Disable turns sound recording off. You might not want to record sound if you want to shoot silently, and add voice over, narration, music, or other sound later in your movie-editing software.
- **Metering Timer (4 sec. to 30 min.).** This option allows you to specify how long the EOS T6's metering system will remain active before switching off.

- **Grid Display.** You can select Off, Grid #1, or Grid #2. Grid #1 is a "rule of thirds" type grid that you might find useful for composition. Grid #2 is a 6 × 4–cell array that's handy when lining up architectural shots and other images with vertical or horizontal lines.
- **Video Snapshot.** You can enable or disable this feature, described later in this chapter.
- **Video System.** Choose NTSC or PAL. As I noted earlier, the NTSC television standard is used in North America, Japan, Korea, and a few other places. The PAL standard reigns in Europe, Russia, China, Africa, Australia, and other places.

The Movie Shooting 3 menu (not pictured) has four entries that have the same functions as their counterparts in the still photography Shooting 2 menu. Those entries are Exposure Compensation, Auto Lighting Optimizer, Custom White Balance, and Picture Style. They operate in exactly the same manner.

Seven Easy Steps to Shoot Video

To shoot movies with your camera, just follow these steps:

1 **Change to Movie mode.** Rotate the Mode Dial to the Movie setting.

2 **Focus.** Use the autofocus or manual focus techniques described in the preceding lessons to achieve focus on your subject.

3 **Begin filming.** Press the Start/Stop button to begin shooting. A red dot appears in the upper-right corner of the screen to show that video/sound are being captured. The access lamp also flashes during shooting.

4 **Changing shooting functions.** As with live view, you can change settings or review images normally when shooting video.

5 **Lock exposure.** You can lock in exposure by pressing the Reduce button on top of the T6, located just aft of the Main Dial. Unlock exposure again by pressing the Magnify button.

6 **Stop filming.** Press the Start/Stop button again to stop filming.

7 **View your clip.** Press the Playback button (located to the bottom right of the LCD). You will see a still frame with the clip timing and a symbol telling you to press the SET button to see the clip. A series of video controls appear at the bottom of the frame. Press SET again and the clip begins. A blue thermometer bar progresses in the upper-left corner as the timing counts down. Press SET to stop at any time.

GETTING INFO

The information display shown on the LCD screen when shooting movies is almost identical to the one displayed during live view shooting. The settings icons in the left column show the same options, which can be changed in Movie mode, too, except that the Drive mode choice is replaced by an indicator that shows the current movie resolution and time remaining on your memory card.

39. CAPTURING BETTER VIDEO AND SOUND

YOU DON'T HAVE to be Quintin Tarantino or Martin Scorcese to shoot great movies. Even if you're just shooting casual video to document your vacation or to showcase stage performances by your kids or grandkids, your T6 has all the tools you need to make top-notch movies. You can even create video montages and edit your flicks right in the camera, as I'll show you in **Lesson 40** and **Lesson 41**. This lesson provides tips for improving your video with better sound, and a storytelling approach to shooting.

Tips for Better Audio

Recording high-quality audio is a must for those home videos or epic sagas you're planning to produce. Here are some ideas for improving the quality of the audio your T6 records:

- **Get the camera and its built-in microphone close to the speaker.** The farther the microphone is from the audio source, the less effective it will be in picking up that sound. This means you'll have to boost volume, which will also amplify any background noises. While having to position the camera closer to the subject affects your lens choices and lens perspective options, it will make the most of your audio source. Fortunately, most common movie subjects can be captured from moderate distances. A stage production in an auditorium can be problematic, though. Get as close as possible and use the widest zoom setting available to take in the performers. You'll still have to contend with audience noises (including wild applause for exceptional performances), but that's really part of the show.
- **Turn off any sound makers you can.** When *not* shooting in a noisy environment, you can improve your audio by taking care of little things like fans and air handling units that aren't obvious to the human ear but will be picked up by the microphone. Turn off any machinery or devices that you can, plus make sure cell phones are set to silent mode. Also, do what you can to minimize sounds such as wind, radio, television, or people talking in the background. Don't forget to close windows if you're inside to shut out noises from the outside.
- **Make sure to record some "natural" sound.** If you're shooting video at an event of some kind, make sure you get some background sound that you can add to your audio as desired in postproduction, if you're ambitious and using movie-editing software.
- **Consider recording audio separately.** Keeping with the amateur post-production theme, keep in mind you can record audio separately. That can be a useful technique if you're doing a mini-documentary, or perhaps a humorous movie in which the narration doesn't quite describe what really happened. Lip-syncing is probably beyond most of the people you're going to be shooting, but there's nothing that says you can't record narration separately and add it later. Any time the speaker is off camera, you can work with separately recorded narration, using a program like Adobe Premiere, rather than recording the speaker on camera. This can produce much cleaner sound. As mentioned earlier, you can disable recording audio with the Sound Recording entry in the Movie 2 menu.

Planning with a Shooting Script and Storyboards

If you're planning a more ambitious video production using video-editing software to assemble multiple shorter clips together, there are a number of different things to consider, such as a shooting script or storyboard, which can help you create a better-organized movie. A shooting script is nothing more than a coordinated plan that covers both audio and video and provides order and structure for your video. A detailed script will cover what types of shots you're going after, what dialogue you're going to use, audio effects, transitions, and graphics. When you first begin shooting movies, your shooting scripts will be very simple. As you gain experience, you'll learn how to tell stories with video, and

will map out your script in more detail before you even begin to capture the first sequence.

A shooting script will also help you if you need to shoot out of sequence. For example, you may have several scenes that take place on different days at the same location. It probably will make sense to shoot all those scenes at one time, rather than in the movie's chronological order. You can check the shooting script to see what types of video and audio you need for the separate scenes, as well as what dialogue your "actors" need to deliver (even if, as is the case for most informal videos, the "lines" are ad-libbed as you shoot).

A storyboard is a series of panels providing visuals of what each scene should look like. While the ones produced by Hollywood are

generally of very high quality, there's nothing that says drawing skills are important for this step. Stick figures work just fine if that's the best you can do. The storyboard just helps you visualize locations, placement of actors/actresses, props, and furniture, and also helps everyone involved get an idea of what you're trying to show. It also helps show how you want to frame or compose a shot. You can even shoot a series of still photos and transform them into a "storyboard" if you want, as I did in **Figure 39.1**. In this case, I took pictures of a parade, and then used them to assemble a storyboard to follow when I shot video at a similar parade on a later date.

Figure 39.1 A storyboard is a series of simple sketches or photos to help visualize a segment of video.

Storytelling in Video

Composition is one of the most important tools available to you for telling a story in video. However, while you can crop a still frame any old way you like, in movie shooting, several factors restrict your composition, and impose requirements you just don't always have in still photography (although other rules of good composition do apply). For example, you're limited to horizontal compositions only, which limits your options with very tall or vertically oriented subjects.

Within those compositional restraints, you still have a great deal of flexibility. It only takes a second or two for an establishing shot to impart the necessary information. For example, **Figure 39.2** shows typical scenes for a video documenting a model being photographed in a Rock and Roll music setting using close-ups and talking heads, but an establishing shot showing the studio where the video was captured helps set the scene.

Provide variety too. Change camera angles and perspectives often and never leave a static scene on the screen for a long period of time. (You can record a static scene for a reasonably long period and then edit in other shots that cut away and back to the longer scene with close-ups that show each person talking.)

When editing, keep transitions basic! I can't stress this one enough. Watch a television program or movie. The action "jumps" from one scene or person to the next. Fancy transitions that involve exotic "wipes," dissolves, or cross fades take too long for the average viewer and make your video ponderous.

Here's a look at the different types of commonly used compositional tools:

- **Establishing shot.** Much like it sounds, this type of composition, as shown at top left in **Figure 39.2**, establishes the scene and tells the viewer where the action is taking place. Let's say you're shooting a video of your offspring's move to college; the establishing shot could be a wide shot of the campus with a sign welcoming you to the school in the foreground. Another example would be for a child's birthday party; the establishing shot could be the front of the house decorated with birthday signs and streamers or a shot of the dining room table decked out with party favors and a candle-covered birthday cake. In this case, I wanted to show the studio where the video was shot.

- **Medium shot.** This shot is composed from about waist to head room (some space above the subject's head). It's useful for providing variety from a series of close-ups and also makes for a useful first look at a speaker. (See **Figure 39.2**, top right.)

- **Close-up.** The close-up, usually described as "from shirt pocket to head room," provides a good composition for someone talking directly to the camera. Although it's common to have your talking head centered in the shot, that's not a requirement. In the middle-left image in **Figure 39.2**, the subject was offset to the right. This would allow other images, especially graphics or titles, to be superimposed in the frame in a "real" (professional) production. But the compositional technique can be used with T6 videos, too, even if special effects are not going to be added.

- **Extreme close-up.** When I went through broadcast training, this shot was described as the "big talking face" shot and we were actively discouraged from employing it. Styles and tastes change over the years and now the big talking face is much more commonly used (maybe people are better looking these days?) and so this view may be appropriate. Just remember, the T6 is capable of shooting in high-definition video and you may be playing the video on a high-def TV; be careful that you use this composition on a face that can stand up to high definition. (See middle right, **Figure 39.2**.)

- **"Two" shot.** A two shot shows a pair of subjects in one frame. (See **Figure 39.2**, lower left.) They can be side by side or one subject in the foreground and one in the background. This does not have to be a head-to-ground composition. Subjects can be standing or seated. A "three shot" is the same principle except that three people are in the frame.

- **Over-the-shoulder shot.** Long a composition of interview programs, the "over-the-shoulder shot" uses the rear of one person's head and shoulder to serve as a frame for the other person. This puts the viewer's perspective as that of the person facing away from the camera. (See **Figure 39.2**, lower right.)

Figure 39.2 Using a variety of shots helps tell a story.

40. EDIT MOVIES IN YOUR CAMERA

ALTHOUGH MOVIE EDITING software, such as Apple iMovie or Corel VideoStudio Ultimate (for Macs and PCs, respectively) are versatile and not too complex, there's a lot you can do right in your Rebel T6, including reviewing your movies and making simple edits to your movies and video. You can play back your video snapshots (discussed next) from the confirmation screen, too. Or, you can exit Movie mode and review your stills and images and play any of them back by pressing the Playback button located to the lower right of the LCD. A movie will be marked with an icon in the upper-left corner. Press the SET button to play back a movie when you see this icon.

As a movie is being played back, options appear at the bottom of the screen, as shown in **Figure 40.1**. When the icons are shown, use the left/right cross keys to highlight one, and then press the SET button to activate that function:

1 **Playback time.** This bar displays playback progress as the clip is shown.
2 **Exit.** Exits playback mode.
3 **Playback.** Begins playback of the movie. To pause playback, press the SET button again. That restores the row of icons, so you can choose a function.
4 **Slow motion.** Displays the video in slow motion.
5 **First frame.** Jumps to the first frame of the video, or the first scene of an album's first video snapshot.
6 **Previous frame.** Press SET to view the previous frame; hold down SET to rewind the movie.
7 **Next frame.** Press SET to view the next frame; hold down SET to fast forward the movie.
8 **Last frame.** Jumps to the last frame of the video, or the last scene of the album's last video snapshot.
9 **Edit.** Summons an editing screen (see **Figure 40.2**).
10 **Background music/volume.** Select to turn background music on/off. Rotate the Main Dial to adjust the volume of the background music. I showed you how to install background music on your memory card in **Lesson 34**.

While reviewing your video, you can trim from the beginning or end of your video clip by selecting the scissors symbol. The icons that appear have the following functions:

1 **Trim beginning.** Trims off all video prior to the current point.
2 **Trim end.** Removes video after the current point.
3 **Playback.** Play back your video to reach the point where you want to trim the beginning or end.
4 **Save.** Saves your video to the memory card. A screen appears offering to save the clip as a New File, or to Overwrite the existing movie with your edited clip.
5 **Exit.** Exits editing mode.
6 **Adjust volume.** Modifies the volume of the background music.

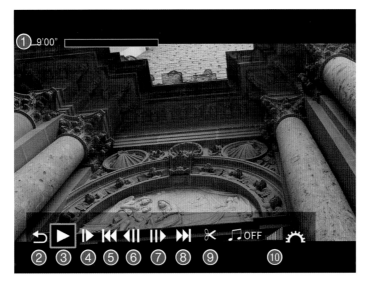

Figure 40.1 Options appear as a movie is being played back.
1. Playback time
2. Exit
3. Playback
4. Slow motion
5. First frame
6. Previous frame
7. Next frame
8. Last frame
9. Edit
10. Background music/volume

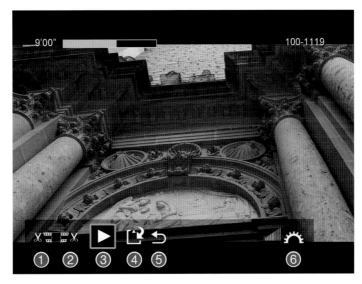

Figure 40.2 The editing screen allows you to snip off the beginning or end of a video clip.
1. Trim beginning
2. Trim end
3. Playback
4. Save
5. Exit
6. Adjust volume

41. CREATE A MINI-MOVIE WITH VIDEO SNAPSHOTS

VIDEO SNAPSHOTS ARE movie clips, all the same length, assembled into video albums as a single movie. You can choose a fixed length of 2, 4, or 8 seconds for all clips in a particular album. Video snapshots are a great way to create your own montages, especially when you aren't planning to shoot extensive conventional video. For example, you might be concentrating on vacation stills that day, but still would like a concise video compilation to view later. You can use your compilation as a summary of your day, or as a reminder of where you were and what you were doing. Video snapshots are useful on vacations, or to create a mini-documentary, say, of the daily life of a child or grandchildren, or even a pet.

I use the 2-second length to compile mini-movies of fast-moving events, such as parades, giving me a lively album of clips that show all the things going on without lingering too long on a single scene. The 8-second length is ideal for landscapes and many travel clips, because the longer scenes give you time to absorb all the interesting things to see in such environments. The 4-second clips are an excellent way to show details of a single subject, such as a cathedral or monument when traveling, or an overview of the action at a sports event.

Activate the video snapshot feature in the Movie 2 menu, as pictured in **Figure 38.2** above. Then, follow these steps:

1 **Begin an album.** In Movie mode, press the Start/Stop button. The T6 will begin shooting a clip, and a set of blue bars will appear at the bottom of the frame showing you how much time remains before shooting stops automatically.

2 **Save your clip as a video snapshot album.** A confirmation appears at the bottom of the LCD. Press the left/right cross keys to choose the left-most icon, Save as Album. (see **Figure 41.1**).

3 **Press SET.** Your first clip will be saved as the start of a new album.

4 **Shoot additional clips.** Press the Movie button to shoot more clips of the length you have chosen and indicated by the blue bars at the bottom of the frame. At the end of the specified time, the confirmation screen will appear again.

5 **Add to album or create new album.** Select the left-most icon again if you want to add the most recent clip to the album you just started. Alternatively, you can choose the second icon from the left, Save as New Album (see **Figure 41.1**). That will complete your previous album and start a new one with the most recent clip.

Or, if you'd like to review the most recent clip first to make sure it's worth adding to an album, select the Playback Video Snapshot icon (see **Figure 41.1**) and review the clip you just shot. You can then Add to Album, Create New Album, or Delete the Clip.

6 Delete most recent clip. If you decide the most recent clip is not one you'd like to add to your current album, you can select Do Not Save to Album/Delete without Saving to Album (see **Figure 41.1**).

7 Switch from video snapshots to conventional movie clips. If you want to stop shooting video snapshots and resume shooting regular movie clips (of a variable length), navigate to the Movie 2 menu again, and disable Video Snapshot.

In Playback mode, you can play back your snapshots that have been combined into an album using the same screen used to review stills and movies. In single-image display, an icon in the upper left of the review image indicates that the snapshot can be played back by pressing the SET button.

The clips in a video album can be edited, either by deleting a particular snapshot from the collection or moving it to a new location within the album. Video album editing inside your camera is much like editing conventional video clips, as described previously.

Figure 41.1
① Save as album
② Save as new album
③ Playback video snapshot
④ Do not save to album

7

BEST ACCESSORIES FOR THE CANON EOS REBEL T6

CHAPTER 7

The Rebel T6 has so many features and capabilities built-in that many budding photo enthusiasts find that they can shoot hundreds—or thousands—of great photos using nothing more than their imaginations and the contents of the box their camera came in. It's true that the camera *takes* pictures, but the photographer *makes* them. Even so, you'll find that certain accessories—including many that are quite inexpensive—can open doors to even more photo opportunities. Lenses can bring you closer to distant subjects or take in more of a scene when your back is—literally—up against a wall. As I showed you in **Lesson 20**, inexpensive add-ons can let you view familiar subjects from a new, close-up perspective. Other accessories make it possible to capture subjects under lower light levels, brighten your movie scenes, or help you add special visual effects to your pictures without recourse to an image-editing program. Whether you're looking at accessories to provide new capabilities or just let you perform some tasks more conveniently, I think you'll find the gear described in this chapter interesting.

42. CHANGE YOUR PERSPECTIVE WITH LENSES!

WOULD YOU PURCHASE an off-road vehicle and never shift into four-wheel drive? Why buy a camera with interchangeable lenses, and then never purchase or use an additional lens? Actually, both scenarios are possible. Some folks like to have four-wheel drive because they live in snowy climes and want the ability to tough it out in rough weather—"just in case"—even though they never personally drive off-road. Similarly, some Rebel T6 owners find that the kit lens does everything they want in an optic and have more of a need for the camera's other features, such as its great movie-making capabilities, than for its lens interchangeability.

However, if you purchased this book, it's likely you're a photo enthusiast looking to get the most of what the T6 can do, and are one of those who start thinking, "What lens will give me some new options I can use to expand my photography into other areas?" This lesson will explain some of those options and help you choose the type of lens that will really boost your creative opportunities. Here's a general guide to the sort of capabilities you can gain by adding a new lens to your repertoire.

- **Wider perspective.** Your 18-55mm f/3.5-5.6 lens has served you well for moderate wide-angle shots. Now you find your back is up against a wall and you *can't* take a step backward to take in more subject matter. Perhaps you're standing on the rim of the Grand Canyon, and you want to take in as much of the breathtaking view as you can. You might find yourself just behind the baseline at a high school basketball game and want an interesting shot with a wider-angle look tossed in the mix. There's a lens out there that will provide you with what you need, such as the EF-S 10-22mm f/3.5-4.5 USM zoom. It costs close to $600 new— roughly what you paid for your T6—but is one of the best wide-angle zooms available.

 If you want to stay in the roughly $400 price category, you'll need something like the Sigma 10-20mm f/3.5 EX DC HSM Zoom lens. For a distorted view, there is the Rokinon HD8M-C 8mm f/3.5 HD and Opteka 6.5mm f/3.5 HD Aspherical fisheye lenses, for about $200 and $125, respectively. Both are manual focus lenses, but as you learned in **Lesson 10**, conventional wide-angle lenses have a great deal of depth-of-field, and fisheyes have even more. **Figure 42.1** shows the perspective you get from an ultra-wide-angle fisheye lens.

- **Bring objects closer.** A long lens brings distant subjects closer to you, offers better control over depth-of-field, and avoids the perspective distortion that wide-angle lenses provide. Telephoto lenses compress the apparent distance between objects in your frame. In the telephoto realm, Canon is second to none, with a dozen or more offerings in the sub-$650 range, including the Canon EF 100-300mm f/4.5-5.6 USM autofocus and Canon EF 70-300mm f/4-5.6 IS USM autofocus telephoto zoom lenses. If those prices are a little steep, you can find older models, like the Canon EF 75-300mm f/4.5-5.6 zoom used to capture **Figure 42.2** (at the 300mm zoom setting) in new or used condition for a couple hundred dollars. Sigma, Tamron, and other third parties offer more affordable long lenses. I also find it's often worth a trip to www.keh.com to look for used lenses—from Canon and other vendors.

Figure 42.1 A manual focus fisheye lens can be an affordable—if quirky—addition to your lens kit.

Figure 42.2 The 300mm zoom setting on a 75-300mm zoom allowed capturing this unsuspecting avian.

- **Bring your camera closer.** Macro lenses allow you to focus to within an inch or two of your subject. Canon's best close-up lenses are all fixed focal length optics in the 50mm to 180mm range (including the well-regarded Canon EF-S 60mm f/2.8, mentioned in **Lesson 20**, and Canon EF 100mm f/2.8 USM macro autofocus lenses). But you'll find macro zooms available from Sigma and others. The more affordable third-party lenses don't tend to focus quite as close, but they provide a bit of flexibility when you want to vary your subject distance (say, to avoid spooking a skittish creature).

- **Look sharp.** While many high-end lenses, particularly Canon's luxury "L" line, are prized for their sharpness and overall image quality, most brand-name optics are plenty sharp for most applications, lacking only the more rugged build quality demanded by professional photographers who subject their equipment to vigorous, daily use.

- **More speed.** Your Canon EF 75-300mm f/4.5-5.6 telephoto zoom lens might have the perfect focal length and sharpness for sports photography, but the maximum aperture won't cut it for night baseball or football games, or, even, any sports shooting in daylight if the weather is cloudy or you need to use some unusually fast shutter speed, such as 1/4,000th second. You might be happier with the Canon EF 100mm f/2 medium telephoto for close-range stuff, or even the pricier Canon EF 135mm f/2L. If money is no object, you can spring for Canon's 400mm f/2.8 and 600mm f/4 L-series lenses (both with image stabilization and priced in the four- and five-figure stratosphere).

Or, maybe you just need the speed and can benefit from an f/1.8 or f/1.4 lens in the 20mm-85mm range. They're all available in Canon mounts (there's even an 85mm f/1.2 and 50mm f/1.2 for the real speed demons). With any of these lenses you can continue photographing under the dimmest of lighting conditions without the need for a tripod or flash.

- **Special features.** Accessory lenses give you special features, such as tilt/shift capabilities to correct for perspective distortion in architectural shots. These are invariably expensive and not usually needed by the average Rebel T6 owner. Canon offers four of these TS-E lenses in 17mm, 24mm, 45mm, and 90mm focal lengths, at more than $1,300 to $2,000 (and up) each. You'll also find macro lenses, including the MP-E 65mm f/2.8 1-5x macro photo lens, a manual focus lens which shoots *only* in the 1X to 5X life-size range. If you want diffused images, check out the EF 135mm f/2.8 with two soft-focus settings. The fisheye lenses mentioned earlier and all IS (image-stabilized) lenses also count as special-feature optics. The recent Canon EF 8-15mm f/4L Fisheye USM ultra-wide zoom lens is highly unusual in offering a *zoomable* fisheye range. Tokina's 10-17mm fisheye zoom is its chief competitor; I've owned one and it is not in the same league in terms of sharpness and speed (or price). Despite their cost, these lenses with special features are available for rent, can be purchased used, or might be justifiable for those who do a great deal of photography requiring their features.

Categories of Lenses

Lenses can be categorized by their intended purpose—general photography, macro photography, and so forth—or by their focal length. The range of available focal lengths is usually divided into three main groups: wide-angle, normal, and telephoto. Prime lenses fall neatly into one of these classifications. Zooms can overlap designations, with a significant number falling into the catch-all, wide-to-telephoto zoom range. This section provides more information about focal length ranges, and how they are used.

Any lens with an equivalent focal length of 10mm to 20mm is said to be an *ultra-wide-angle lens*; from about 20mm to 40mm (equivalent) is said to be a *wide-angle lens*. *Normal lenses* have a focal length roughly equivalent to the diagonal of the film or sensor, in millimeters, and so fall into the range of about 45mm to 60mm (on a full-frame camera). *Telephoto lenses* usually fall into the 75mm and longer focal lengths, while those from about 300mm to 400mm and longer often are referred to as *super-telephotos*.

Using Wide-Angle and Wide-Zoom Lenses

To use wide-angle prime lenses and wide zooms, you need to understand how they affect your photography. Here's a quick summary of the things you need to know.

- **More depth-of-field.** Practically speaking, wide-angle lenses offer more depth-of-field at a particular subject distance and aperture. You'll find that helpful when you want to maximize sharpness of a large zone, but not very useful when you'd rather isolate your subject using selective focus (telephoto lenses are better for that).

- **Stepping back.** Wide-angle lenses have the effect of making it seem that you are standing farther from your subject than you really are. They're helpful when you don't want to back up or can't because there are impediments in your way.
- **Wider field of view.** While making your subject seem farther away, as implied above, a wide-angle lens also provides a larger field of view, including more of the subject in your photos.
- **More foreground.** As background objects retreat, more of the foreground is brought into view by a wide-angle lens. That gives you extra emphasis on the area that's closest to the camera. Photograph a structure with a normal lens/normal zoom setting, and the front yard probably looks fairly conventional in your photo (that's why they're called "normal" lenses), as you can see in **Figure 42.3**. Switch to a wider lens and you'll discover that your lawn now makes up much more of the photo, as shown in **Figure 42.4**. So, wide-angle lenses are great when you want to emphasize that lake in the foreground, but problematic when your intended subject is located farther in the distance.

Figure 42.3 A "normal" or intermediate focal length produces this look.

Figure 42.4 An extreme wide-angle lens emphasizes everything in the foreground.

- **Super-sized subjects.** The tendency of a wide-angle lens to emphasize objects in the foreground, while de-emphasizing objects in the background, can lead to a kind of size distortion that may be more objectionable for some types of subjects than others. Shoot a bed of flowers up close with a wide angle, and you might like the distorted effect of the larger blossoms nearer the lens. Take a photo of a family member with the same lens from the same distance, and you're likely to get some complaints about that gigantic nose in the foreground.
- **Perspective distortion.** When you tilt the camera so the plane of the sensor is no longer perpendicular to the vertical plane of your subject, some parts of the subject are now closer to the sensor than they were before, while other parts are farther away. So, buildings, flagpoles, or NBA players appear to be falling backward, as you can see in **Figure 42.5**. While this kind of apparent distortion (it's not caused by a defect in the lens) can happen with any lens, it's most apparent when a wide angle is used.
- **Steady cam.** You can get better results hand-holding a wide-angle lens at slower shutter speeds, without need for image stabilization, than you can with a telephoto lens. The reduced magnification of the wide-lens or wide-zoom setting doesn't emphasize camera shake like a telephoto lens does.
- **Interesting angles.** Many of the factors already listed combine to produce more interesting angles when shooting with wide-angle lenses. Raising or lowering a telephoto lens a few feet probably will have little effect on the appearance of the distant subjects you're shooting. The same change in elevation can produce a dramatic effect for the much-closer subjects typically captured with a wide-angle lens or wide-zoom setting.

Figure 42.5 Tilting the camera back produces this "falling back" look in architectural photos.

Avoiding Potential Wide-Angle Problems

Wide-angle lenses have a few quirks that you'll want to keep in mind when shooting so you can avoid falling into some common traps. Here's a checklist of tips for avoiding common problems:

- **Symptom: converging lines.** Unless you want to use wildly diverging lines as a creative effect, it's a good idea to keep horizontal and vertical lines in landscapes, architecture, and other subjects carefully aligned with the sides, top, and bottom of the frame. That will help you avoid undesired perspective distortion, like that shown in **Figure 42.5**. Sometimes it helps to shoot from a slightly elevated position, if available, so you don't have to tilt the camera up or down.

- **Symptom: color fringes around objects.** Lenses are often plagued with fringes of color around backlit objects, produced by *chromatic aberration* in which the three colors of light (red, green, and blue) don't all focus at the same plane or position on the sensor. One type can be reduced by using a smaller f/stop; the other cannot. Canon uses a material in many of its lenses called *low diffraction index glass* (or UD elements, in Canon nomenclature) to cancel the color fringing effect.

- **Symptom: lines that bow outward.** Some wide-angle lenses cause straight lines to bow outward, with the strongest effect at the edges. In fisheye (or *curvilinear*) lenses, this defect is a feature, as you saw earlier in **Figure 42.1**. Manufacturers like Canon do their best to minimize or eliminate it (producing a *rectilinear* lens), often using *aspherical* lens elements (which are not cross-sections of a sphere). You can also minimize less severe barrel distortion simply by framing your photo with some extra space all around, so the edges where the defect is most obvious can be cropped out of the picture.

- **Symptom: dark corners and shadows in flash photos.** The Canon EOS T6's built-in electronic flash is designed to provide even coverage for lenses as wide as 17mm. If you use a wider lens, you can expect darkening, or *vignetting*, in the corners of the frame. At wider focal lengths, the lens hood of some lenses can cast a semi-circular shadow in the lower portion of the frame when using the built-in flash. Sometimes removing the lens hood or zooming in a bit can eliminate the shadow. An optional external flash unit attached to the camera will have a higher vantage point to eliminate the problem of lens hood shadow, too.

- **Symptom: light and dark areas when using polarizing filter.** One popular filter among landscape photographers is the *polarizing filter*, which reduces reflections and provides more contrast in a sky dotted with clouds. These filters work best when the camera is pointed 90 degrees away from the sun (the sun is at your left or right) and have the least effect when the camera is oriented with the sun behind you. However, ultra-wide-angle lenses, like the Canon 10-20mm lens have a wide enough field of view to cause problems. Think about it: when a 10mm lens is pointed at the proper 90-degree angle from the sun, objects at the edges of the frame will be oriented at 135 to 41 degrees, with only the center at exactly 90 degrees. Either edge will have much less of a polarized effect. The solution is to avoid using a polarizing filter only with lenses having an actual focal length of less than 18mm.

Using Telephoto and Tele-Zoom Lenses

Telephoto lenses also can have a dramatic effect on your photography, and Canon is especially strong in the long-lens arena, with lots of choices in many focal lengths and zoom ranges. You should be able to find an affordable telephoto or tele-zoom to enhance your photography in several different ways. Here are the most important things you need to know. In the next section, I'll concentrate on telephoto considerations that can be problematic—and how to avoid those problems.

- **Selective focus.** You learned about selective focus in **Lesson 11**. So, as you know, telephoto lenses have reduced depth-of-field within the frame, allowing you to use selective focus to isolate your subject. You can open the lens up wide to create shallow depth-of-field (see **Figure 42.6**) or close it down a bit to allow more to be in focus. The flip side of the coin is that when you *want* to make a range of objects sharp, you'll need to use a smaller f/stop to get the depth-of-field you need. Like fire, the depth-of-field of a telephoto lens can be friend or foe.

- **Getting closer.** Telephoto lenses bring you closer to wildlife, sports action, and candid subjects. No one wants to get a reputation as a surreptitious or "sneaky" photographer (except for paparazzi), but when applied to candids in an open and honest way, a long lens can help you capture memorable moments while retaining enough distance to stay out of the way of events as they transpire.

Figure 42.6 A wide f/stop helped isolate the Key Deer from its background.

- **Reduced foreground/increased compression.** Telephoto lenses have the opposite effect of wide angles: they reduce the importance of things in the foreground by squeezing everything together. This compression even makes distant objects appear to be closer to subjects in the foreground and middle ranges. You can use this effect as a creative tool with proper f/stop selection.
- **Accentuates camera shakiness.** Telephoto focal lengths hit you with a double-whammy in terms of camera/photographer shake. The lenses themselves are bulkier, more difficult to hold steady, and may even produce a barely perceptible see-saw rocking effect when you support them with one hand halfway down the lens barrel. Telephotos also magnify any camera shake. It's no wonder that image stabilization is popular in longer lenses.
- **Interesting angles require creativity.** Telephoto lenses require more imagination in selecting interesting angles, because the "angle" you do get on your subjects is so narrow. Moving from side to side or a bit higher or lower can make a dramatic difference in a wide-angle shot but raising or lowering a telephoto lens a few feet probably will have little effect on the appearance of the distant subjects you're shooting.

Avoiding Telephoto Lens Problems

Many of the "problems" that telephoto lenses pose are really just challenges and not that difficult to overcome. Here is a list of the seven most common picture maladies and suggested solutions.

- **Symptom: flat faces in portraits.** Head-and-shoulders portraits of humans tend to be more flattering when a focal length of 50mm to 85mm is used. Longer focal lengths compress the distance between features like noses and ears, making the face look wider and flat. A wide angle might make noses look huge and ears tiny when you fill the frame with a face. So stick with 50mm to 85mm focal lengths, going longer only when you're forced to shoot from a greater distance, and wider only when shooting three-quarters/full-length portraits, or group shots.
- **Symptom: blur due to camera shake.** Use a higher shutter speed (boosting ISO if necessary), consider an image-stabilized lens, or mount your camera on a tripod, monopod, or brace it with some other support. Of those three solutions, only the first will reduce blur caused by *subject* motion; an IS lens or tripod won't help you freeze a race car in mid-lap.
- **Symptom: color fringes.** Chromatic aberration, explained in the wide-angle section above, is the most pernicious optical problem found in telephoto lenses. There are others, including spherical aberration, astigmatism, coma, curvature of field, and similarly scary-sounding phenomena. The best solution for any of these is to use a better lens that offers the proper degree of correction or stop down the lens to minimize the problem. But that's not always possible. Your second-best choice may be to correct the fringing in your favorite RAW conversion tool or image editor. Photoshop's Lens Correction filter offers sliders that minimize both red/cyan and blue/yellow fringing.
- **Symptom: low contrast from haze or fog.** When you're photographing distant objects, a long lens shoots through a lot more atmosphere, which generally is muddied up with extra haze and fog. That dirt or moisture in the atmosphere can reduce contrast and mute colors. Some feel that a skylight or UV filter can help, but this practice is mostly a holdover from the film days. Digital sensors are not sensitive enough to UV light for a UV filter to have much effect. So, you should be prepared to boost contrast and color saturation in your Picture Styles menu or image editor if necessary.

- **Symptom: low contrast from flare.** Lenses are furnished with lens hoods for a good reason: to reduce flare from bright light sources at the periphery of the picture area, or completely outside it. Because telephoto lenses often create images that are lower in contrast in the first place, you'll want to be especially careful to use a lens hood to prevent further effects on your image (or shade the front of the lens with your hand).

- **Symptom: dark flash photos.** Edge-to-edge flash coverage isn't a problem with telephoto lenses as it is with wide angles. The shooting distance is. A long lens might make a subject that's 50 feet away look as if it's right next to you, but your camera's flash isn't fooled. You'll need extra power for distant flash shots, and probably more power than your T6's built-in flash provides. If you take many telephoto flash pictures, an add-on external flash may be needed.

- **Symptom: lines that curve inward.** Pincushion distortion is found in many telephoto lenses. You might find after a bit of testing that it is worse at certain focal lengths with your particular zoom lens. Like chromatic aberration, it can be partially corrected using tools like Photoshop's Lens Correction filter and Photoshop Elements' Correct Camera Distortion filter. (See **Figure 42.7.**)

Figure 42.7 Pincushion distortion can cause parallel lines to appear to curve inward.

43. EIGHT BEST LENSES FOR CREATIVE PHOTOGRAPHY

THE CANON EOS T6 is frequently purchased with a lens, usually the Canon EF-S 18-55mm f/3.5-5.6. There are several versions available new and used, including an original edition, a Mark II version, and the most recent IS STM autofocus lens that has image stabilization (IS) and stepper motor technology (STM). As I've noted before, the kit lens is very versatile and may be all you need. However, if you do want to expand your zoom range there are other lenses to consider. For the most part, my recommendations will stick to zoom lenses with variable focal lengths available; prime lenses, which have a single focal length (such as 50mm, 85mm, or 200mm) are generally more expensive. That's often because they are extra sharp and/or have large maximum apertures in the f/1.4 to f/2.8 range. I've described some other lenses, including Canon macro lenses, elsewhere in this book. The lenses I'm describing in this lesson are some of the others that are popular among Rebel T6 owners. But first, when buying an accessory lens, there are several factors you'll want to consider:

- **Cost.** You might have stretched your budget a bit to purchase your T6, so you might want to keep the cost of your first lenses fairly low. Fortunately, there are excellent lenses available that will add from $100 to $600 to the price of your camera if purchased at the same time.
- **Zoom range.** If you have only one lens or two lenses, you'll want a fairly long zoom range to provide as much flexibility as possible. Fortunately, the two most popular basic lenses for the T6 have 3X to 5X zoom ranges, extending from moderate wide-angle/normal out to medium telephoto. These are fine for everyday shooting, portraits, and some types of sports.
- **Adequate maximum aperture.** You'll want an f/stop of at least f/3.5 to f/4 for shooting under fairly low-light conditions. The thing to watch for is the maximum aperture when the lens is zoomed to its telephoto end. You may end up with no better than an f/5.6 maximum aperture at the long end. That's not great, but you can often live with it; many kit lens owners do just fine.
- **Image quality.** Any lens you buy should have good image quality, befitting a camera with 18 MP of resolution, because that's one of the primary factors that will be used to judge your photos. Even at a low price, the several different lenses sold for the T6 include that extra-low dispersion (UD) glass and aspherical elements that minimize distortion and chromatic aberration; they are sharp enough for most applications. If you read the user evaluations in the online photography forums, you know that owners of the kit lenses have been very pleased with their image quality.
- **Size matters.** A good walking-around lens is compact in size and light in weight.
- **Fast/close focusing.** Your first lens should have a speedy autofocus system. The Canon lenses that focus the fastest will include the USM (ultrasonic motor) or STM designation in their name. You'll also want close focusing (to 12 inches or closer) to let you use your lens for some types of macro photography.

You can find comparisons of the lenses discussed in the next section, as well as third-party lenses from Sigma, Tokina, Tamron, and other vendors, in online groups and websites. I'll provide my recommendations but obtaining more information from these additional sources is always helpful when making a lens purchase, because, while camera bodies come and go, lenses may be a lifetime addition to your kit.

Here are my nominations for the eight most useful lenses you should consider; many of them are quite affordable. While I am recommending only Canon lenses here, you should look for Sigma, Tamron, Tokina, and other third-party brands for lower-cost alternatives, and scour keh.com for used lens bargains. My select list includes three wide-angle to telephoto zooms, and five that cover the normal/short telephoto range to medium/long telephoto range.

- **Canon EF-S 18-135mm f/3.5-5.6 IS STM autofocus lens.** This one, priced at about $550 when not purchased in a kit, is an upgrade from a similar earlier ultrasonic motor-driven lens without the stepper motor technology. It's also light, compact (you can see it mounted on the T6 in **Figure 43.1**) and covers a useful range from true wide-angle to intermediate telephoto. As with Canon's other affordable zoom lenses, image stabilization partially compensates for the slow f/5.6 maximum aperture at the telephoto end, by allowing you to use longer shutter speeds to capture an image under poor lighting conditions.

- **Canon EF-S 18-200mm f/3.5-5.6 IS autofocus lens.** This one, priced at about $700, has been popular as a basic lens for the T6, because it's light, compact, and covers a full range from true wide-angle to long telephoto. Image stabilization keeps your pictures sharp at the long end of the zoom range, allowing the longer shutter speeds that the f/5.6 maximum aperture demands at 200mm. Automatic panning detection turns the IS feature off when panning in both horizontal and vertical directions. An improved "Super Spectra Coating" minimizes flare and ghosting, while optimizing color rendition.

- **Canon EF-S 17-85mm f/4-5.6 IS USM autofocus lens.** This older lens (introduced in 2004) is a very popular "basic" lens still available for use with the T6. The allure here with this lens is the longer telephoto range, coupled with the built-in image stabilization, which allows you to shoot rock-solid photos at shutter speeds that are at least two or three notches slower than you'd need normally (say, 1/8th second instead of 1/30th or 1/60th second), as long as your subject isn't moving. It also has a quiet, fast, reliable ultrasonic motor. (See **Figure 43.2**.)

- **Canon EF-S 55-250mm f/4-5.6 STM IS telephoto zoom lens.** This is an image-stabilized EF-S lens (which means it can't be used with Canon's 1.3X and 1.0X crop-factor pro cameras), providing the longest focal range in the EF-S range to date, and that 4-stop Image Stabilizer. It's about $300, but it's worth the cost for the stabilization. (See **Figure 43.3**.)

- **Canon EF 24-85mm f/3.5-4.5 USM autofocus wide-angle telephoto zoom lens.** If you can get by with normal focal length to medium telephoto range, Canon offers four affordable lenses, plus one more expensive killer lens that's worth the extra expenditure. All of them can be used on full-frame or cropped-frame digital Canons, which is why they include "wide angle" in their product names. They're really wide-angle lenses only when mounted on a full-frame camera. This one, priced in the $300 range if you can find one for sale, offers a useful range of focal lengths, extending from the equivalent of 38mm to 136mm.

43.1

43.2

Figure 43.1 The EF-S 18-135mm f/3.5-5.6 IS STM lens is affordable and features near-silent autofocus that's perfect for video shooting.

Figure 43.2 The Canon EF-S 17-85mm f/4-5.6 IS USM autofocus lens is another popular lens.

43.3

Figure 43.3 The Canon EF-S 55-250mm f/4-5.6 STM IS telephoto zoom lens.

- **Canon EF 28-105mm f/3.5-4.5 II USM autofocus wide-angle telephoto zoom lens.** If you want to save about $100 and gain a little reach compared to the 24mm–85mm zoom, this 45mm–168mm (equivalent lens) might be what you are looking for.
- **Canon EF 28-200mm f/3.5-5.6 USM autofocus wide-angle telephoto zoom lens.** If you want one lens to do everything except wide-angle photography, this 7X zoom lens costs less than $400 in excellent condition used and takes you from the equivalent of 45mm out to a long 320mm.

- **Canon EF-75-300mm f/4.5-5.6 III telephoto zoom.** No image stabilization or exotic lens elements in this lens, and it has a relatively small maximum aperture, but you can usually locate a new one for under $200, or a used one for even less. It verges on compact at the 75mm zoom position but gets considerably longer as you zoom toward the 300mm range. I consider this a decent lens and a bargain for T6 owners looking to stretch their telephoto reach without stretching their budget. (See **Figure 43.4**.)

What Lenses Can You Use?

With the Canon T6, the compatibility issue is a simple one: It accepts any lens with the EF or EF-S designation, with full availability of all autofocus, auto aperture, autoexposure, and image-stabilization features (if present). It's comforting to know that any EF (for full-frame or cropped sensors) or EF-S (for cropped sensor cameras only) lens will work as designed with your camera. That's more than 100 million lenses built to date.

43.4

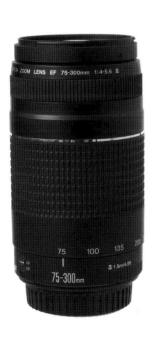
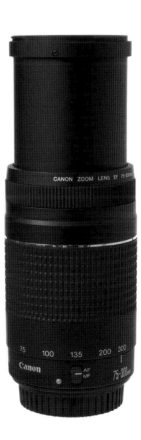

Figure 43.4 A bargain at $200 or less, the Canon EF 75-300mm f/4.5-5.6 telephoto zoom doesn't have the large maximum aperture needed for low-light photography and gets longer as you zoom.

Ingredients of Canon's Alphanumeric Soup

The actual product names of individual Canon lenses are fairly easy to decipher; they'll include either the EF or EF-S designation, the focal length or focal length range of the lens, its maximum aperture, and some other information. Additional data may be engraved or painted on the barrel or ring surrounding the front element of the lens. Here's a decoding of what the individual designations mean:

- **EF/EF-S.** If the lens is marked EF, it can safely be used on any Canon EOS camera, film or digital. If it is an EF-S lens, it should be used only on an EF-S-compatible camera.

- **Focal length.** Given in millimeters or a millimeter range, such as 60mm in the case of a popular Canon macro lens, or 17-55mm, used to describe a medium-wide to short-telephoto zoom.

- **Maximum aperture.** The largest f/stop available with a particular lens is given in a string of numbers that might seem confusing at first glance. For example, you might see 1:1.8 for a fixed-focal length (prime) lens, and 1:4.5-5.6 for a zoom. The initial 1: signifies that the f/stop given is actually a ratio or fraction (in regular notation, f/ replaces the 1:). With many zoom lenses, the maximum aperture changes as the lens is zoomed to the telephoto position, so a range is given instead: 1:4.5-5.6. (Some zooms, called *constant aperture* lenses, keep the same maximum aperture throughout their range.)

- **Autofocus type.** Most newer Canon lenses use Canon's *ultrasonic motor* autofocus system and are given the USM designation, or they include stepper motor (STM) technology. If USM or STM does not appear on the lens or its model name, the lens uses the less sophisticated AFD (arc-form drive) autofocus system or the micromotor (MM) drive mechanism.

- **Series.** Canon adds a Roman numeral to many of its products to represent an updated model with the same focal length or focal length range, so some lenses, such as the kit lens offered with the T6, will have a II or III added to their name.

- **Pro quality.** Canon's more expensive lenses with more rugged construction and higher optical quality, intended for professional use, include the letter L (for "luxury") in their product name. You can further differentiate these lenses visually by a red ring around the lens barrel and the off-white color of the metal barrel itself in virtually all telephoto L-series lenses.

- **Filter size.** You'll find the front lens filter thread diameter in millimeters included on the lens, preceded by a Ø symbol, as in Ø67 or Ø72.

- **Special-purpose lenses.** Some Canon lenses are designed for specific types of work, and they include appropriate designations in their names. For example, close-focusing lenses such as the Canon EF-S 60mm f/2.8 Macro USM lens incorporate the word *Macro* into their name. Lenses with perspective control features preface the lens name with T-S (for tilt-shift). Lenses with built-in image-stabilization features, such as the nifty EF 28-300mm f/3.5-5.6L IS USM telephoto zoom include *IS* in their product names.

44. KILLER ACCESSORIES

YOU NEEDN'T SPEND a fortune on gadgets for your camera. Even the costliest accessories have more affordable counterparts that are suitable for careful or occasional use. Many of the recommended add-ons described in this lesson cost less than $50, and some are virtually free.

Battery Grips

Battery grips from third-party vendors are inexpensive—in the $40 range—and provide two significant benefits that you can discern from the name alone: *battery* and *grip*. The typical grip can hold two LP-E10 batteries, effectively doubling the time you can spend shooting before you need to swap a depleted battery for a fresh one. In addition, a well-designed grip can actually *improve* the handling of your T6, especially when you swivel the camera to a vertical position for portrait-oriented images. The added bulk fits some hands better, and the vertical controls on the grip (once you're comfortable with using them) prevent some awkward finger-twisting maneuvers.

Grips are especially useful if you're involved in some heavy-duty shooting, such as sports or event photography, particularly when continuous shooting is involved. In these situations, you may spend more time than you can spare swapping batteries. As I noted, a grip holding *two* batteries effectively doubles your shooting time between reloads. So, I end up using such a grip when shooting sports and video to gain extended battery life, and for portraits and basketball, where the vertical orientation seems natural. There are indeed types of photography that, once you've gotten used to using a vertical grip, you'll wonder how you ever got along without one. Those who shoot video are special candidates, because I guarantee that, sooner or later, you're going to run out of power while capturing an important scene.

Those of us with limited budgets and unlimited amounts of equipment lust can be better served by one of the many available third-party grips offered by Vello, Vivitar, Neewer, Meike, and others (although they all are identical and seem to be made by Meike). The Vivitar version—VIV-PT-T6—is shown in **Figure 44.1**. The shell and components include a lot of plastic, but a textured rubber covering on the bottom and part of the front/back surfaces are comfortable to hold. The grip mates easily with your T6 and once mounted looks like it belongs.

The only weak point seems to be the battery door of the camera itself, which must be removed to use the grip. The door snaps right off. Don't open the door all the way; release the latch and open it a tiny bit, then give a gentle tug toward the back of the camera to release the hinge pins, so the door can be removed. You won't need to pull hard; if you do that means the angle is wrong. You don't want to snap off the plastic hinge pins. I can only speculate about how difficult it would be to purchase a replacement for a lost/broken door from Canon.

Once inserted into the empty battery compartment of the T6, the grip's internal batteries supply juice. A cable supplied, shown at upper right in the figure, connects the shutter-release button of the grip to the remote-control port of the T6, so you can snap a photo using the grip's control.

44.1

Figure 44.1 A low-cost Vivitar battery pack/vertical grip.

LED Video Lights

If you're paying attention, you already know that you can't use electronic flash bursts when shooting video. Instead, you can also use more powerful special-purpose LED video lights that mount on the accessory shoe, like the one shown in **Figure 44.2**. It's a Neewer 160-LED dimmable panel that cost me all of $26. It uses six AA batteries and comes with colored filter/diffusers to tailor the light to match daylight or tungsten ambient illumination. A rotating on/off/intensity wheel lets you adjust the light from soft fill to blinding main light.

Lighting choices for amateur videographers are a lot better these days than they were a decade or two ago and won't cost you a lot. An inexpensive incandescent or LED video light, which will easily fit in a camera bag, can be found for less than $30. Even more expensive LED video lights may sell for less than $100. Work lights sold at many home improvement stores can also serve as video lights since you can set the camera's white balance to correct for any color casts. You'll need to mount these lights on a tripod or other support, or, perhaps, to a bracket that fastens to the tripod socket on the bottom of the camera.

Much of the challenge depends upon whether you're just trying to add some fill light on your subject versus trying to boost the light on an entire scene. A small video light will do just fine for the former. It won't handle the latter.

Filter Accessories

As your collection of lenses grows, your need for an expanding number of filters may grow as well. Canon lenses take a variety of filter sizes, but that doesn't necessarily mean you must purchase duplicate sets of filters. If you choose to use a "protective" UV or clear glass filter, you *will* want a separate filter for each lens (I recommend the brass versions of B+W's lineup). But your polarizer, infrared, neutral-density filters can all be shared among your lenses through the use of inexpensive *step-up* and *step-down* rings. The former allows using larger filters on lenses that have smaller diameter filter threads (say, a 72mm filter on a lens that has a 55mm filter thread), or smaller filters (if they can be used without vignetting) on a lens with a larger filter thread.

I get some use out of a set of Fotodiox anodized aluminum 49-52mm, 52-55mm, 55-58mm, 58-62mm, 62-67mm, 67-72mm, and 72-77mm *step-up rings*, which can be used in combination for multiple "steps." I also have the Fotodiox 77-72mm, 72-67mm, 67-62mm, 62-58mm, 58-55mm, 55-52mm, and 52-49mm *step-down* rings. These come in handy when I want to fit a particular filter on an odd-ball lens. They cost about $17 a set.

However, I recommend purchasing specific rings that go directly from each lens filter size to the size of your "standard" set of filters. For example, if you wanted to standardize on 72mm filters and owned lenses with 67mm, 55mm, and 49mm filter threads, you'd purchase 67-72mm, 55-72mm, and 49-72mm adapters. Those rings would allow you to avoid combining rings; the more rings in a set, the more likely you are to experience vignetting in the corners of your images. Vignetting is also more likely when using wide-angle lenses that have a larger field of view.

I reduce the traveling size of my filter kit by threading all my 72mm filters together into a stack. Then a threaded "stack cap" set with a male threaded screw in 72mm front cap and female threaded 72mm rear cap allows carrying. If I'm traveling with just my "trinity" I screw the 67-72mm step up ring into the back of the stack and use a 67mm rear cap instead. (See **Figure 44.3**.)

44.2

44.3

Figure 44.2 This inexpensive LED video light cost $26.

Figure 44.3 Step-up and step-down rings, and a set of "stack caps" can streamline your use of filters.

What do you do if your filter stack is stuck? Or if you have screwed a filter onto the front of your lens too tightly and can't remove it? What you need is a handy filter remover band, like the one shown in **Figure 44.4**. It's an elastic latex band that you can wrap around the filter edge and grip the filter tightly enough that it can (usually) be easily removed. The band is compact and eliminates the need for a filter "wrench." Best of all, it's probably the least expensive accessory mentioned in this chapter. It's actually a strip from a tourniquet band, and you can probably get one for free the next time you donate blood. Non-latex versions are usually on hand for those with allergies.

44.4

Figure 44.4 An elastic band can help you loosen a stubborn filter.

Just-for-fun Lenses

Earlier in this chapter I recommended some favorite lenses for your T6, made by Canon and a few third-party vendors. However, if you're interested in exploring some quirky (and relatively inexpensive) options, there are a number of routes open to you.

One way to go is to purchase an adapter that allows using lenses sold for another camera platform on your Canon T6. Your camera's "flange to sensor" distance—the gap between the lens mount and the sensor—is relatively short, so there is room to insert an adapter that will allow you to use Nikon lenses, old Minolta optics, and other brands (although in manual focus and exposure modes only). You just need to accept manual focus and, usually, a ring on the adapter that's used to stop down the "adopted" lens to the aperture used to take the photo. You can find these from Novoflex (www.novoflex.com), Fotodiox (www.fotodiox.com), Rainbow Imaging (www.rainbowimaging.biz), Cowboy Studio (www.cowboystudio.com), and others. Some adapters of certain types and brands sell for as little as $20 to $30. While you are giving up autofocus and full autoexposure features, you can often retain automatic exposure by setting the T6 to Aperture Priority, stopping down to the f/stop you prefer, and firing away.

Adapters pave the way to mounting some really oddball lenses on your camera. With a C-mount to Canon adapter, you can readily use lenses not meant for still cameras. My absolute favorite lens bargain is the 35mm f/1.7 Fujian (no relation to Fuji) optic, which I purchased brand new for a total of $28, with the EF mount adapter included in the price. It's actually a tiny CCTV (closed-circuit television) lens in C-mount (a type of lens mount used for cine cameras). It's manual focus and manual f/stop, of course (and it works in Aperture Priority mode); it's a toy lens, or something like a super-cheap Lensbaby, or a great experimental lens for fooling around. It covers the full APS-C frame (more or less; expect a bit of vignetting in the corners at some f/stops), so you'll have to use it in APS-C crop mode. It is not incredibly sharp wide open and exhibits a weird kind of "bokeh" (out-of-focus rendition of highlights) that produces fantasy-like images. The only drawback (or additional drawback, if you will), is that you may have to hunt some to find one; the manufacturer doesn't sell directly in the USA. I located mine on Amazon.com.

Once you own the C-mount to EF mount adapter, you can use any of the host of other similar CCTV lenses on your T6. Also relatively cheap, but not necessarily of equal quality, are a 25mm f/1.4, 35mm f/1.7, and 50mm f/1.4 lens (shown in **Figure 44.5**), as well as a Tamron 8mm f/1.4, and other lenses that I haven't tried and probably won't cover, even though they cover the APS-C image area, but are worth borrowing to try out if you have a friend who does CCTV.

Figure 44.5 These CCTV lenses make great "toys" for your T6.

Figure 44.6 Lensbaby optics are specialized lens replacements with some special soft-focus features.

You should also explore the wonderful Lensbaby line of optics, because Canon doesn't offer anything similar, nor as delightfully affordable. The Lensbaby comes in several varieties and uses distortion-heavy glass elements mounted on a system that allows you to bend, twist, and distort the lens's alignment to produce transmogrified images unlike anything else you've ever seen. Like the legendary cheap-o Diana and Holga cameras, the pictures are prized expressly because of their plastic image quality. Jack and Meg White (formerly of the White Stripes) have, in fact, sold personalized Diana and Holga cameras on their website for wacky *lomography* (named after the Lomo, another low-quality/high-concept camera). The various Lensbaby models are for more serious photographers, if you can say that about anyone who yearns to take pictures that look like they were shot through a glob of corn syrup.

Lensbaby optics are capable of creating all sorts of special effects. You use a Lensbaby by shifting the front mount to move the lens's sweet spot to a particular point in the scene. (See **Figure 44.6**.) This is basically a selective focus lens that gets very soft outside the sweet spot. There are several different types, which can be interchanged using the system's Optic Swap technology.

- **Macro.** A Lensbaby accessory makes it possible to use this tool for macro photography.
- **Wide-angle/telephoto conversion.** Add-on lenses convert the basic Lensbaby into a wide-angle or telephoto version.
- **Edge 80.** This is an 80mm f/2.8 lens with a flat field of focus—ideal for portraits. It has a 12-blade adjustable aperture, focuses as close as 17 inches, and functions as a tilt-shift lens. When canted, the Edge 80 delivers a slice of tack sharp focus through the image, bordered by a soft blur. When pointed straight ahead, Edge 80 can be used like a conventional lens. You can also use it in any of the traditional selective focus applications you'd use one of Canon's PC-E lenses for—but *not* for perspective correction. (It tilts, but it does not shift from side to side.)
- **Creative aperture kit.** Various shaped cutouts can be used in place of the regular aperture inserts that control depth-of-field. These shapes can include things like hearts, stars, and other shapes.
- **Optic swap kit.** This three-lens accessory kit provides different adapters that include a pinhole lens, plastic lens, and single glass lens.

Among the interchangeable components are the Sweet 35, Fisheye, Soft Focus, Double Glass, Single Glass, and Pinhole lenses. Models have names like Composer Pro, Composer, Muse, Control Freak, and Scout, each with varying amounts of adjustments. (The Scout does not bend at all, making it ideal for use with the fisheye component.)

Other Lensbaby models have the same tilting lens configuration as previous editions but are designed for easier and more precise distorting movements. Hold the camera with your finger gripping the knobs as you bend the camera to move the central "sweet spot" (sharp area) to any portion of your image. With two (count 'em) multicoated optical glass lens elements, you'll get a blurry image, but the amount of distortion is under your control. F/stops from f/2 to f/22 are available to increase/decrease depth-of-field and allow you to adjust exposure. The 50mm lens focuses down to 12 inches and is strictly manual focus/manual exposure in operation. At up to $300 or so, these lenses are not cheap accessories, but there is really no other easy way to achieve the kind of looks you can get with a Lensbaby.

Figure 44.7 is an example of the type of effect you can get, in photographs crafted by Cleveland photographer Nancy Balluck. Nancy regularly gives demonstrations and classes on the use of these optics, and you can follow her work at www.nancyballuckphotography.com.

44.7

Figure 44.7 Everything is uniquely blurry outside the Lensbaby's "sweet spot," but you can move that spot around within your frame at will.

45. READY, STEADY, WITH YOUR TRIPOD

WHILE IMAGE STABILIZATION (IS) built into many Canon lenses might let you use a tripod slightly less often, when you want absolutely the best possible sharpness when working with telephoto lenses or exposures longer than 1/15th second, a tripod is a must.

Indeed, of all the things that help photographers produce great photographs, use of tripods is not only one of the most important, but is also the most neglected. Novice photographers frequently underestimate the importance of camera steadiness and its effect on image sharpness. You may *think* you can take landscape photographs in the waning light of dusk with a wide-angle lens setting hand-held at 1/30th second, but you'd probably be shocked to see how much sharper the same shot is at 1/125th second. And you'd be further surprised to see how even *more* sharpness can be gained at 1/125th second by adding a tripod.

A good tripod is a vital ingredient in this task. While it's true that lugging a heavy tripod around makes your camera outfit that much heavier and your life a little more complicated, it is also true that a good solid tripod will help you improve the quality of your photographs. Tripods give you a chance to make sure that your camera is properly positioned and level and also help you make sure your composition is spot on.

The enhanced stability a tripod offers also provides you with the opportunity for improved creativity. With a good tripod, exposures of 30 seconds or longer are possible. This means that you can produce some stunning effects and solve some normally unsolvable problems. Turn the local creek into a mystical field of spun glass. Eliminate cars and pedestrians from roadways and sidewalks. Create razor sharp landscape photos with amazing depth-of-field. A good tripod is your ticket to admission for a whole new world of photography.

These are the main uses for a camera support:

- **Steady the camera during long exposures.** A tripod or monopod can improve sharpness for any exposure longer than 1/60th second and is essential when exposing for more than one second—unless you're looking for a creative streaky look.
- **Reduce vibration when shooting with longer focal lengths.** Telephoto lenses magnify camera shake, so that even a little vibration is multiplied. Front-heavy lenses can make the tendency to jiggle the camera even worse. Even if your camera has vibration reduction/image stabilization/anti-shake built into the body or you have a similar feature in a lens, a tripod or monopod can often do a better job.
- **Increase sharpness during close-ups.** Shooting up close has the same effect as working with a telephoto lens—any vibrations are multiplied. In addition, as the camera moves, your carefully calculated focus point shifts. A tripod reduces the effect of camera shake and helps keep your focus point where it belongs.
- **Lock in your composition.** You can be sure that when Ansel Adams was creating his most memorable compositions, he used a tripod to lock in the arrangement long before he snapped the shutter. You can do the same.
- **Let you get in the picture.** With the camera on a tripod or other steadying support, you can trip the self-timer and run and get in the photo yourself.
- **Provide a base for panoramic photos.** Shooting a wide-screen panorama calls for the ability to swivel the camera through an arc of overlapping photos. You can do this hand-held, of course, and image-editing tools like Adobe's PhotoMerge (found in Photoshop and Elements) actually do a good job of re-orienting your panorama set as they are stitched together. But for the best results, using a tripod with a panorama head (discussed later in this chapter) can't be beat.
- **Allow repeated exposures for bracketing and High Dynamic Range** (HDR). HDR photography is all the rage right now, allowing shooters to take several pictures at different exposures, and then merge them together into a single shot with greater detail in highlights, shadows, and everything in-between. This technique works best if all the exposures are made with the camera locked down on a tripod.

The biggest mistake first-time tripod buyers make is to buy the wrong one. That wastes your money and time, and you'll probably lose more than a few pictures when your inadequate tripod isn't up to the task. That big, impressive, $49 aluminum tripod you saw at the megamart certainly looks like a good deal. It comes with leg braces and a nifty two-way tilting head. Unfortunately, those leg braces are there because that poorly designed tripod would probably sway like a reed without them (most quality tripods have legs that are stiff enough that they don't need special bracing). That pan-and-tilt head is slow to use and doesn't offer the flexibility you need to orient your camera quickly and precisely. After toting your bargain tripod around for a while, you'll find that its "lightweight" aluminum construction makes it, compared to better quality units, as easy to carry around as a boat anchor. Save your $49 and apply the money to a good-quality tripod that can, potentially, last a lifetime. A basic tripod has certain features, shown in **Figure 45.1**. These include:

1 **Mounting platform.** Some sort of head that attaches to your camera is needed. The available styles include tilting heads, or, commonly, a rotating *ball head* like the one shown in **Figure 45.1**. Inexpensive tripods may include a non-removable head. More expensive models are sold as tripod legs, with a platform where you can attach the type of head you prefer.

2 **Locking legs.** The legs extend to provide additional height, and can come in two, three, four, or more extension sections, with a locking mechanism to fix their length at the desired height.

3 **Leg braces.** As I noted, these are found on some tripods to provide more rigidity. They are very common on cheap tripods, because the spindly legs on those models absolutely need bracing. But braces can be found on some more expensive tripods, too, adding to their stability.

4 **Rubber feet.** Most tripod legs end with soft rubber feet, which can rest on many types of surfaces without damaging them. With some tripods, the rubber feet can be removed or replaced with spikes suitable for implanting in the earth or other surfaces.

5 **Center column.** The center column is a pole that can be extended to provide additional height. Some center columns can be reversed to point the camera downward.

6 **Anchoring hook.** The hook is often used to support an extra weight (your camera bag will do), adding some additional solidity to a tripod.

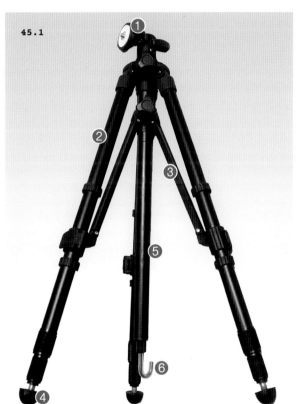

45.1

Figure 45.1 Components of a typical tripod.
① Mounting platform
② Locking legs
③ Leg braces
④ Rubber feet
⑤ Center column
⑥ Anchoring hook

The secret to finding a tripod you can live with is to consider all the features you must have, add in some that you'd really like to have, and buy a tripod that offers those capabilities at a reasonable price. This section will get you started, with an overview of essential tripod features. I'll explain the most important considerations in more detail later in the lesson, along with some tripod alternatives, ranging from monopods to Gorillapods, clamps, and beanbags.

- **Cost.** What can you afford? Your budget is the first place to start, as the amount of money you have to spend on your tripod will affect the features you'll expect to have. Decent tripods can cost $100 and up. Tripods come in different configurations and are made from different materials, as described next.

- **Capacity.** One of the specifications that vendors list for their tripods is *load capacity*. This is the amount of weight *with lens mounted* that the tripod can reasonably be expected to support without the legs bowing or bending. Load capacities vary from a few pounds to about 22 pounds, and on up to 44 pounds or more (they're often designed with capacities measured in kilograms, which is where these odd numbers come from). If you use a heavy camera and/or long lenses (say, for wildlife photography or birding), you need to take that into account and choose a tripod that can support your gear reliably.

- **Maximum height.** This is the height at which the tripod will place the camera, generally measured without the center column (if present) extended. You'll want a tripod that can bring the camera at least up to eye level (although, ironically, for many types of photography, eye level can be the *worst* and least imaginative position for your camera). Most tripods will have a maximum height of 50 to 60 inches or a little more. I own one older studio tripod that extends to nearly seven feet, and I need a step-stool to look through the camera—which is why this one is used only in the studio these days.

- **Minimum height.** Tripod specs also show the minimum height they can be set at, which is useful for photographing plant life and other subjects that are low to the ground. This height isn't necessarily the height of the tripod when the legs are completely collapsed—many models allow folding the legs out at an extreme angle to take the tripod head down to within a few inches of the ground. Or, you may be able to reverse the center column and mount your camera upside down to get very low.

- **Folded length.** The length of the tripod when all the legs are collapsed can be important when traveling. This size parameter is often a compromise between compactness, sturdiness, and cost. Three-section tripods tend to be a little cheaper, a little more solid, and collapse to a larger size than their four-section kin. A four-section tripod will collapse down to a smaller height (making it a better choice for travel and backpacking) but may be a bit more expensive and slightly less sturdy. The extra section also means the tripod may take longer to set up, and slightly increases the chance of breakdown since there's one more part to malfunction.

- **Materials/Weight.** The material a tripod is made of goes hand-in-hand with its weight. Some materials, such as carbon fiber, basalt, and titanium provide less weight to carry around, but can cost considerably more.

- **Tripod head.** Very cheap tripods tend to be furnished with a built-in, fixed head. Better quality models are purchased only as a set of legs, with the head bought separately. Buying the head separately gives you more ways to tailor the device to meet your exact needs. It also means deciding can get that much more complicated. I'll explain how to choose a tripod head later in this lesson.

- **Available accessories.** You may want to consider the accessory and expansion options available for your tripod. The ability to substitute the stock center column with a short column, or no column at all, can be useful. Some center columns can be reversed, allowing you to capture those low-to-the-ground plants and critters. Perhaps you want "spike" leg tips that dig into loose ground to steady the tripod. Some models have net-like "trays" that can be suspended between the legs to hold extra gear, or, perhaps, a few rocks to create a little ground-hugging weight. The better tripod brands offer lots of accessories that everyone may not need, but which can be indispensable when you must have them.

Tripod legs, purchased without an attached head, come in a variety of materials. The most common are aluminum and carbon fiber, but alternatives are also available in basalt, titanium, and, believe it or not, wood (which are still available from precision manufacturers like Berlebach). Your choice of material will probably be determined by how much weight you can tolerate, and how much you are willing to pay. Aluminum tripods are the least expensive, but also are the heaviest, while those made from more exotic materials, like multi-layer carbon fiber, may have half the weight, and cost two or three times as much.

Using Your Head

The tripod head holds your camera and allows adjusting its position once the legs have been extended and fixed in place. You'd think any old head for your tripod legs would do. In fact, you'd think it would be easier just to purchase a complete tripod and not have to worry about the whole issue. Well, it *would* be easier, but it wouldn't necessarily be better. In fact, if you buy one of those $49 specials with a fixed tripod head, you're losing a great deal of flexibility.

Purchasing the head that best suits your needs is the second most important decision you can make when it comes to camera support—or perhaps even the first, as you can get by with legs that are too heavy or slow to set up, but most of your picture-taking adjustments once you've set up come from fiddling with the tripod head.

Tripod heads help you get your camera oriented the way the works best for your photograph. For some types of shooting, positioning is no big deal, but for others, the right head can mean the difference between getting the shot and not getting it. Let's take a look at some of the choices available and their strengths and weaknesses. Here are some basics on the type of heads you can choose from:

- **Three-position heads.** This is a simple head that lets you control the camera's position on X-, Y-, and Z-axes. You have three separate locks to unlock and three separate movements to make, but you gain very specific control over how your camera is positioned. Some very nice things about the three-position head are its low cost, small size, and relatively light weight. The big drawback is that it can be a slow process to try and get the head and camera positioned

exactly the way you want. Fail to tighten one of the knobs properly and your camera tilts unexpectedly too.

- **Video heads.** Video-style heads are really designed for video cameras (d'oh), but some photographers like them for still cameras too. A video head features a longish handle that twists to loosen or tighten the head. Loosen the head and swing the camera around and pan and tilt it while a separate control lets you swing the camera from horizontal to vertical. It's not a bad system, although sometimes the handle gets in your way when you're trying to look through the viewfinder. There's a difference though between a video *style* head designed for still cameras versus a true heavy-duty video head made just for video. These heads won't orient your camera vertically the way a still-camera-capable video head will. Another version of these heads is known as "fluid" heads. This variant

uses a liquid to create a damping effect that smoothes out its movements. This feature is more important for video than stills, but if you shoot both, it's worth considering. Fluid heads can get pretty expensive, but there are some inexpensive ones that work well too.

- **Pan/tilt heads.** Pan and tilt heads (see **Figure 45.2**) are inexpensive and flexible choices for the photographer on a budget. They offer separate handles for pan, tilt, and swing movements unlike the video head, which combines all of these in one control. While that may sound like more work, it does come in handy when precision is required because you can set each one in turn, then worry about the next one. When you're working with a video-style head it can be hard to get both dead on without a lot of fussing. Some photographers love the control they provide while others find these frustrating.

45.2

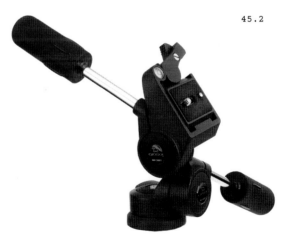

Figure 45.2 Pan/tilt heads are the simplest and least expensive type of tripod head.

- **Ball heads.** These ball-and-socket mounts are the heads that most advanced photographers prefer. They are available in pistol-grip-type configurations, plus the standard ball head. My personal favorite, the ball head, lets you rapidly position your camera with comparative ease. Twist a knob with one hand and swing your camera into position with the other. Get it set just right, and twist the knob in the other direction and your camera's locked in. (See **Figure 45.3**.)

Pro football quarterbacks aren't the only ones who need quick releases; photographers who change lenses often and shoot from tripods and monopods do too. It's not a real big deal if all you're using are wide-angle lenses, but if you're regularly switching between telephoto lenses, a quick-release system is a good idea. It's also handy if you're going to be switching between cameras (such as when spouses are taking turns using the same tripod).

The idea behind a quick-release system is that you have one part that attaches to your tripod head and then another that mounts on the tripod foot of the telephoto lens or zoom, or underneath your camera. This way, rather than unscrewing your lens or camera from the tripod head, you just push a button and pull your camera and lens off the tripod. Swap lenses and so long as the new lens has the right adapter plate, pop your camera back on the tripod. Trust me, it's much faster this way.

There are a fair number of choices out there, but the one of the most popular is the Bogen/Manfrotto QR system, which works well with the Manfrotto pistol-grip ballheads as well pan-and-tilt and other smaller camera mounts. This system includes two parts, a tripod platform, which you can see at left in **Figure 45.4**, and a camera plate, shown at right.

For heavy-duty and pro use, the most popular quick-release equipment uses the Arca Swiss–compatible system used by higher-end ball heads, shown in **Figure 45.3**. You'll find proprietary QR systems available for specific tripod models, too, and even the flexible, super-versatile Gorillapod comes with its own quick-release mechanism.

45.3

Figure 45.3 Ball heads provide a great range of movement.

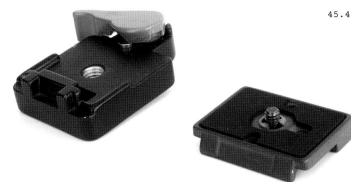

45.4

Figure 45.4 The Bogen/Manfrotto quick-release system is a lower-cost alternative.

Carrying the Load with Monopods and Alternatives

Sometimes you don't need three legs. Sometimes one is just enough. Monopods offer at least some stability (particularly if they're used properly) and also help take the weight of a heavy camera and lens combination off your neck and put it where it belongs, on a solid, extendable rod that can double as a walking stick or flash stand in a pinch. They're also handy for extending your camera up over crowds or for providing bird's- or bug's-eye views thanks to your camera's self timer. You can also mount a remote flash on a monopod and use it for some nice off-camera directional light.

Bear in mind, a monopod isn't a tripod "lite." Whereas a good tripod can open you up to the world of 30-second exposures, even the best monopod isn't going to give you much more than an extra stop or two's worth of shutter speed gain. That telephoto shot that displays camera motion with a 1/500th second shutter speed may be as sharp, when using a monopod, as if you used a 1/1,000th or 1/2,000th second exposure.

Monopods are handy because they carry the weight of your rig and make your life easier. They are particularly useful when shooting sports with long lenses, because in such situations, a bulky tripod can be impractical or even dangerous to yourself and the players.

There are a wide variety of monopods on the market. Some of them are cheap, but good, solid and heavy pieces of equipment. Some of them are just cheap. It is possible to find a useable aluminum one for $30 or so. If you're willing to spend more, you can upgrade to a much better unit. I keep a monopod in the trunk of each of my cars at all times, in a duffel bag that also contains a tripod and a few reflectors. My "main" vehicle stores a sturdy carbon-fiber monopod, while a serviceable aluminum monopod from the same manufacturer resides in my alternate vehicle.

Other alternatives to tripods include Gorillapods, which are all the rage right now amongst equipment freaks because they offer something gadget gurus love—versatility! Although you can stick a camera on one of these gizmos and place the rig on the ground and have a good, steady device, that's not where the fun begins. You see, the Gorillapod has flexible legs that wrap around all sorts of things. So, while you may want to set these things on the ground occasionally, they're also good for wrapping around tree branches or chain link fence posts or street lamps—the possibilities are endless. Gorillapods come in several different sizes; make sure you get one big enough to support your camera (when in doubt go with sturdier than you think you need). (See **Figure 45.5**.)

Beanbags may belong in your kit, as well. The humble beanbag toy from grade school has a bigger brother that actually makes a pretty nifty camera support for a big telephoto lens. You can place the beanbag on a wall or car hood and balance your lens on it. While you're not going to get tripod-like long exposures out of it, you will gain at least a couple of f/stops stability and reduce the weight you're trying to manage while shooting. Beanbags are nice because you can swing your lens around a bit while still benefiting from the support they offer. If you travel a lot, it's easy enough to fly with the beanbag empty to save weight and then buy some cheap dried beans at a local supermarket to fill it back up.

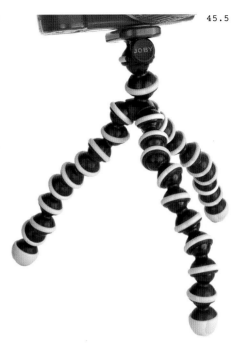

45.5

Figure 45.5 The Gorillapod is a flexible tool—in more than one sense of the word.

8

TROUBLESHOOTING YOUR REBEL T6

CHAPTER 8

Make no mistake, your Canon EOS Rebel T6 is one tough pixel-grabbing machine. There is very little that can go wrong with it. Your camera has few moving parts aside from the shutter and quick-return mirror that flips up and down between still shots, each likely to last for more than 100,000 actuations—roughly 400 shots a week for nearly five years!

Unless you're extraordinarily clumsy or unlucky or give your built-in flash a good whack while it is in use, there's not a lot that can go wrong mechanically with your Rebel T6.

But all digital cameras have sensors that need cleaning to remove dust and grime periodically. And memory cards, while generally reliable, need to be safeguarded because they store your treasured photographs. The last two lessons in this book will show you the keys to trouble-free troubleshooting of the two most common problems you're likely to encounter.

46. YOUR SENSOR'S DIRTY SECRET

EVEN IF YOU never remove the kit lens from your camera, a small amount of dust is going to find a way past the lens mount and, eventually, onto your camera's sensor. That flapping mirror causes the tiniest dust particles to become airborne and, sooner or later, come to rest on the protective filter atop your sensor. Most of the time you'll never notice the presence of dust on your sensor because the tiny particles are out of focus at most aperture settings. But if you happen to take a few shots using a smaller f/stop, such as f/16 or f/22, these artifacts may become visible, especially against a relatively plain background, such as the sky in the enlargement shown in **Figure 46.1**. No matter how careful you are and how cleanly you work, eventually you will get some of this dust on your camera's sensor. Even the cleanest-working photographers using Canon cameras are far from immune.

Don't panic! You won't need to send your camera in to Canon, or even tote it off to a local camera store for a professional cleaning in most cases. The vast majority of dust specks can be quickly removed with a puff of air, and more rigorous cleaning isn't dangerous or difficult. If your dust problem is minor, you can often map it out of your images (making it invisible) using software techniques with the Dust Delete Data feature in the Shooting 3 menu. Even so, you may still be required to manually clean your sensor from time to time. This lesson explains the phenomenon and provides some tips on minimizing dust and eliminating it when it begins to affect your shots.

Figure 46.1 Only the dust spots in the sky are apparent in this shot.

Identifying and Dealing with Dust

Many new owners of digital cameras spot a few tiny specks in their viewfinder and think they have a problem. These sharp, well-defined specks are clinging to the underside of your focus screen and not on your sensor. They have absolutely no effect on your photographs and are merely annoying or distracting. You can often remove dust on the mirror or focus screen with a bulb air blower, which will loosen it and whisk it away. Stubborn dust on the focus screen can sometimes be gently flicked away with a soft brush designed for cleaning lenses. I don't recommend brushing the mirror or touching it in any way. The mirror is a special front-surface-silvered optical device (unlike conventional mirrors, which are silvered on the back side of a piece of glass or plastic) and can be easily scratched. If you can't blow mirror dust off, it's best to just forget about it. You can't see it in the final photograph, anyway.

Others see a bright spot located in the same place in their photos and fear that it is dust. It's more likely you're looking at either a "hot" pixel or one that is permanently "stuck" due to a tiny defect in the sensor. A hot pixel is one that shows up as a bright spot only during long exposures as the sensor warms. A pixel stuck in the "on" position always appears in the image. Both show up as bright red, green, or blue pixels, usually surrounded by a small cluster of other improperly illuminated pixels, caused by the camera's interpolating the hot or stuck pixel into its surroundings, as shown in **Figure 46.2**. A stuck pixel can also be permanently dark. Either kind is likely to show up when they contrast with plain, evenly colored areas of your image. Generally, a small number of defective pixels can be ignored, as they are easy to remove with an image editor. If they become bothersome, Canon can remap your sensor's pixels with a quick trip to a service center.

Actual sensor dust shows up only under certain circumstances. Unless you have an illuminated magnifier, they are difficult to spot even if you remove the lens from your T6 and examine the sensor visually. The sensor is very small, only about 22.3 × 14.9mm (.88 × .57 inches!) as you can see in **Figure 46.3**. To locate dust motes, take a few test shots of a plain, blank surface (such as a piece of paper or a cloudless sky) at small f/stops, such as f/22, and a few wide open. Open Photoshop, copy several shots into a single document in separate layers, then flip back and forth between layers to see if any spots you see are present in all layers. You may have to boost contrast and sharpness to make the dust easier to spot.

Of course, the easiest way to protect your sensor from dust is to prevent it from settling on the sensor in the first place. Some Canon lenses come with rubberized seals around the lens mounts that help keep dust from infiltrating, but you'll find that dust will still find a way to get inside.

Figure 46.2 A stuck pixel is surrounded by improperly interpolated pixels created by the T6's demosaicing algorithm.

Figure 46.3 Your T6's sensor is quite small compared to the camera itself.

Here are my tips for eliminating the problem before it begins:

- **Clean environment.** Avoid working in dusty areas if you can do so. If you find a great picture opportunity at a raging fire, during a sandstorm, or while surrounded by dust clouds, you might hesitate to take the picture, but, with a little caution (don't remove your lens in these situations and clean the camera afterward!) you can still shoot. However, it still makes sense to store your camera in a clean environment. One place cameras and lenses pick up a lot of dust is inside a camera bag. Clean your bag from time to time, and you can avoid problems.

- **Clean lenses.** There are a few paranoid types that avoid swapping lenses in order to minimize the chance of dust getting inside their cameras. It makes more sense just to use a blower or brush to dust off the rear lens mount of the replacement lens first, so you won't be introducing dust into your camera simply by attaching a new, dusty lens. Do this before you remove the lens from your camera, and then avoid stirring up dust before making the exchange.

- **Work fast.** Minimize the time your camera is lensless and exposed to dust. That means having your replacement lens ready and dusted off, and a place to set down the old lens as soon as it is removed, so you can quickly attach the new lens.

- **Let gravity help you.** Face the camera downward when the lens is detached so any dust in the mirror box will tend to fall away from the sensor. Turn your back to any breezes, indoor forced air vents, fans, or other sources of dust to minimize infiltration.

- **Protect the lens you just removed.** Once you've attached the new lens, quickly put the end cap on the one you just removed to reduce the dust that might fall on it.

- **Clean out the mirror box.** From time to time, remove the lens while in a relatively dust-free environment and use a blower bulb like the ones shown in **Figure 46.4** (*not* compressed air or a vacuum hose) to clean out the mirror box area. A blower bulb is generally safer than a can of compressed air, or a strong positive/negative airflow, which can tend to drive dust further into nooks and crannies.

46.4

Figure 46.4 Use a robust air bulb for cleaning your sensor.

- **Be prepared.** If you're embarking on an important shooting session, it's a good idea to clean your sensor *now*, rather than come home with hundreds or thousands of images with dust spots caused by flecks that were sitting on your sensor before you even started. Before I left on my most recent trip to Spain, I put both cameras I was taking through a rigid cleaning regimen, figuring they could remain dust-free for a measly 10 days. I even left my bulky blower bulb at home. It was a big mistake, but my intentions were good.

- **Clone out existing spots in your image editor.** Photoshop and other editors have a clone tool or healing brush you can use to copy pixels from surrounding areas over the dust spot or dead pixel. This process can be tedious, especially if you have lots of dust spots and/or lots of images to be corrected. The advantage is that this sort of manual fix-it probably will do the least damage to the rest of your photo. Only the cloned pixels will be affected.

- **Use filtration in your image editor.** A semi-smart filter like Photoshop's Dust & Scratches filter can remove dust and other artifacts by selectively blurring areas that the plug-in decides represent dust spots. This method can work well if you have many dust spots, because you won't need to patch them manually. However, any automated method like this has the possibility of blurring areas of your image that you didn't intend to soften.

Do It Yourself

While you can choose to let someone else clean your sensor, they will be using methods that are more or less identical to the techniques you would use yourself. None of these techniques are difficult, and the only difference between their cleaning and your cleaning is that they might have done it dozens or hundreds of times. If you're careful, you can do just as good a job. The filters that cover sensors tend to be fairly hard compared to optical glass, which is itself quite rugged. Cleaning the sensor in your T6 within the tight confines of the mirror box simply calls for a steady hand and careful touch.

There are three basic kinds of cleaning processes that can be used to remove dusty and sticky stuff that settles on your dSLR's sensor. All of these must be performed with the shutter locked open. You should do them in this order:

- **Air cleaning.** This process involves squirting blasts of air inside your camera with the shutter locked open. This works well for dust that's not clinging stubbornly to your sensor.
- **Brushing.** A soft, very fine brush is passed across the surface of the sensor's filter, dislodging mildly persistent dust particles and sweeping them off the imager.
- **Liquid cleaning.** A soft swab dipped in a cleaning solution such as ethanol is used to wipe the sensor filter, removing more obstinate particles.

The first step is to place the shutter in the locked and fully upright position for landing. Make sure you're using a fully charged battery or the optional AC Adapter Kit ACK-E10.

1 Remove the lens from the camera and then turn the camera on.
2 Set the EOS T6 to any one of the non-fully automatic modes.
3 You'll find the Clean Manually menu choice in the Set-up 2 menu. Press the SET button.

4 Select OK and press SET again. The mirror will flip up and the shutter will open.
5 Use one of the methods described below to remove dust and grime from your sensor. Be careful not to accidentally switch the power off or open the memory card or battery compartment doors as you work. If that happens, the shutter may be damaged if it closes onto your cleaning tool.
6 When you're finished, turn the power off, replace your lens, and switch your camera back on.

Air Cleaning

Your first attempts at cleaning your sensor should always involve gentle blasts of air. Many times, you'll be able to dislodge dust spots, which will fall off the sensor and, with luck, out of the mirror box. Attempt one of the other methods only when you've already tried air cleaning and it didn't remove all the dust. Here are some tips for doing air cleaning:

- **Use a clean, powerful air bulb.** Your best bet is bulb cleaners designed for the job, like the Giottos Rocket. Smaller bulbs, like those air bulbs with a brush attached sometimes sold for lens cleaning or weak nasal aspirators, may not provide sufficient air or a strong enough blast to do much good.
- **Hold the EOS T6 upside down.** Then look up into the mirror box as you squirt your air blasts, increasing the odds that gravity will help pull the expelled dust downward, away from the sensor. You may have to use some imagination in positioning yourself. (See **Figure 46.5**.)
- **Never use air canisters.** The propellant inside these cans can permanently coat your sensor if you tilt the can while spraying. It's not worth taking a chance.
- **Avoid air compressors.** Super-strong blasts of air are likely to force dust under the sensor filter.

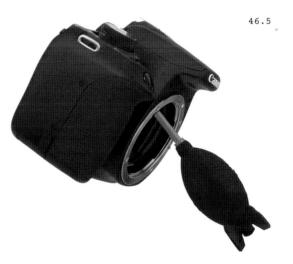

46.5

Figure 46.5 Hold the camera upside down when cleaning to allow dust to fall out.

Brush Cleaning

If your dust is a little more stubborn and can't be dislodged by air alone, you may want to try a brush, charged with static electricity, that can pick off dust spots by electrical attraction. A brush designed specifically for cleaning sensors should be used, like the one shown in **Figure 46.6**, which can be stroked across the short dimension of your camera's sensor.

Ordinary artist's brushes are much too coarse and stiff and have fibers that are tangled or can come loose and settle on your sensor. A good sensor brush's fibers are resilient and described as "thinner than a human hair." Moreover, the brush has a wooden handle that reduces the risk of static sparks.

Brush cleaning is done with a dry brush by gently swiping the surface of the sensor filter with the tip. The dust particles are attracted to the brush particles and cling to them. You should clean the brush with compressed air before and after each use and store it in an appropriate air-tight container between applications to keep it clean and dust-free. Although these special brushes are expensive, one should last you a long time.

I like the Arctic Butterfly, shown in **Figure 46.7**. You activate the built-in motor that spins the brush at high speed to charge it with static electricity. Then, *shut the motor off* and pass the charged brush *above* the sensor surface so that dust will leap off the sensor and onto the brush.

Figure 46.6 A proper brush is required for dusting off your sensor.

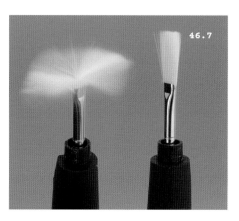

Figure 46.7 The motor in the Arctic Butterfly flutters the brush tips for a few minutes to charge them for picking up dust (left). Then, turn off the power and flick the tip above the surface of the sensor (right).

Liquid Cleaning

Unfortunately, you'll sometimes encounter really stubborn dust spots that can't be removed with a blast of air or flick of a brush. These spots may be combined with some grease or a liquid that causes them to stick to the sensor filter's surface. Pollen is particularly troublesome in this way. In such cases, liquid cleaning with a swab may be necessary. During my first clumsy attempts to clean my own sensor, I accidentally got my blower bulb tip too close to the sensor, and some sort of deposit from the tip of the bulb ended up on the sensor. I panicked until I discovered that liquid cleaning did a good job of removing whatever it was that took up residence on my sensor.

You can make your own swabs out of pieces of plastic (some use fast-food restaurant knives, with the tip cut at an angle to the proper size) covered with a soft cloth or Pec-Pad, as shown in **Figure 46.8** and **Figure 46.9**. However, if you've got the bucks to spend, you can't go wrong with good-quality commercial sensor cleaning swabs, such as those sold by Photographic Solutions, Inc. (www.photosol.com).

You want a sturdy swab that won't bend or break so you can apply gentle pressure to the swab as you wipe the sensor surface. Use the swab with methanol (as pure as you can get it, particularly medical grade; other ingredients can leave a residue), or the Eclipse solution also sold by Photographic Solutions. Eclipse is actually quite a bit purer than even medical-grade methanol. A couple drops of solution should be enough, unless you have a spot that's extremely difficult to remove. In that case, you may need to use extra solution on the swab to help "soak" the dirt off.

Figure 46.8 You can make your own sensor swab from a plastic knife that's been truncated.

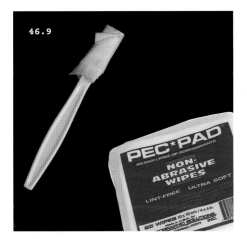

Figure 46.9 Carefully wrap a Pec-Pad around the swab.

Once you overcome your nervousness at touching your T6's sensor, the process is easy. You'll wipe continuously with the swab in one direction, then flip it over and wipe in the other direction. You need to completely wipe the entire surface; otherwise, you may end up depositing the dust you collect at the far end of your stroke. Wipe; don't rub.

If you want a close-up look at your sensor to make sure the dust has been removed, you can pay $50 to $100 for a special sensor "microscope" with an illuminator. (See **Figure 46.10**.) Or, you can do like I do and work with a plain old Carson MiniBrite PO-55 illuminated 5X magnifier, as seen in **Figure 46.11**. It has a built-in LED and, held a few inches from the lens mount with the lens removed from your T6, provides a sharp, close-up view of the sensor, with enough contrast to reveal any dust that remains. You can read more about this great device at http://dslrguides.com/carson/.

Figure 46.10 This SensorKlear magnifier provides a view of your sensor as you work.

Figure 46.11 An illuminated magnifier like this Carson MiniBrite PO-55 can be used as a 'scope to view your sensor.

47. RESURRECTING DEAD CARDS

SOMETIMES GOOD MEMORY cards go bad. Sometimes good photographers can treat their memory cards badly. It's possible that a memory card that works fine in one camera won't be recognized when inserted into another. In the worst case, you can have a card full of important photos and find that the card seems to be corrupted and you can't access any of them. Don't panic! If these scenarios sound horrific to you, there are lots of things you can do to prevent them from happening, and a variety of remedies available if they do occur. You'll want to take some time—before disaster strikes—to consider your options.

If you're like many aspiring photo enthusiasts, you may not own more than one memory card. After all, a single 16GB SD card can hold more than 2,000 of the Rebel T6's JPEG images, and nearly 500 shots if you are using the RAW+JPEG setting. However, you really should have more than one card, because memory cards can fail. I found a 32GB Class 10 SanDisk memory card on Amazon for as little as $12. You don't need to purchase more expensive, faster cards labeled UHS-I or UHS-II. While the T6 writes images to its memory card quickly, it isn't capable of the transfer speeds offered by more costly media. Class 10 cards work fine for both stills and video.

You might want to own several memory cards to avoid putting all your image eggs into a single basket. Of course, if you have multiple smaller cards, you do increase your chances of something happening to one of them (usually

because you lost one or it went through your washing machine), so, arguably, you might be boosting the odds of losing some pictures. If all your images are important, the fact that you've lost 100 rather than 200 pictures isn't very comforting. Your best bet is to put your eggs into one or two baskets, and watch both *very carefully*.

If you shoot photojournalist-type pictures, you probably change memory cards when they're less than completely full in order to avoid the need to do so at a crucial moment. (When I shoot sports, my cards rarely reach 80 to 90 percent of capacity before I change them.) If you are shooting a family wedding it's unlikely you'll be able to restage the nuptials if a memory card goes bad; you'll probably want to shoot no more pictures than you can afford to lose on a single card, and swap cards from time to time. On vacations you might want to take a few hundred or so pictures on one card, or whatever number of images might fill about 25 percent of its capacity. Then, replace it with a different card and shoot about 25 percent of that card's available space. Repeat these steps with diligence (you'd have to be determined to go through this inconvenience), and, if you use four or more memory cards, you'll find your pictures from each location scattered among the different memory cards. If you lose or damage one, you'll still have *some* pictures from all the various stops on your trip on the other cards. That's more work than I like to do (I usually tote around a portable hard disk and copy the files to the drive as I go), but it's an option.

What Can Go Wrong?

There are lots of things that can go wrong with your memory card, but the ones that aren't caused by human stupidity are statistically very rare. Yes, a memory card's internal bit bin or controller can suddenly fail due to a manufacturing error or some inexplicable event caused by old age. However, if your memory card works for the first week or two that you own it, it should work forever. There's really not a lot that can wear out.

The typical memory card is rated for a Mean Time Between Failures of 1,000,000 hours of use. That's constant use 24/7 for more than 100 years! According to the manufacturers, they are good for 10,000 insertions in your camera, and should be able to retain their data (and that's without an external power source) for something on the order of 11 years. Of course, with the millions of memory cards in use, there are bound to be a few lemons here or there.

Given the reliability of solid-state memory, compared to magnetic memory, though, it's more likely that your memory problems will stem from something that you do. Memory cards are small and easy to misplace if you're not careful. For that reason, it's a good idea to keep them in their original cases or a "card safe" offered by Gepe (www.gepecardsafe.com), Pelican (www.pelican.com), and others. Always placing your memory card in a case can provide protection from the second-most common mishap that befalls memory cards: the common household laundry. If you slip a memory card

in a pocket, rather than a case or your camera bag, often enough, sooner or later it's going to end up in the washing machine and probably the clothes dryer, too. There are plenty of reports of relieved digital camera owners who've laundered their memory cards and found they still worked fine, but it's not uncommon for such mistreatment to do some damage.

Memory cards can also be stomped on, accidentally bent, dropped into the ocean, chewed by pets, and otherwise rendered unusable in myriad ways. It's also possible to force a card into your T6's memory card slot incorrectly if you're diligent enough, doing a little damage to the card itself or slot. Or, if the card is formatted in your computer with a memory card reader, your T6 may fail to recognize it. Occasionally, I've found that a memory card used in one camera would fail if used in a different camera (until I reformatted it in Windows, and then again in the camera). Every once in awhile, a card goes completely bad and—seemingly—can't be salvaged.

Another way to lose images is to do commonplace things with your memory card at an inopportune time. If you remove the card from the T6 while the camera is writing images to the card, you'll lose any photos in the buffer and may damage the file structure of the card, making it difficult or impossible to retrieve the other pictures you've taken. The same thing can happen if you remove the memory card from your computer's card reader while the computer is writing to the card (say, to erase files you've already moved to your computer). You can avoid this by *not* using your computer to erase files on a memory card but, instead, always reformatting the card in your T6 before you use it again.

What Can You Do?

Pay attention: If you're having problems, the *first* thing you should do is *stop* using that memory card. Don't take any more pictures. Don't do anything with the card until you've figured out what's wrong. Your second line of defense (your first line is to be sufficiently careful with your cards that you avoid problems in the first place) is to *do no harm* that hasn't already been done. Read the rest of this section and then, if necessary, decide on a course of action (such as using a data recovery service or software described later) before you risk damaging the data on your card further.

Now that you've calmed down, the first thing to check is whether you've actually inserted a card in the camera. If you've set the camera in the Shooting menu so that Shoot w/o Card has been turned on, it's entirely possible (although not particularly plausible) that you've been snapping away with no memory card to store the pictures to, which can lead to massive disappointment later on. Of course, the No Memory Card message appears on the LCD when the camera is powered up, and it is superimposed on the review image after every shot, but maybe you're inattentive, or aren't using picture review. You can avoid all this by turning the Shoot w/o Card feature off and leaving it off.

Things get more exciting when the card itself is put in jeopardy. If you lose a card, there's not a lot you can do other than take a picture of a similar card and print up some Have You Seen This Lost Flash Memory? flyers to post on utility poles all around town.

If all you care about is reusing the card, and have resigned yourself to losing the pictures, try reformatting the card in your camera. You may find that reformatting removes the corrupted data and restores your card to health.

Sometimes I've had success reformatting a card in my computer using a memory card reader (this is normally a no-no because your operating system doesn't understand the needs of your T6), and *then* reformatting again in the camera.

If your memory card is not behaving properly, and you *do* want to recover your images, things get a little more complicated. If your pictures are very valuable, either to you or to others (for example, a wedding), you can always turn to professional data recovery firms. Be prepared to pay hundreds of dollars to get your pictures back, but these pros often do an amazing job. You wouldn't want them working on your memory card on behalf of the police if you'd tried to erase some incriminating pictures. There are many firms of this type, and I've never used them myself, so I can't offer a recommendation. Use a Google search to turn up a ton of them. I use a software program called Rescue-Pro, which came free with one of my SanDisk memory cards.

A more reasonable approach is to try special data recovery software you can install on your computer and use to attempt to resurrect your "lost" images yourself. They may not actually be gone completely. Perhaps your memory card's "table of contents" is jumbled, or only a few pictures are damaged in such a way that your camera and computer can't read some or any of the pictures on the card. Some of the available software was written specifically to reconstruct lost pictures, while other utilities are more general-purpose applications that can be used with any media, including floppy disks and hard disk drives. They have names like OnTrack, Photo Rescue 2, Digital Image Recovery, MediaRecover, Image Recall, and the aptly named Recover My Photos.

INDEX

S

Don't close the book on us yet!

Interested in learning more on the art and craft of photography? Looking for tips and tricks to share with friends? For updates on new titles, access to free downloads, blog posts, our eBook store, and so much more visit rockynook.com/information/newsletter